THE CALIFORNIA
SURF PROJECT

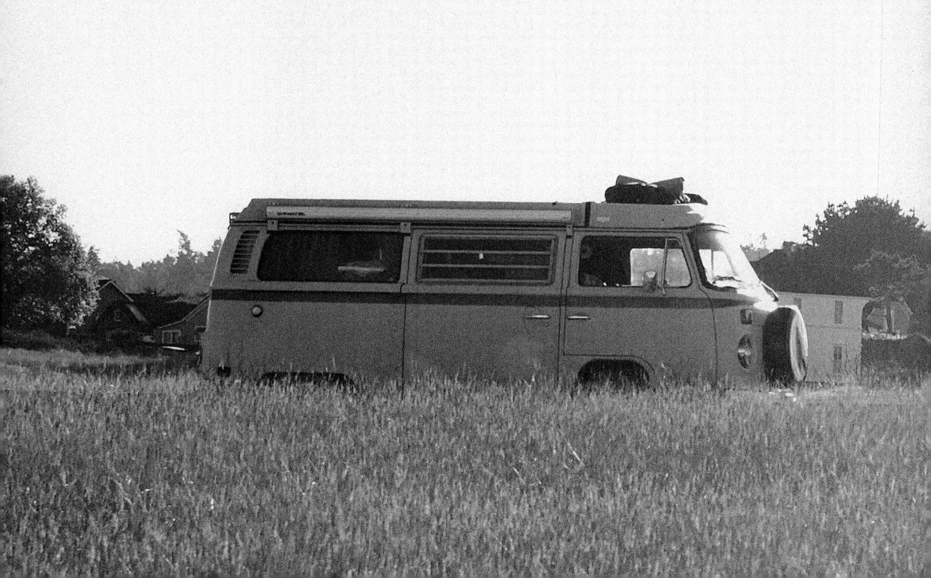

THE CALIFORNIA SURF PROJECT

BY ERIC SODERQUIST & CHRIS BURKARD

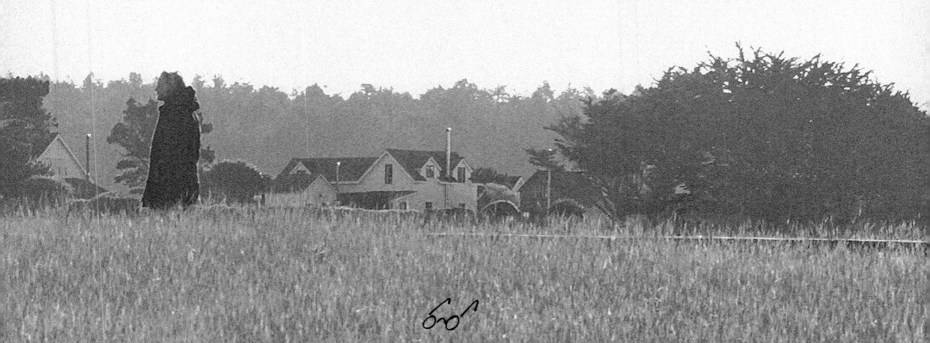

CHRONICLE BOOKS
SAN FRANCISCO

Library of Congress Cataloging-in-Publication Data

Soderquist, Eric.
 The California surf project / by Eric Soderquist & Chris Burkard.
 p. cm.
 ISBN 978-0-8118-6282-0
 1. Surfing–California. I. Burkard, Chris. II. Title.

 GV839.65.C2S64 2008
 797.3'209794–dc22

 2008038187

Manufactured in China
Designed by Jeff Canham
Marquee Color Correction by Marc Hostetter, Transworld Surf

10 9 8 7

Chronicle Books LLC
680 Second Street
San Francisco, California 94107

www.chroniclebooks.com

For more information, visit www.thebookprojectca.com.

TABLE OF CONTENTS

FOREWORD

It's a classic pursuit, this lengthwise traversal of coastal California; its 1,100 variegated Pacific miles have hosted a million surf trips. For some, the Golden State sojourn is a rite of passage, a pilgrimage to the far reaches of nature, ripe for risk and a few smoky campfires, a cold ocean, a casual outdoor repose. For others, the journey is a result of logistical simplicity combined with Americana liberty and alluvial surprise, enough to keep gas in the tank of even the most experienced California surf-searcher.

As a child in Encinitas, I often sat in my dad's den and pored over Automobile Club maps of California's counties, dragging my fingertip along the convoluted coasts of Humboldt and Monterey, thinking, *Damn, would I love to go there.* At the time, one family vacation to Sonoma's Russian River and a handful of Hollister Ranch trips were the extent of my state travels, yet with adulthood arrived freedom, kick-starting my first big surf trip from San Diego to Oregon. First came Imperial Beach, San Onofre, and the crowded Orange County boardwalks; Long Beach, Palos Verdes, and the urban South Bay sandbars; Santa Monica, Malibu, and the fertile Ventura nooks, unfurling to Rincon and sunny Santa Barbara; Gaviota Pass, the windy rainbow bridge from southern to central California, where bucolic San Luis Obispo crept into view, soon fading to Morro Bay and the San Simeon coast, accelerating into the steep wilds of Big Sur, the Monterey Peninsula, the stunning diversity of Santa Cruz, and the vast San Franciscan cosmopolis. North of the Golden Gate Bridge was esoteric and enticing, purely magical including the random town names—Honeydew, Timber Cove, Mendocino. Names like these could latch my young mind to the sensations, the vivid auras of outdoor wonder, the cold and never-drying wetsuit, woodsmoke, rain and fog, morning dew on green campground grass, loud surf, birdsong, and the sweet earthen scents of forest: fir, redwood, pine sap, moss, fungi, ferns, bramble berries, rotting bark. For a San Diego–bred surfer, weaned on crowds and warmth and acres of concrete, this was good stuff.

For budding photographer Chris Burkard, it was indeed a first; for surfer Eric Soderquist, a California-travel veteran, it was a return. In October 2006, the two San Luis Obispo County natives took to historic Highways 1 and 101, alighting with no set plan other than to have none at all, living for the next two months in Soderquist's 1978 Volkswagen bus, touring the crisp, cruisey autumnal scene from the Oregon border south to the Tijuana Sloughs, Burkard photographing, Soderquist surfing and painting (and driving most of the time). Adventure abounded along the state's north and central coasts, from surfing a veritable river bore in Del Norte to witnessing attempted murder in Fort Bragg to revisiting favorite spots in Carmel to catching the flu in San Simeon. Southward, mining the Highway 1 soul presented a new challenge, and Pacific Coast Highway became the duo's next vein of vicissitude, a storied land- and cityscape unfolding all the way to Baja. And so for Chris and Eric, the journey's end at Tijuana marked a profound and enlightening trek mentally, physically, and spiritually—as California is, naturally.

— **Michael Kew,** Santa Barbara County

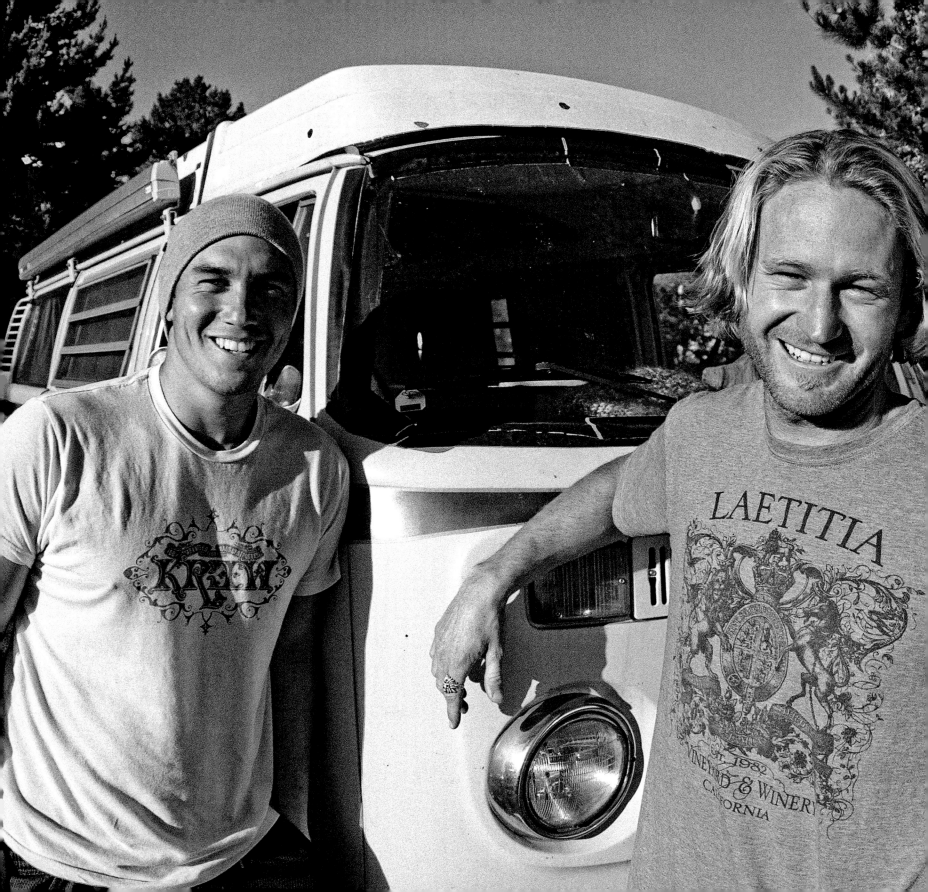

INTRODUCTION

My name is Eric Soderquist and for the past twenty years, I have been on a mission to get to the beach. I was born and raised in the sleepy farm town of Arroyo Grande, which has an abundance of creeks and creatures. It was my family's playground, and as far back as I can remember, my brothers and I were on some kind of adventure. Our transportation evolved from Big Wheels to bikes, skateboards, and eventually to motor vehicles. With each new transport came a notch of exploration, and I soon found myself exploring every nook and cranny of Central California.

A few hills over from my house sat a young Chris Burkard, who I would not meet until years later. As I recall we first met at the beach. Chris was an overenthusiastic kid with an extreme excitement for photography. He was so amped that I could not help but laugh and think, "Who is this kid?" And it didn't help that he ran with a pack of wily boogie boarders. They were always up to something. The pack loved pranks and stunts and on any given day, you could witness some incredibly stupid stuff. For example, a kid would try a backflip off his mom's station wagon, get a boogie board thrown at him, and simultaneously you would see a kid get kicked in the butt, and close by would be Chris trying to get a photo of it all. That was my first impression of Chris, and I definitely got a good laugh out of it.

I kept seeing Chris surfing and we started carpooling to the beach to save gas. We were equally broke and zealous. So we combined our resources and the journey was born. We were up at first light, surfing day in and day out. The sunrises were beautiful and the inspiration was endless. I had been painting oil landscapes at that time and was studying California impressionism. Chris was studying landscape photography and our mediums proved to be compatible. We fed off each other and thought how cool would it be to do a book with all this in mind. It would be a tribute to everything we were studying, seeing, and feeling: a book on California.

We agreed to drive from Oregon to Mexico, but we were broke and for the time being it remained a daydream. A few months went by and one day Chris mentioned he had heard of a photo contest. The contest was in memory of Larry Flame Moore who was an amazing photographer and fixture in the surf world. The winner of the photo contest was to receive a grant to do his or her respective project. I encouraged Chris to enter his photos along with an essay of our plan to do a book on California. Long story short, Chris won the "Follow the Light Grant," in honor of Larry Flame. Now we had gas money and no excuses. A week or so later we packed my VW bus and headed for Oregon. We had achieved the daydream, our vision unraveled before us, and this is the story of our adventure.

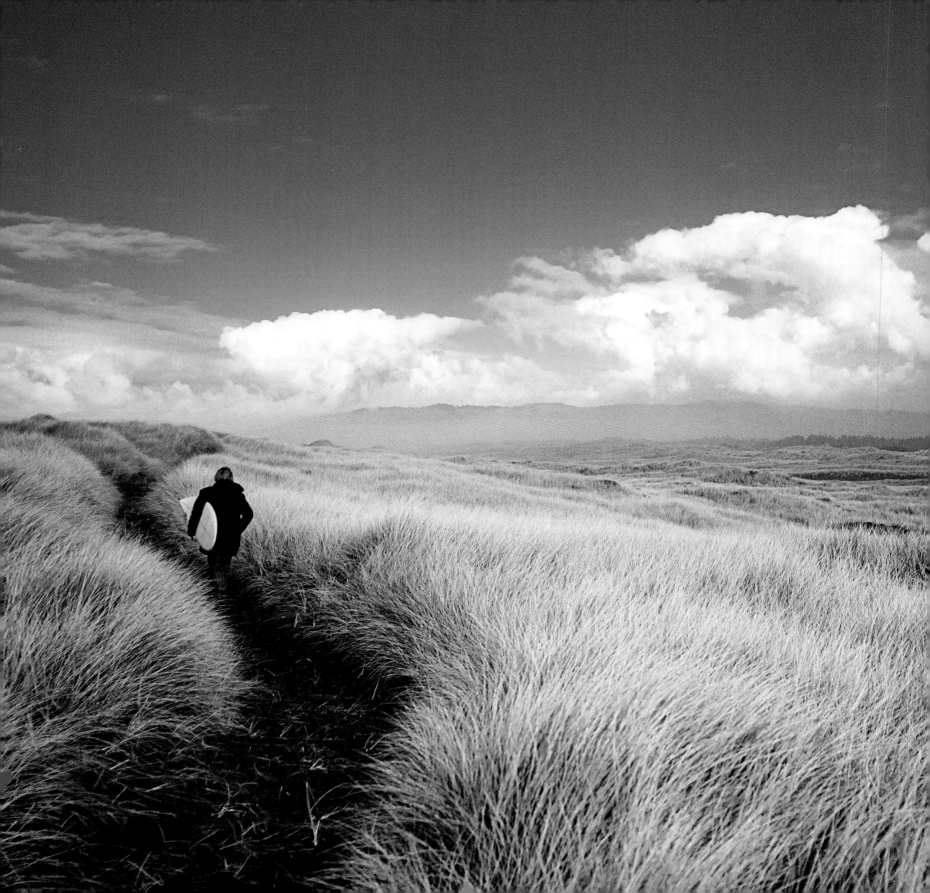

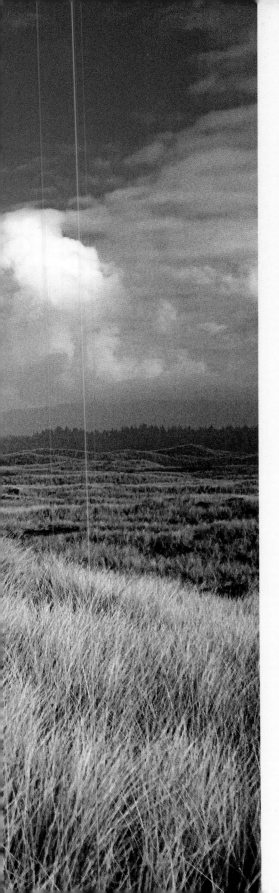

THE BORDER

On a gray afternoon we arrived at the Oregon-California border, which was so sleepy that I almost missed it. I'm accustomed to big checkpoints and dramatic police presence from our southern border, but the northern border consisted of a single-lane road lined by thick native berry bushes and trees and a nod by some sort of Oregon trooper. To our left sat the vast cold Pacific and to our right a small green sign read "Welcome to Oregon."

We arrived after three slow-moving days in my 1978 VW bus. Our pace was far under the speed limit, which was fine considering we were equipped with two beds, a sink, a refrigerator, stove, surfboards, and gear. The bus felt more like a pack mule than a vehicle.

We settled into a large empty campground just past the border. It was like a perfectly thought-out painting: massive ancient trees towered over each site and the richly soaked soil glistened red from fallen pine needles. Ferns followed the creeks and bright green mosses climbed every footbridge. From a distance, my bus looked like a mechanical speck amongst nature's giants.

A golden path leading to the unknown.

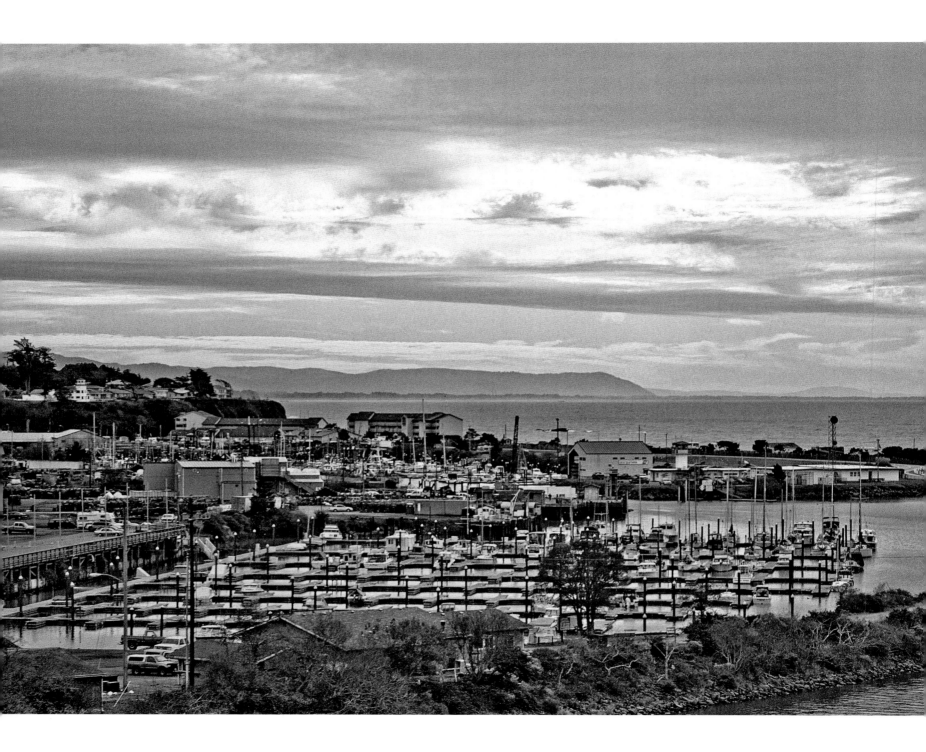

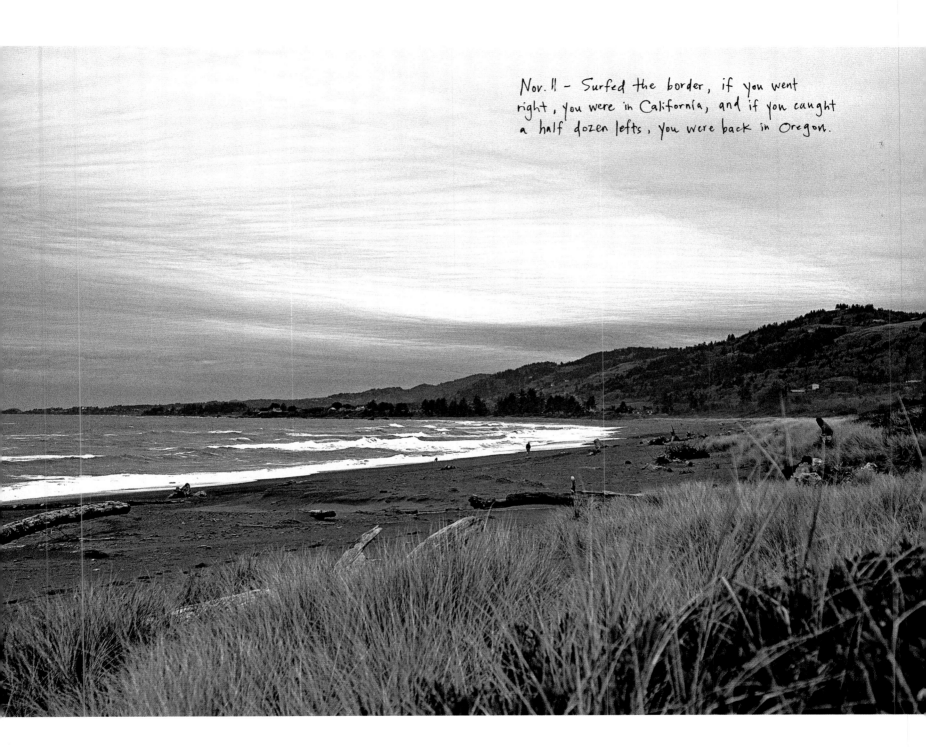

Nov. 11 - Surfed the border, if you went right, you were in California, and if you caught a half dozen lefts, you were back in Oregon.

made a new friend.

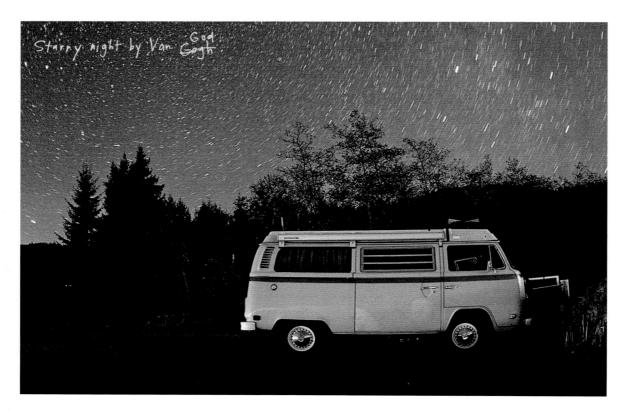

Starry night by Van Gogh

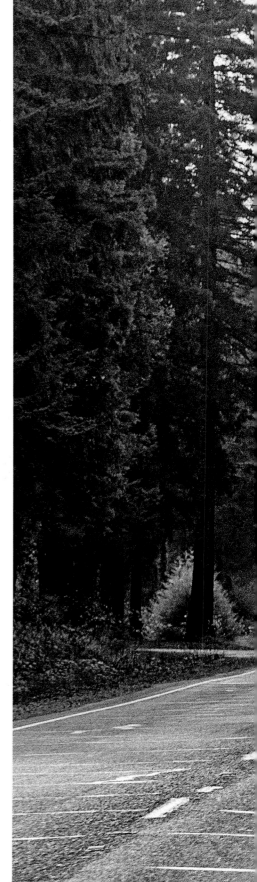

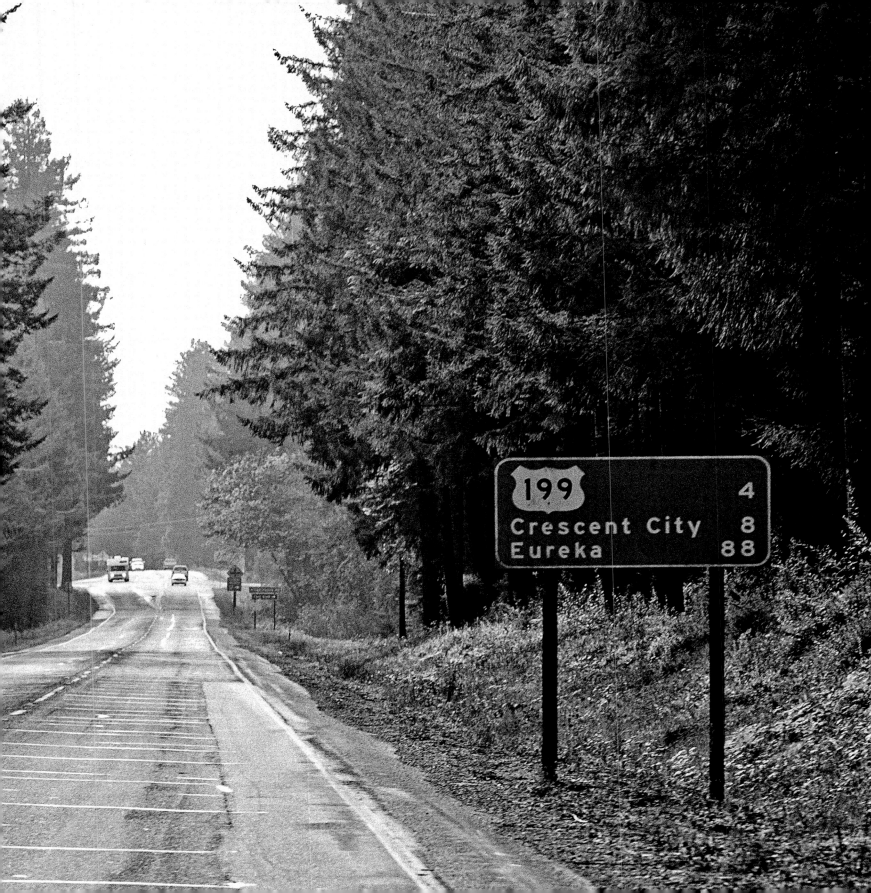

Doghouse

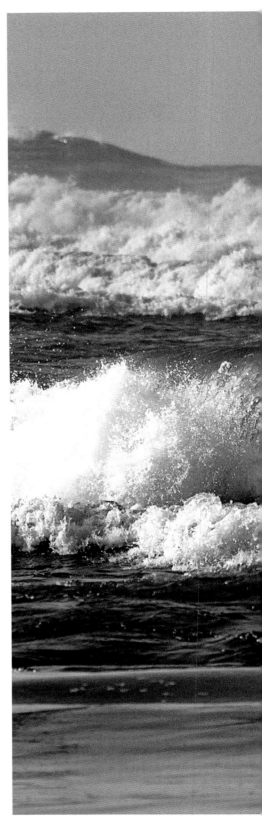

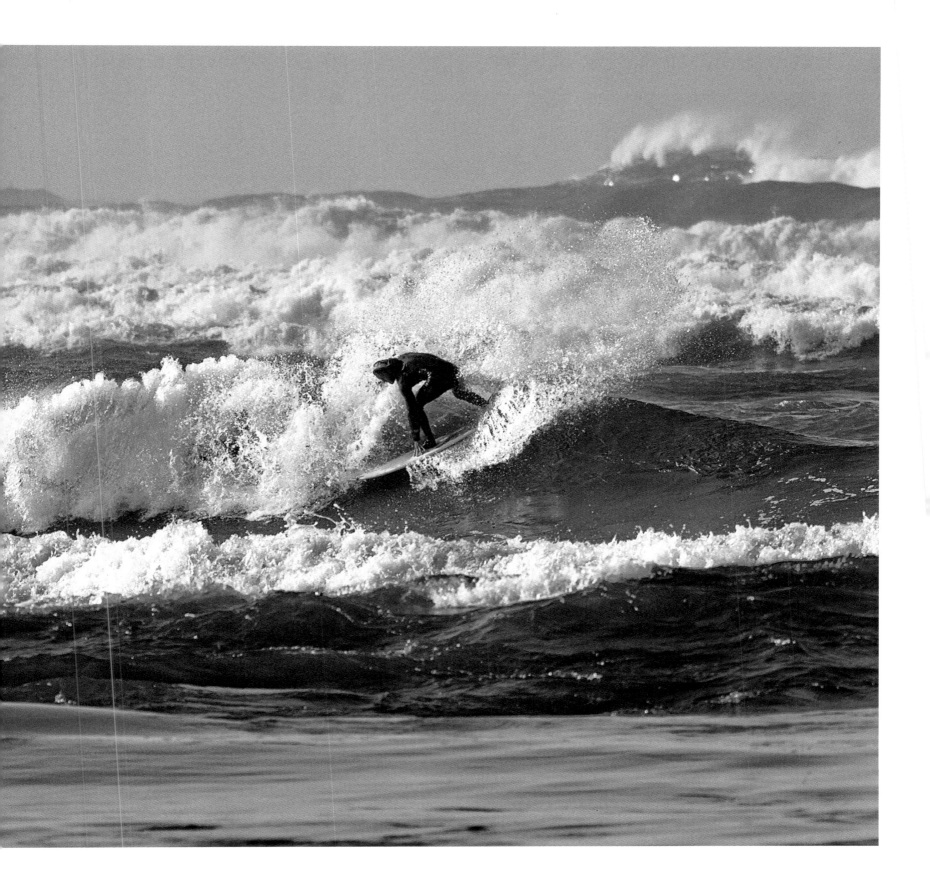

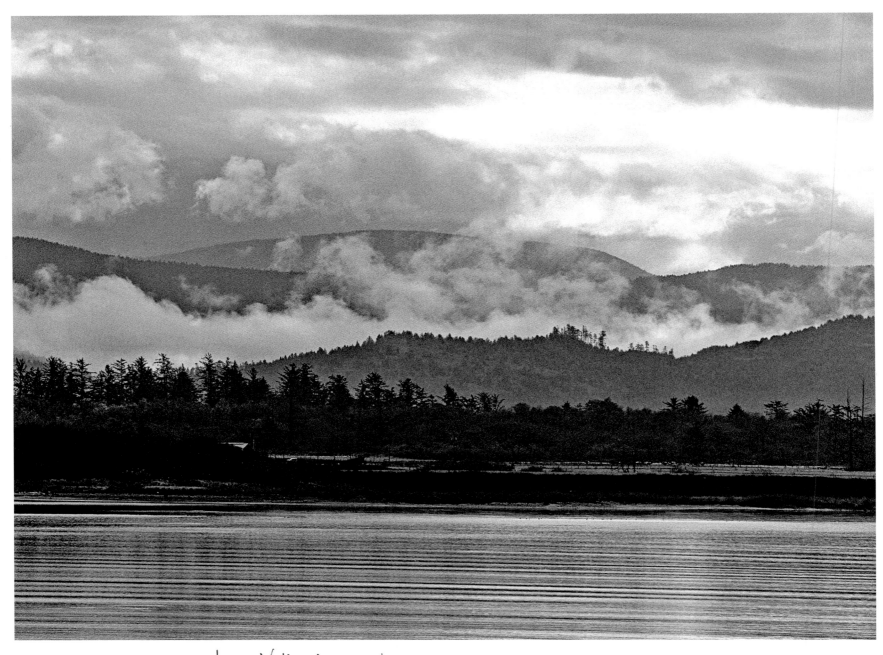

Nov 12 — Hung out in a damp Native American town
and surfed a wave where the Smith River meets the ocean.
After two waves, I got tangled in a tree limb and was
sucked out to sea.

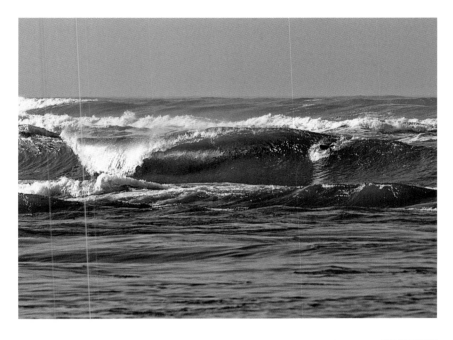

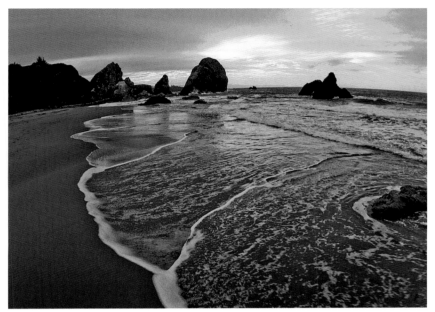

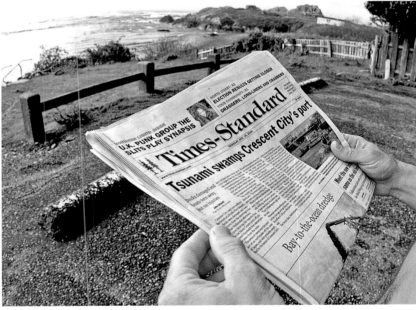

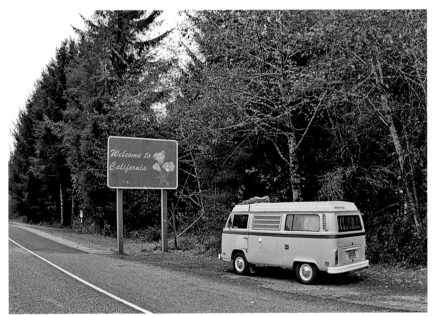

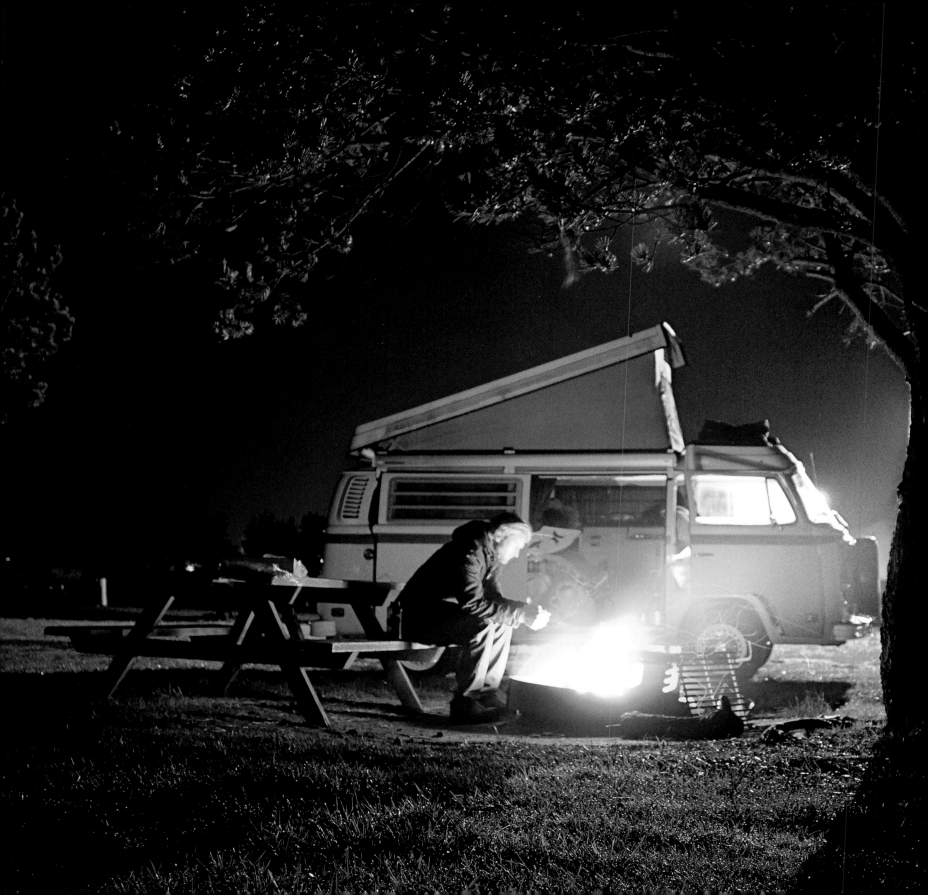

DEL NORTE

In the morning I walked a narrow path down to the beach. The damp forest opened up to a vast view of a rugged coastline. I stood on a soon-to-be island, a tattered rock that clung to the land while the ocean washed nearly around it. To the north, giant rock formations peppered the coast as far as I could see while to the south was a series of small bays and beaches. In a meandering creek, giant fallen trees created small clear ponds that trickled over river rock, across the sand, and out to the Pacific. Seagulls rode the air currents above and I spent the morning taking it all in.

We headed south fading in and out of the forest, catching glimpses of the beach. Generally farms separated us from the water's edge until we arrived in Crescent City, a spread-out town with a strong fishing presence and a somewhat industrial feel. The town sits on a large harbor with long jetties shooting in every direction. A headland with towering redwoods cradles the south, and an old lighthouse on a lonely rock island sits at the north entrance of the harbor. A distant foghorn resonated in the damp ocean air.

After several days of downpour and wandering, I found myself looking down at a massive rivermouth, feeling about a thousand feet high. The view spanned over the endless sea and far up the tranquil river. Swell trains marched in and the whitewater spun in the currents as massive waves crashed on the sand atoll. I imagined the atoll as the line that divided the ying and the yang, the calm river and raging sea that pushed back and forth on each other. As a surfer I found this place to be peacefully terrifying; Del Norte's beauty is raw and rugged.

A fire under the stars welcomed us to Crescent City.

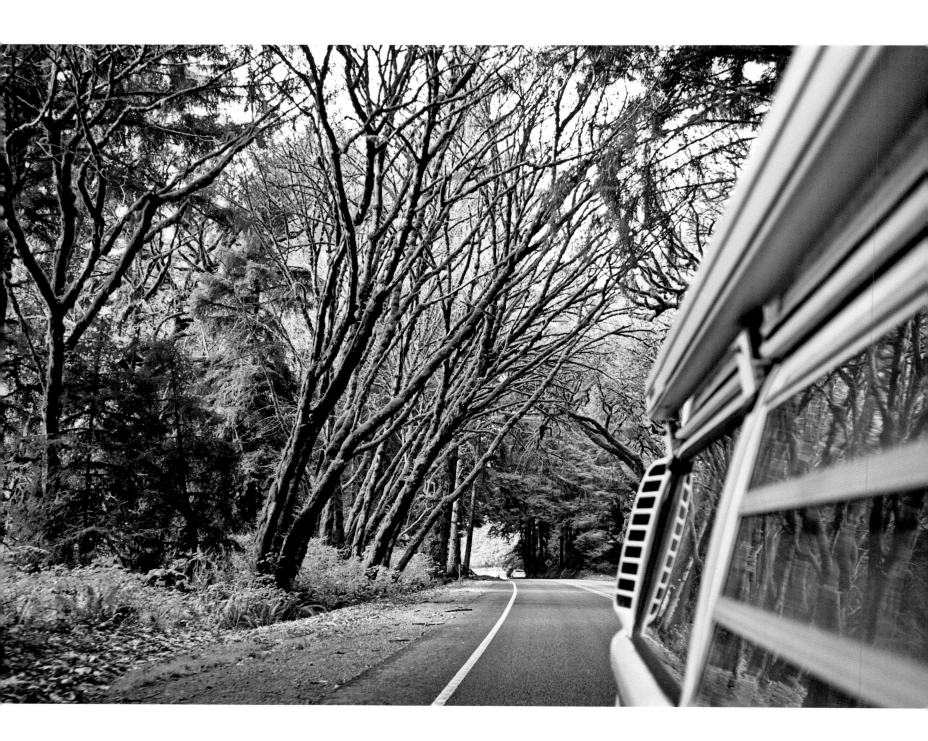

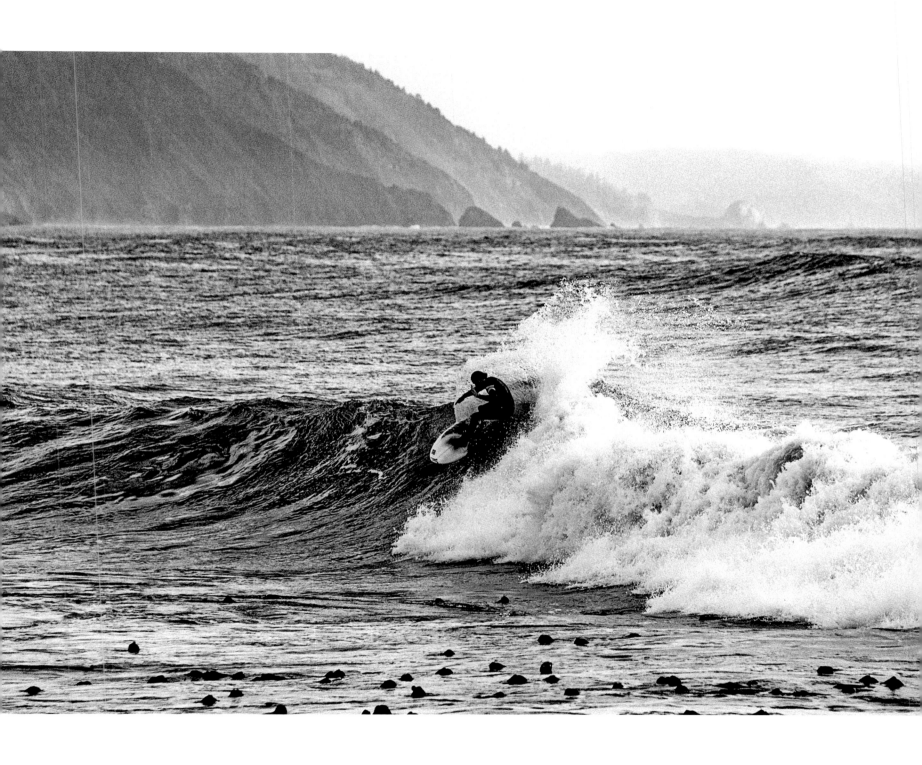

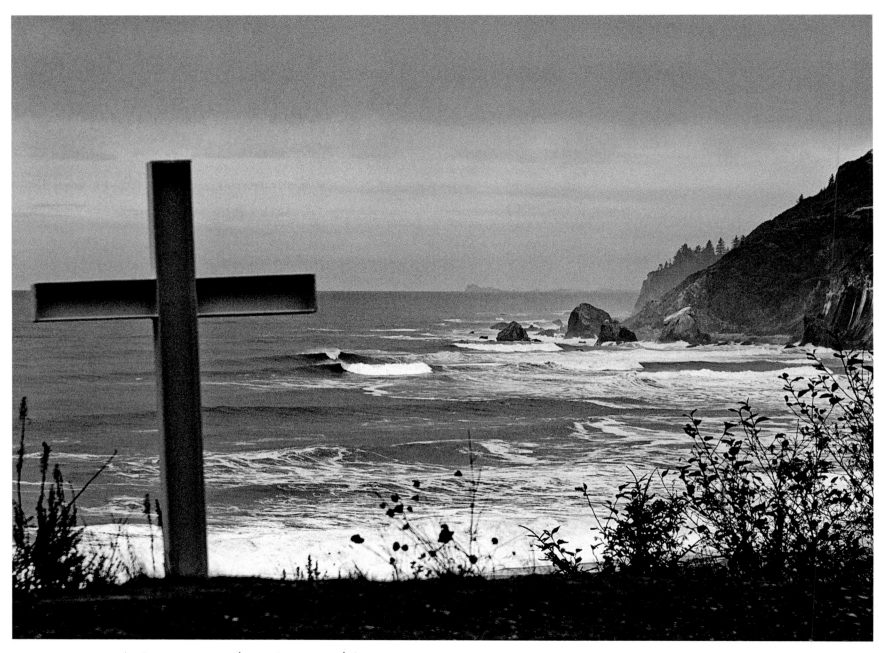

After several shark stories, all the religious symbolism
in the world couldn't save this wave from being
completely terrifying.

Things seemed a bit weathered.

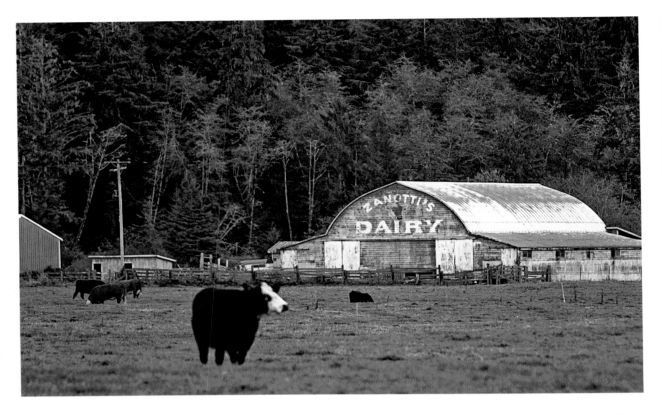

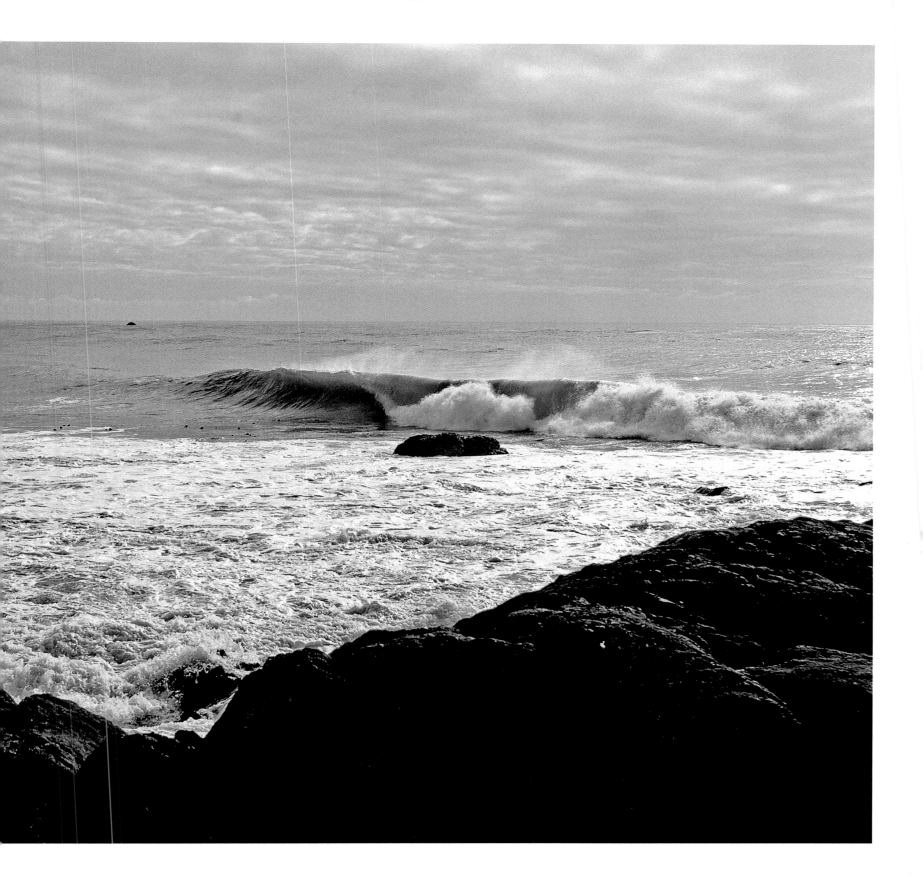

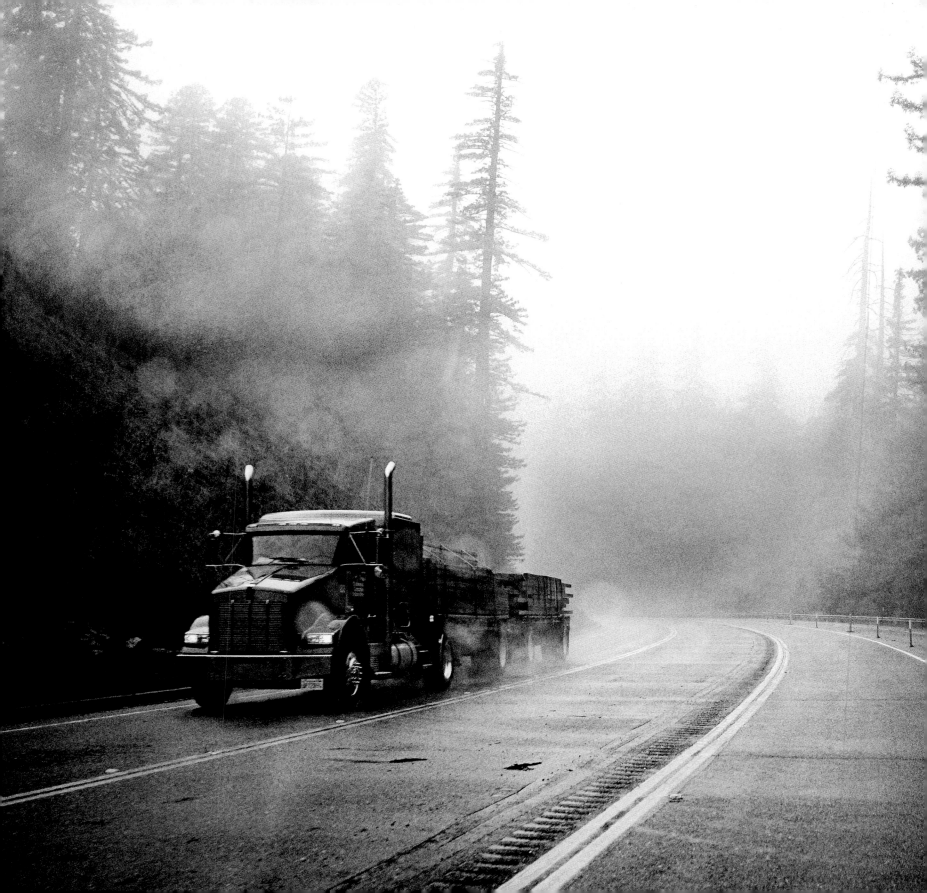

HUMBOLDT

Around sunset, we pulled into Humboldt. The rain let up and sky turned fire red as we wove through the redwoods and found a great site near a giant bluff. We enjoyed a big fire and a beautiful night off from the rain.

In the morning some fellow campers told us that *Return of the Jedi* was filmed there, the scene where the Ewoks flew through the redwoods on those jet-looking things. As I wandered out to check the surf I thought I saw Chewbacca himself, but he turned out to be a hippie left over from the Reggae on the River festival. His spaceship was actually a converted school bus with hula-hoops and other cool stuff plastered all over it. He came in peace and I continued on the trail that tunneled through the trees out to the beach.

The giant bluff behind me blocked the morning light, shading the whole beach. The morning was freezing cold and the sand was wet from a nearby creek, and changing into my dripping-wet wetsuit nearly gave me a heart attack. Unfortunately the ocean proved no warmer than the land. I paddled out to the beachbreak at the base of a long left point. Trees leaned over the bluff as if reaching out to see me. It reminded me of surfing in Chile, a very rugged and unspoiled place.

Humboldt is full of interesting setups: waves bouncing off rocks and spinning down sandbars, huge waves funneling into harbors, distant waves requiring long hikes. But overall it was the surrounding land that made these waves so special. Imagine driving to the beach past trees that were around when Columbus stumbled upon America, trees so massive you can stand up in their root systems and drive through their trunks. It's a strange surf trip when you're so captivated by your surroundings that you completely forget to surf.

King of the road

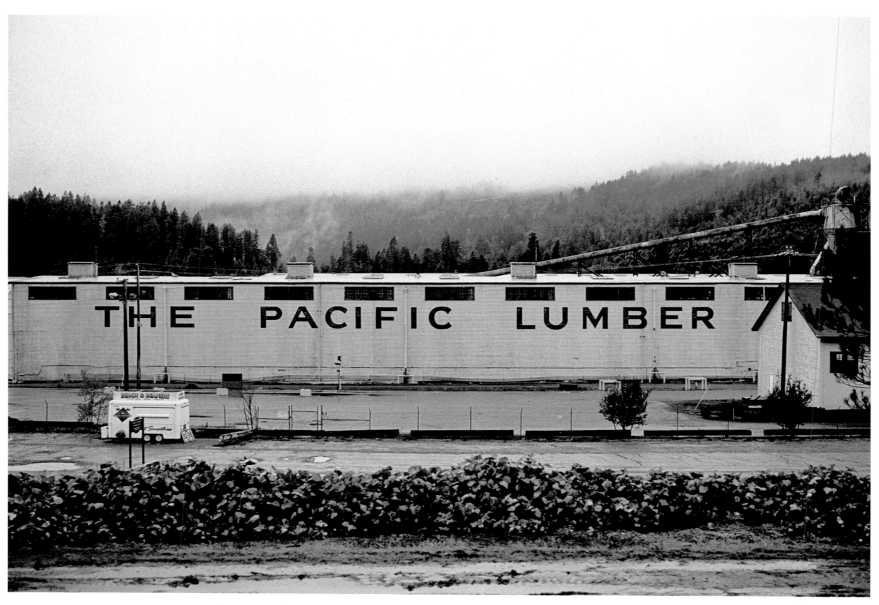

Cold waves and signs of an aged industry.

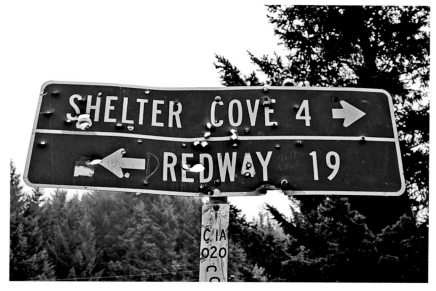

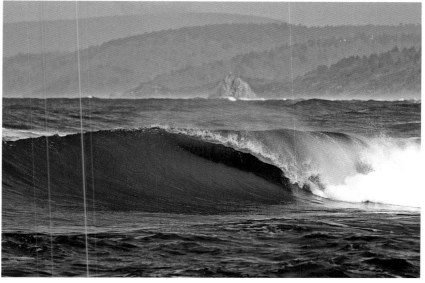

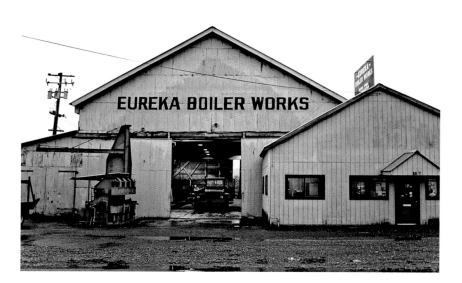

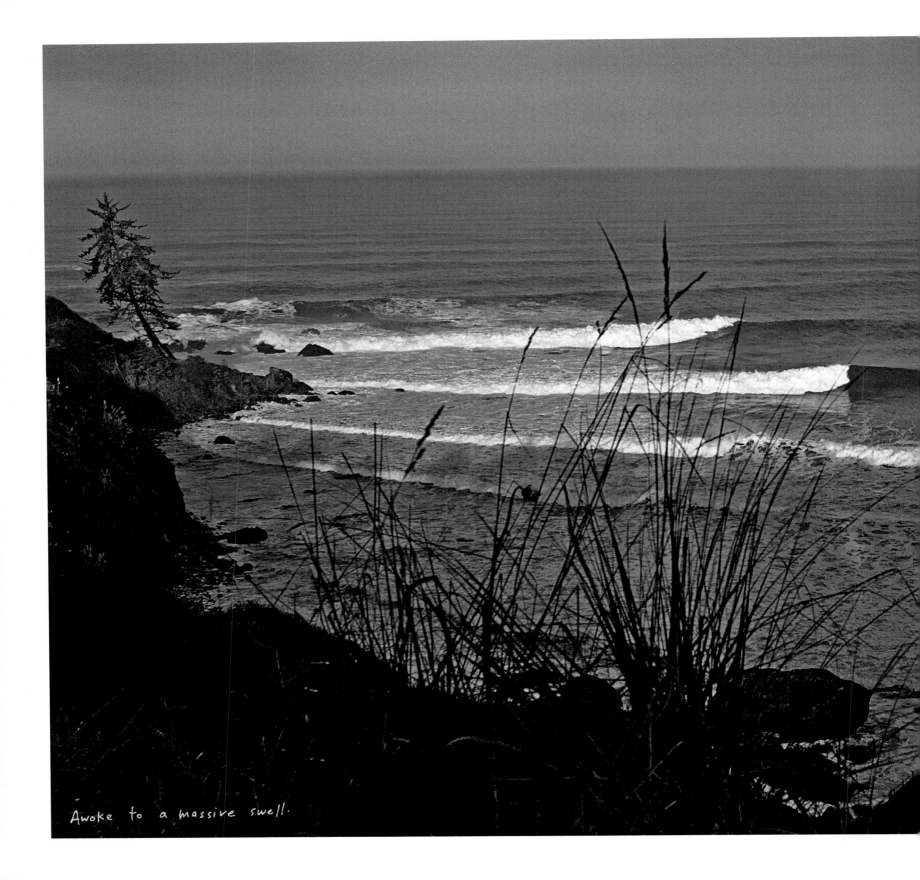

Awoke to a massive swell.

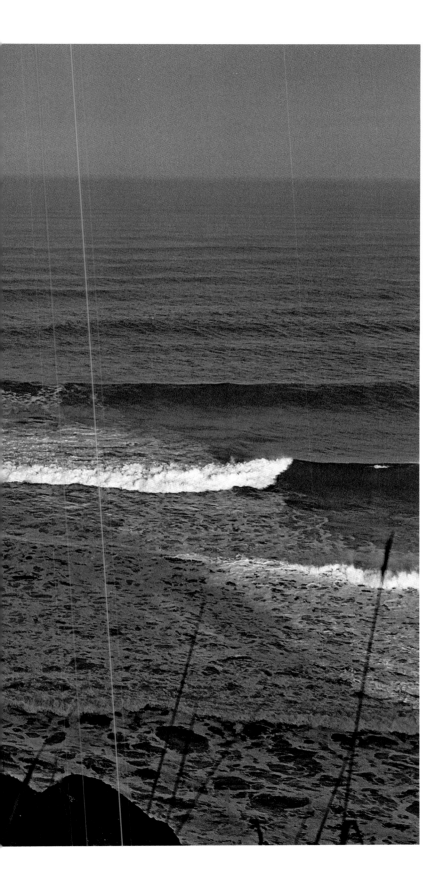
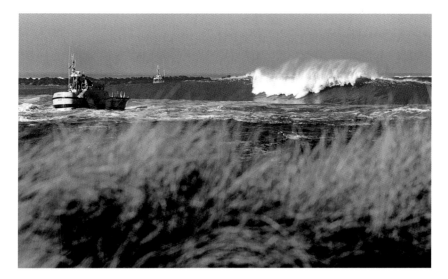
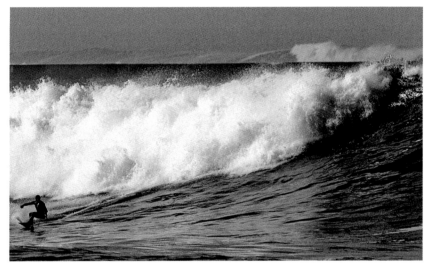
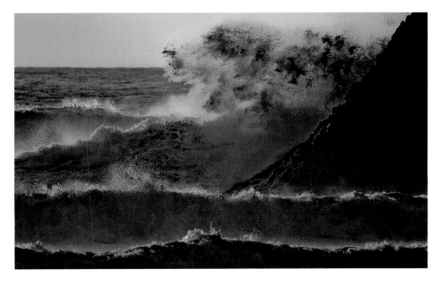

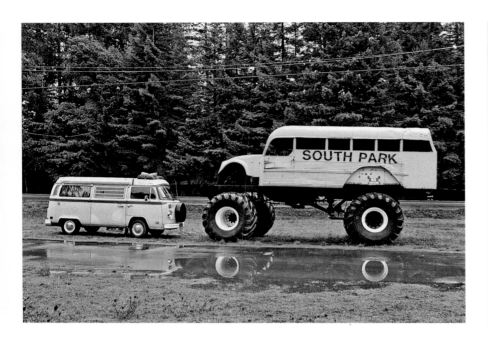

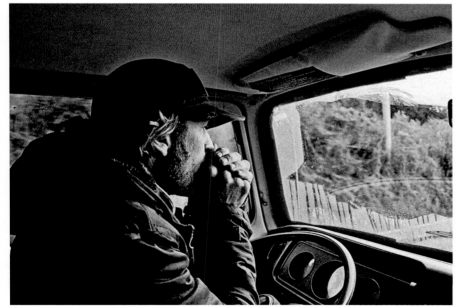

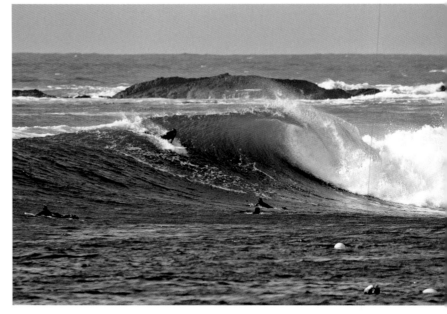

Spectacular trees, waves and my
cousin's General Lee.

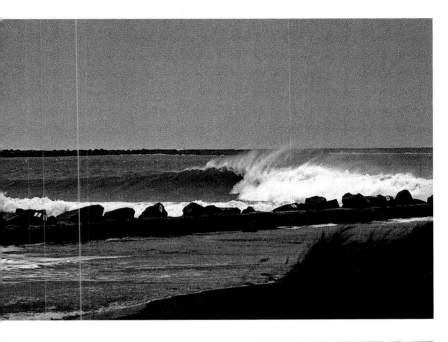
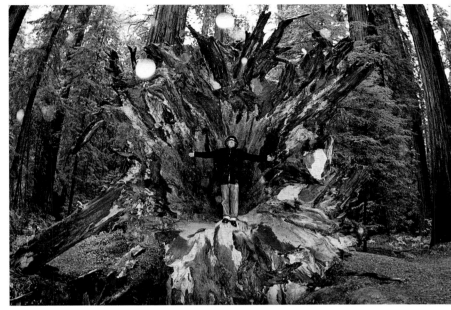
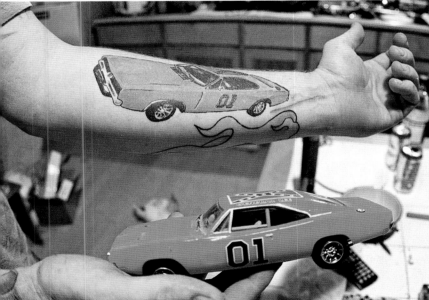
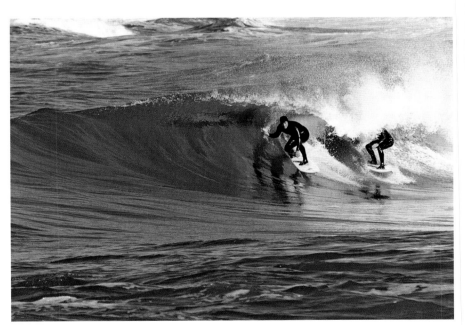

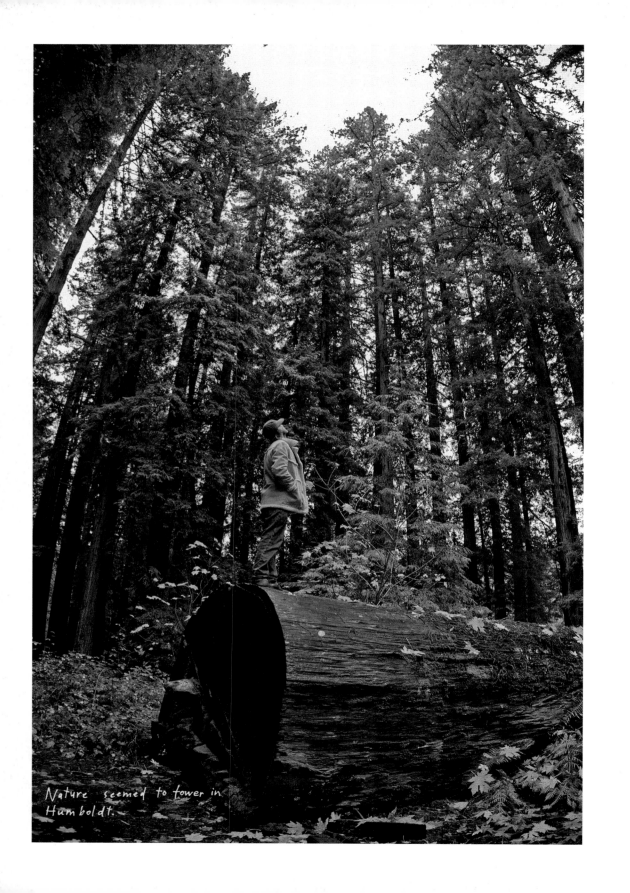

Nature seemed to tower in Humboldt.

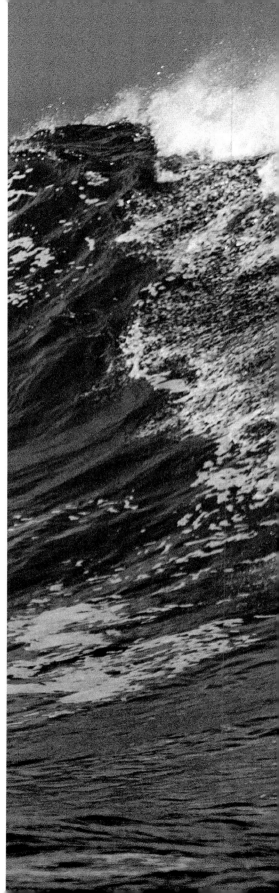

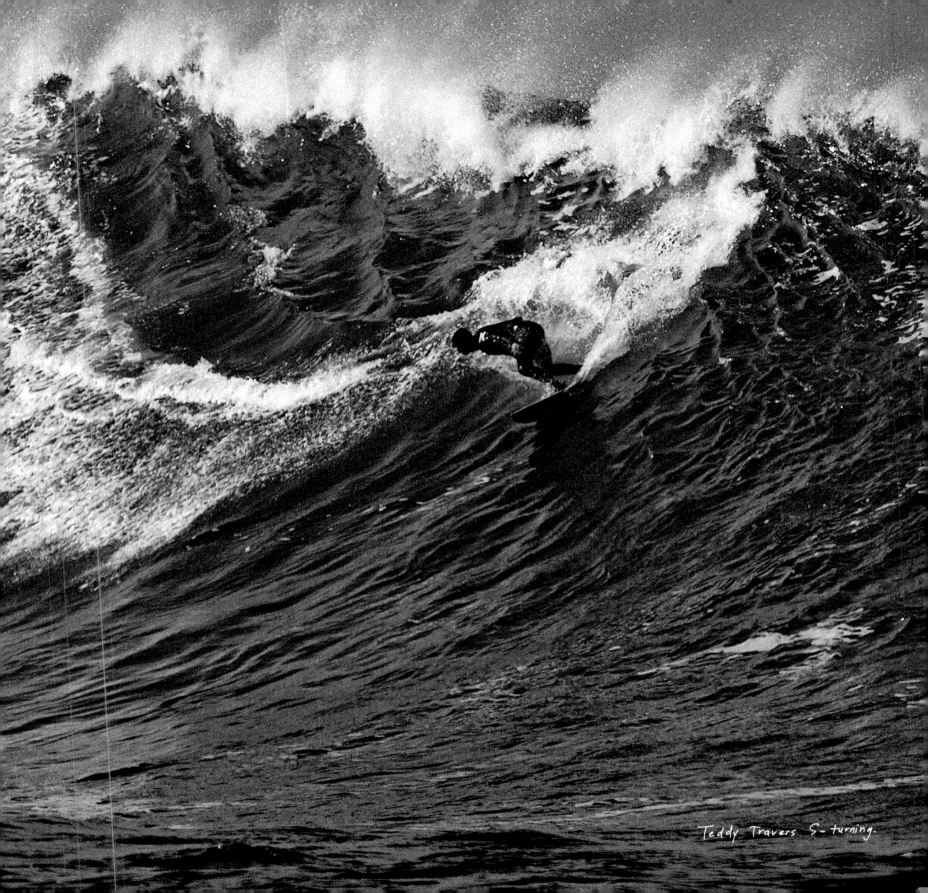

Teddy Travers S-turning.

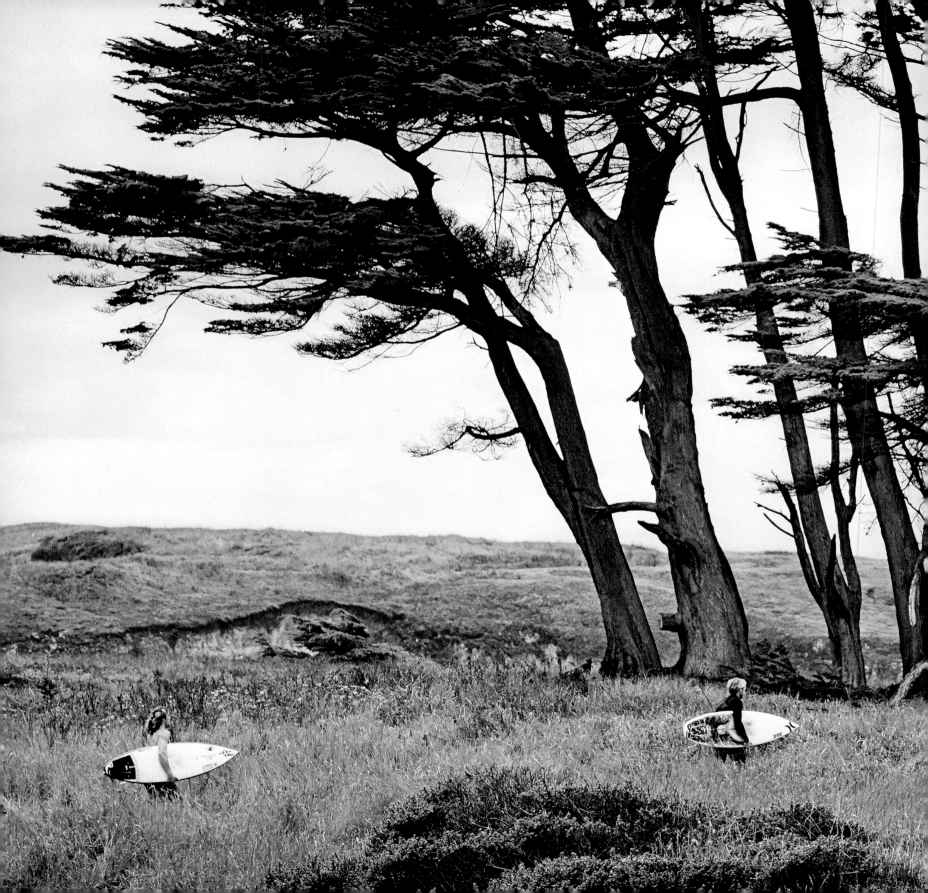

MENDOCINO

After being inland in Humboldt we were glad to be back on the coast in Mendocino. The coastline appeared especially rugged as we arrived in the rain with rough seas. Large rocks line the coast and an inaccessible mountainous region looms to the north.

My first surf consisted of blown-out chop, similar to being in a washing machine. There wasn't a person in sight and after twenty duck dives I had an intense ice-cream headache and started thinking of sharks. Simultaneously, a seal popped up two feet away, looking as scared as me. I caught two closeouts and went in. After changing in the rain I wondered where we would make camp.

Although we were reluctant to head all the way to town because it would mean backtracking to surf in the morning, a few hours cooped up in the bus in the rain made the decision easy. The sight of a coffee shop with hot food and room to stretch was like an oasis in the desert. We were always really excited to get out of the bus when the rain was heavy. Dripping-wet and spastic, we would burst into a pit stop and people would look at us like we were crazy. Every so often we would get lucky and find genuinely friendly people and then we would share stories or enjoy some live music.

Forty-eight hours of heavy rain finally let up as we approached the town of Mendocino. It was like an old Western, rolling into a pleasant town where everyone is out and about. The main street is lined with small storefronts, plus an old church and schoolhouse. If only the children wore bonnets and overalls it could have been a scene from *Little House on the Prairie.*

The town sits on a peninsula that pokes out to sea, next to a beautiful cliff-lined bay that connects to an amazing river. On this part of the coast the terrain begins to change: the headlands are flatter with fields of native grasses and the mountains are pushed back farther from the ocean.

The ocean became more pleasant and organized as we drove south, and the elements also grew more hospitable. We enjoyed our time in Mendocino, where the vibe felt real country and down to earth.

Nov. 22 — Mendocino.

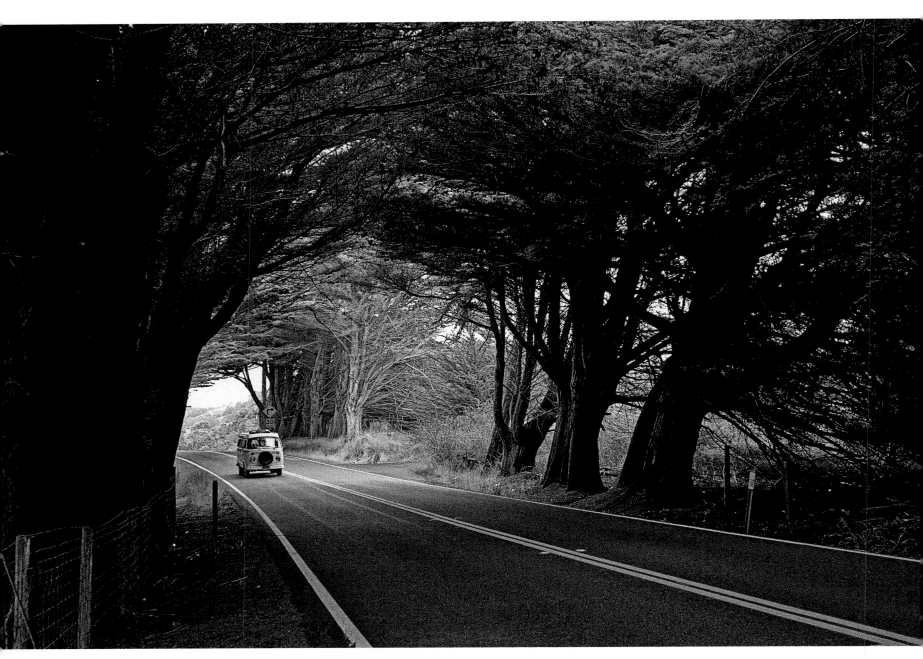

Barrels so big you could drive a bus through them.

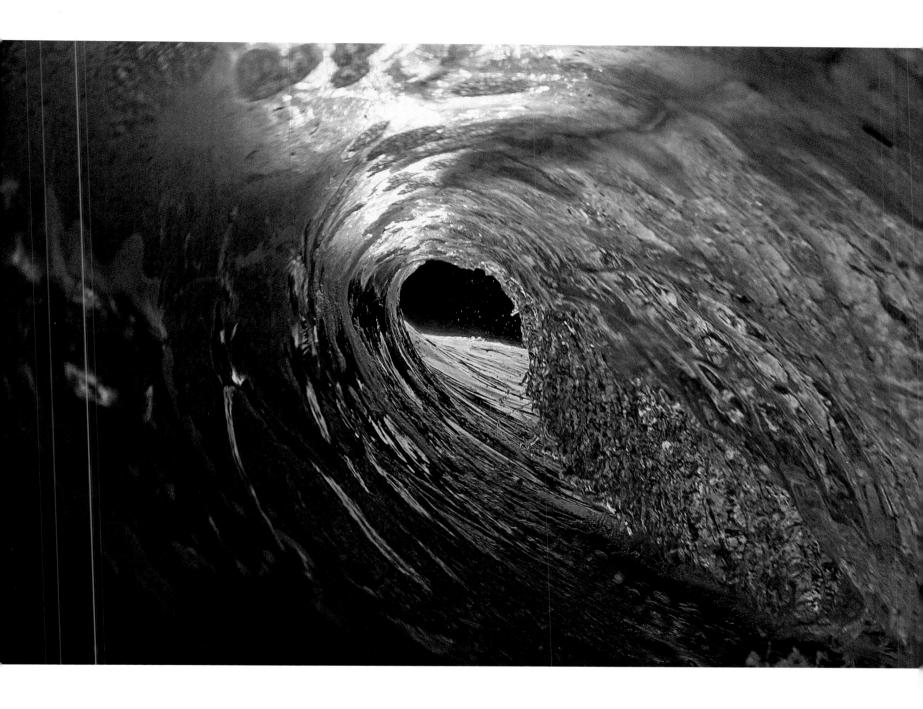

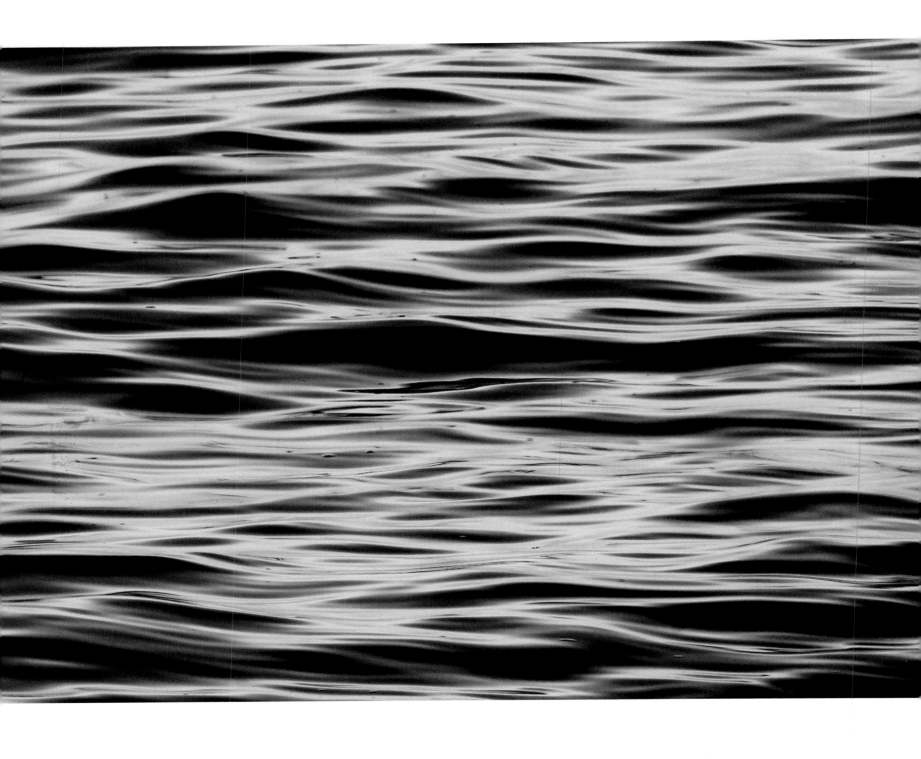

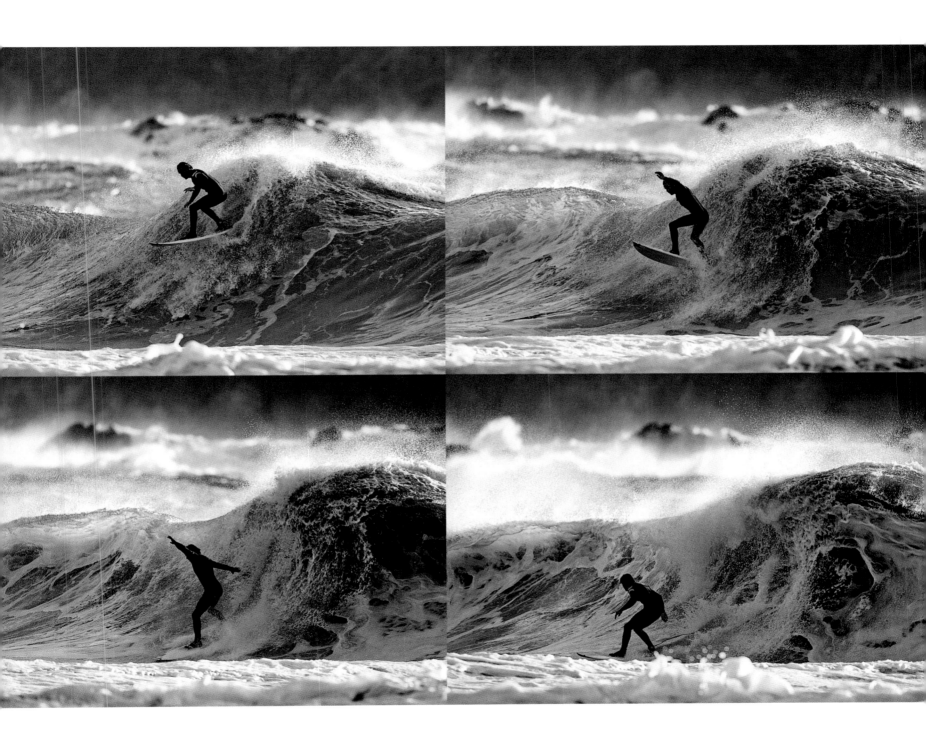

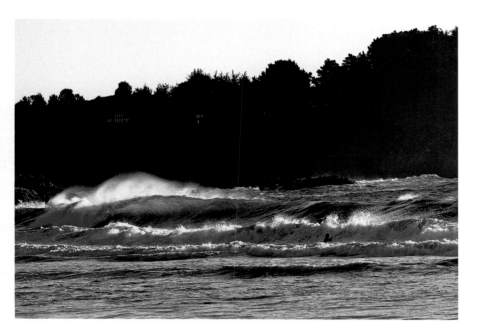

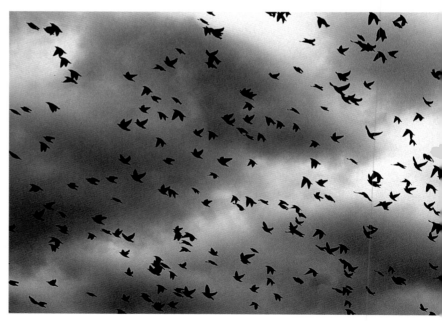

Thanksgiving - I surfed all day, we had no groceries and everything was closed. Burky and I split a sad cup of noodles and bummed heat off a lone camper.

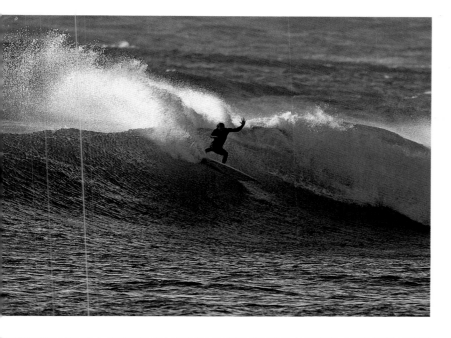
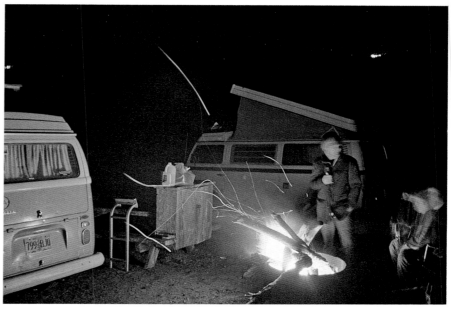
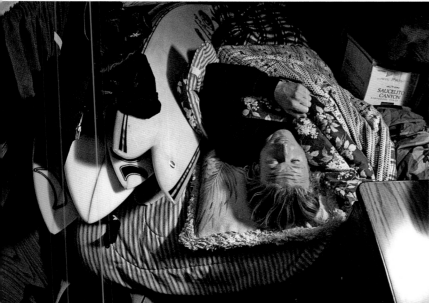
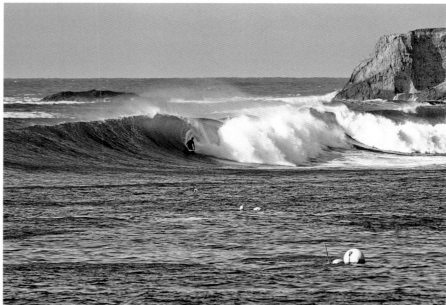

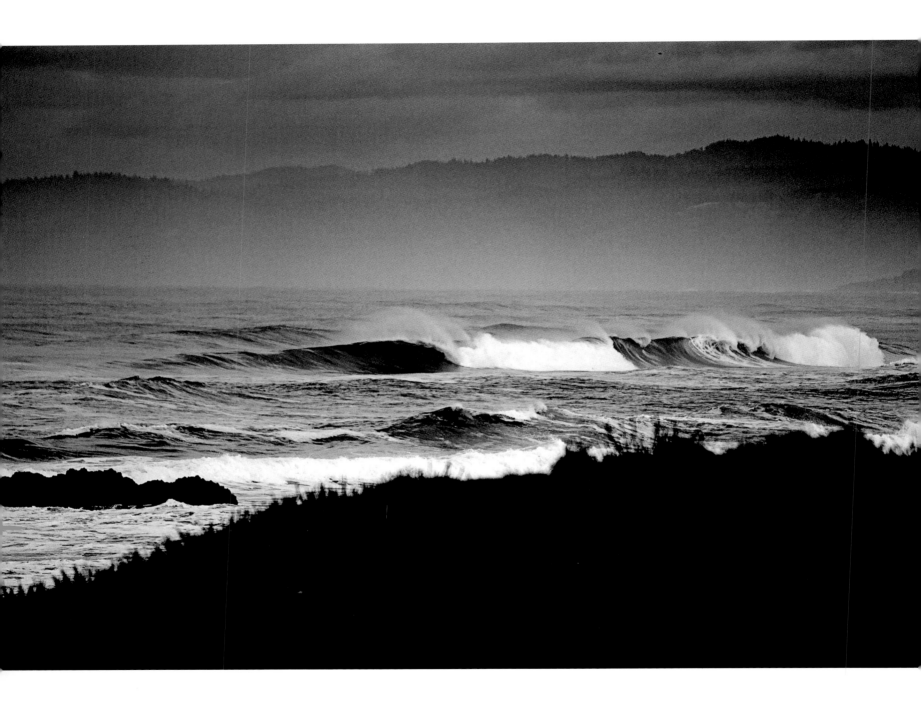

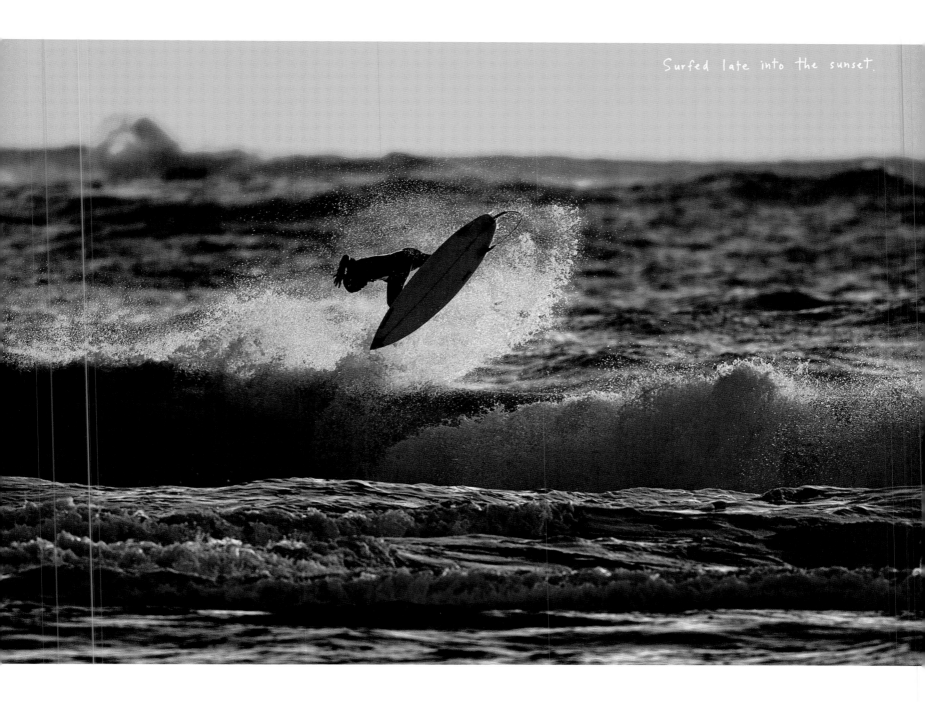

Surfed late into the sunset.

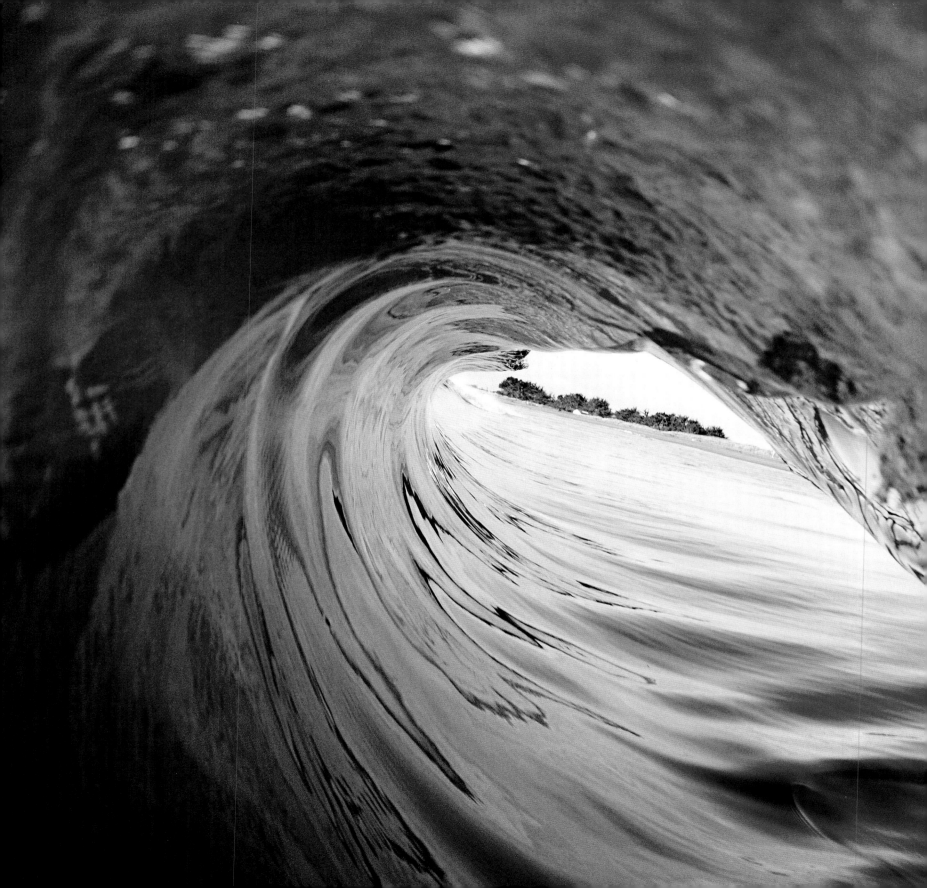

SONOMA

Like a dog, the bus tried to shake off the rain as we came clanking into Sonoma County with a blown CV joint and a mysterious electrical problem.

Old redwood fences lined the road, flickering the warm light as we putted by. The redwoods receded and the steep mountains gave way to rolling hills. Golden meadows spanned clear to the ocean, occasionally punctuated by a lone barn at the water's edge. In the foreground cows grazed, ignoring the vast blue Pacific rushing in behind them.

Right when I thought the coast was mellowing out, the narrow road wound us to one of our highest vantages yet. In some spots a mere two feet separated us from a thousand-foot cliff with no guardrail, which only got worse when some poor cyclists iron-manning their way up had to squeeze through that two-foot death zone.

It was a relief to get off that road and settle into an empty campground, nestled in the trees behind a beautiful meadow. Under a bright gray sky, the stone cliffs appeared to be sculpted, and head-high teardrop-shaped rocks glowed yellow with some kind of moss. As night fell it turned cold and started to sprinkle. After an hour of desperate attempts to start a fire, we finally achieved success and hovered over it like two excited Neanderthals.

A bike bell rang in the distant black nothingness, and two silhouetted cyclists appeared in the glow of our fire. Sopping wet, they asked if they could join us for the night. After setting up tarps, we talked story over a can of beans and corn.

The cyclists were riding from Canada to Mexico, and I realized they were the ones I had seen riding up the death-defying road. By morning these Canadians had us convinced that eating out of dumpsters was cool. Recycled sandals made out of bike tires were efficient and growing a beard only on your neck was all right.

But then our bus wouldn't start and the Canadians wouldn't budge to help. For a second I thought, "That goat-bearded dumpster-diver drank all my wine—and his tire shoes suck!" but then we got the bus started and I mentally forgave him. I figured if he's riding his bike all the way to Mexico he deserved a lazy morning.

Sonoma blues.

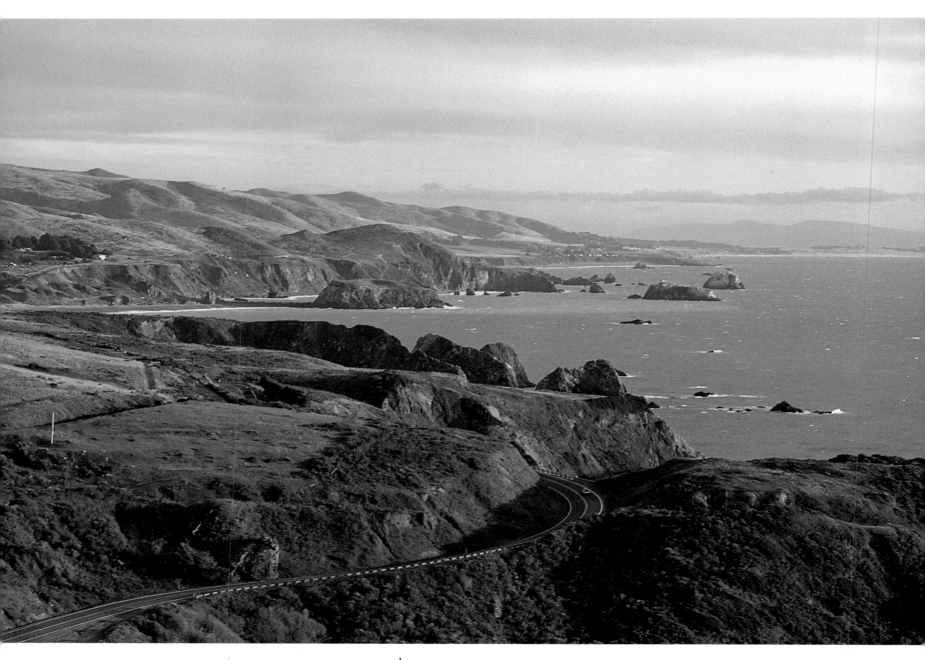

The road evolved from its preconceived course and
turned into a creature of its own.

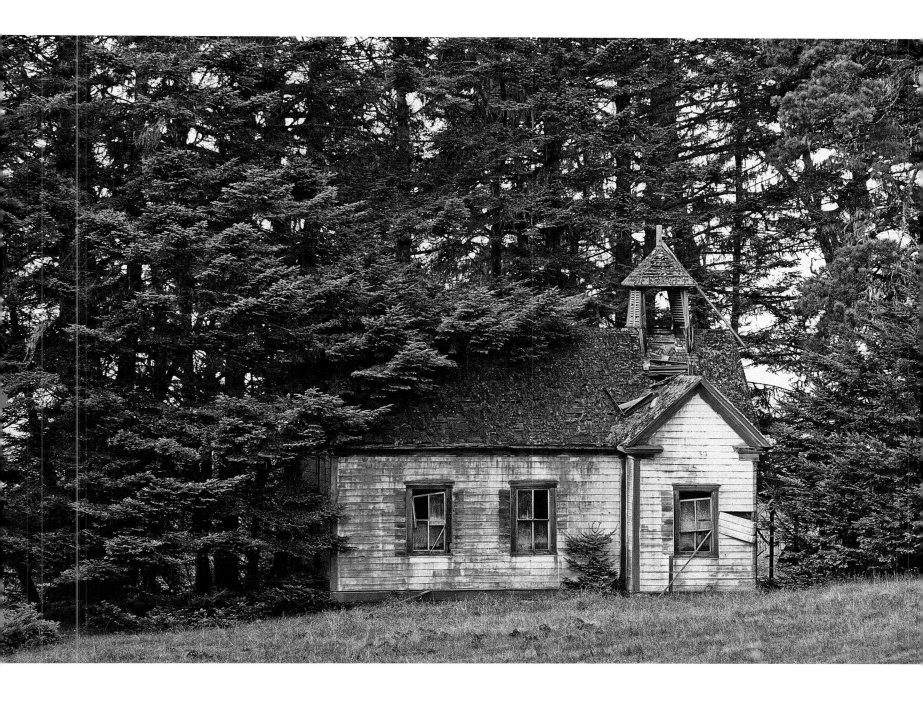

We awoke this morning to a blaring horn and a man screaming "illegal camping not cool!" He revved his engine and started doing brodies around the bus. Over the screeching tires I could hear "illegal camping not coooooool!" It was hysterical and became a great inside joke.

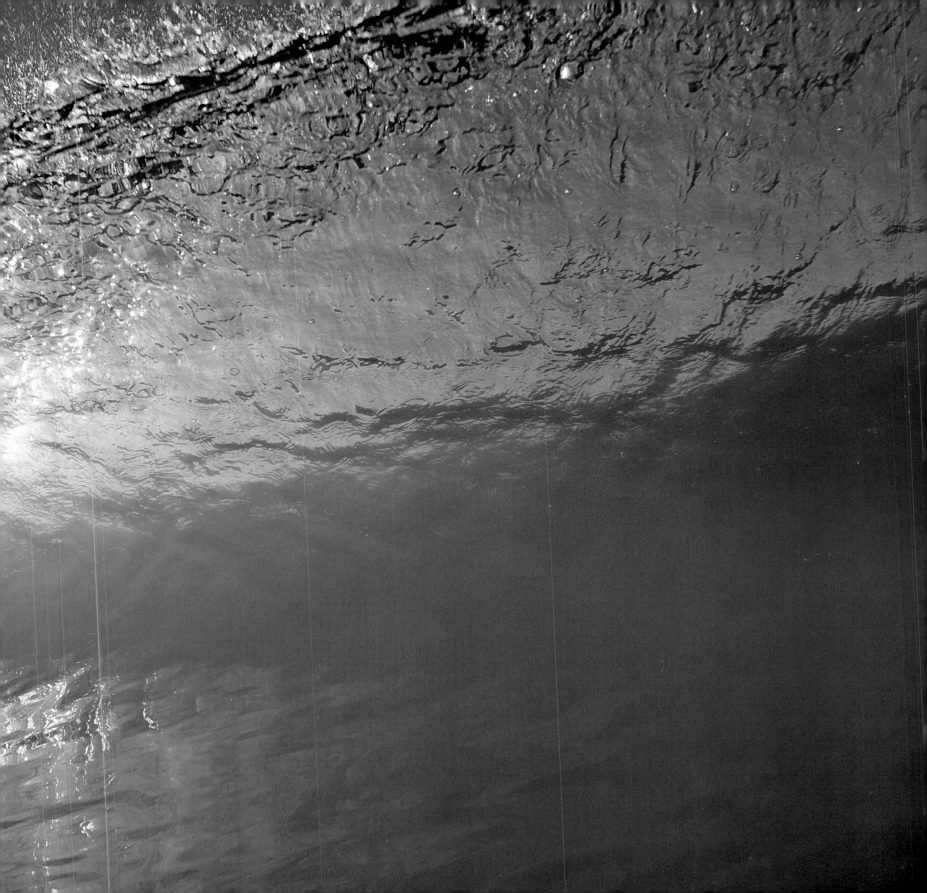

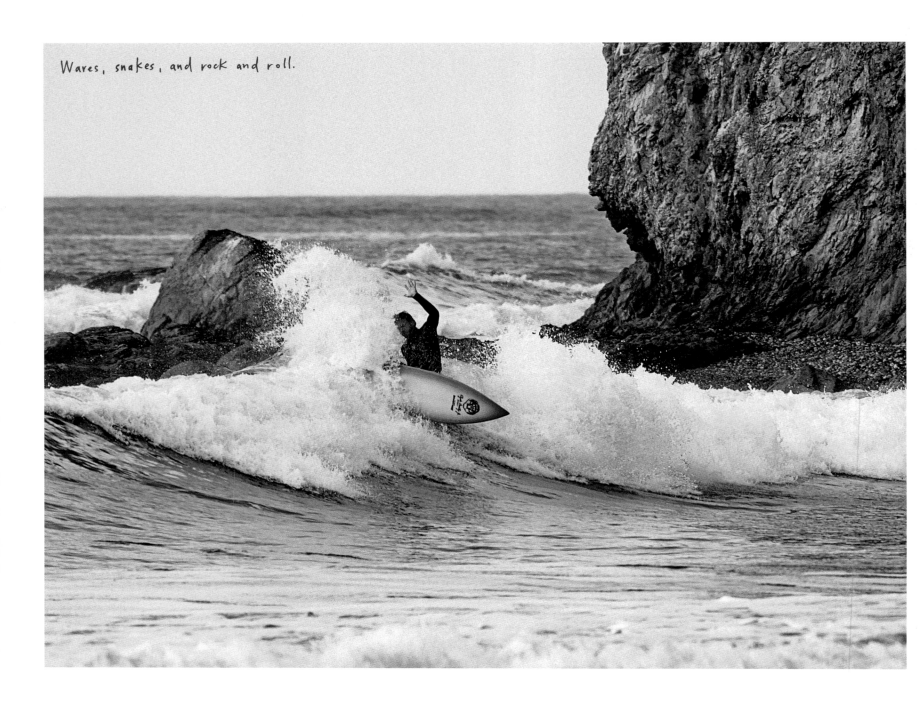

Waves, snakes, and rock and roll.

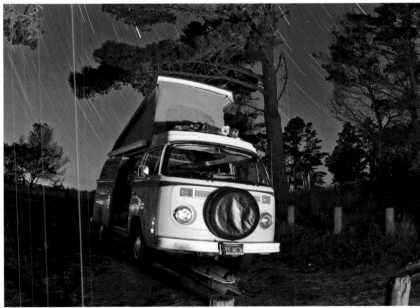
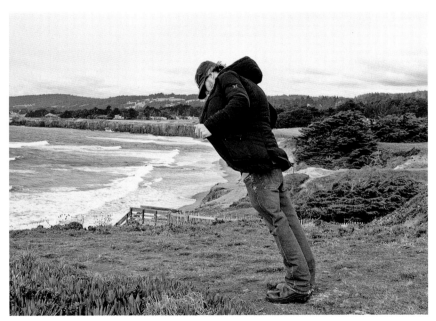

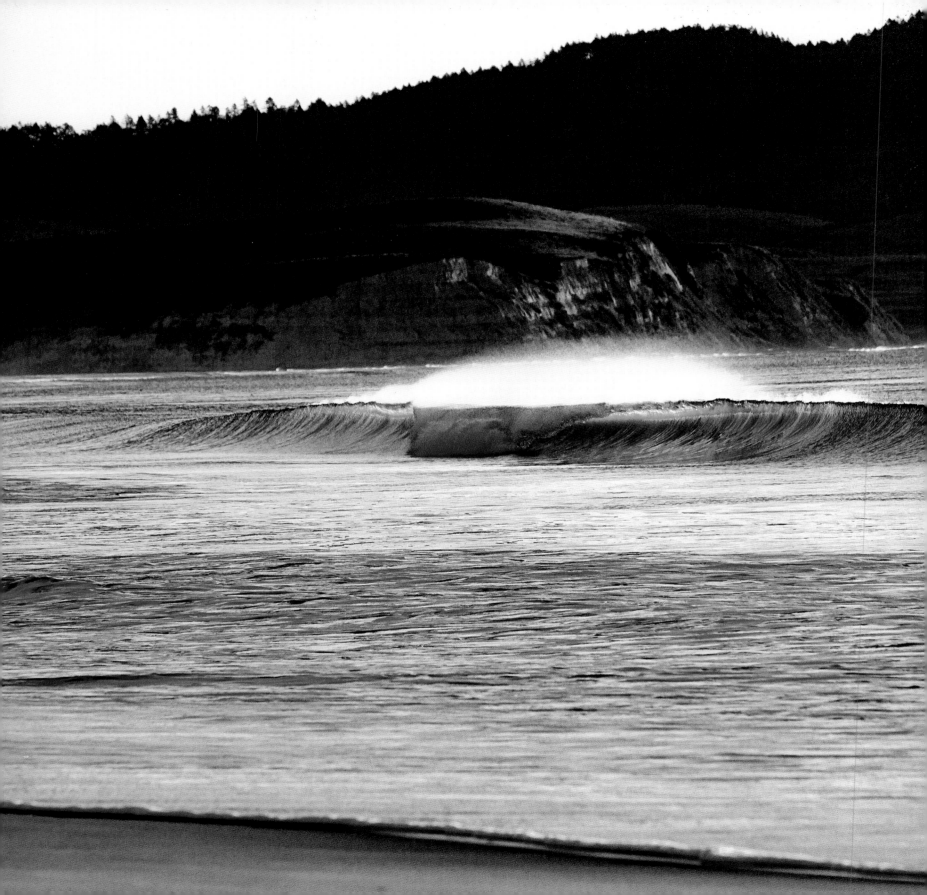

MARIN

We popped out of a canyon to a beautiful distant view of Marin County. The green hills rolled to the horizon until they disappeared into a blue haze, and giant cumulus clouds layered the blue sky, casting shadows on glowing green fields. It struck me as a masterpiece; or on a less poetic level, it looked like a milk commercial, with lazy cows chewing grass near a windy road.

The peaceful bays and rolling hills contrasted with the rocky headlands. The countryside here is very slow paced and relaxing and the farmlands reminded me of home.

At most beaches signs read, "Do not swim or surf, dangerous currents and undertow." Every once in a while one read, "Confirmed shark attack," or, "Great white research in this area." The Farallon Islands are visible here from most surf spots—we were officially in the Red Triangle. I felt pretty spooked surfing by myself. Eerily, I found out a great white shark attacked a man five days later right down the beach from where I surfed.

Marin was kind of the last frontier for us. We were getting close to the familiar territory of San Francisco, yet we felt a million miles away. Point Reyes, for instance, is about as untouched as it gets. Very few structures are on the headland, just a few farms and an old lighthouse that sits atop a jagged coastline with sheer cliffs jutting straight up. The rolling hills are home to an array of wildlife: deer casually cross the road while fat seals bark from the rocks below. We even saw a buck standing by his baby.

We slept near the tip of the point, hiding under a tree at the end of an empty parking lot. The ghostly wind howled, and I was wary of any approaching cars, hoping no one would be crazy enough to drive out here in the middle of the night. When so exposed to the elements, an instinctual fear kicks in and you hear every little sound. I stayed alert until sleep overwhelmed me.

I awoke at dawn and the bluffs glowed gold in the morning light. The massive point took the brunt of the swell and we sat on a peaceful beach and watched the sunrise. It was a good way to start our day, before we headed south to San Francisco.

Nov. 27 - Glowing splendor.

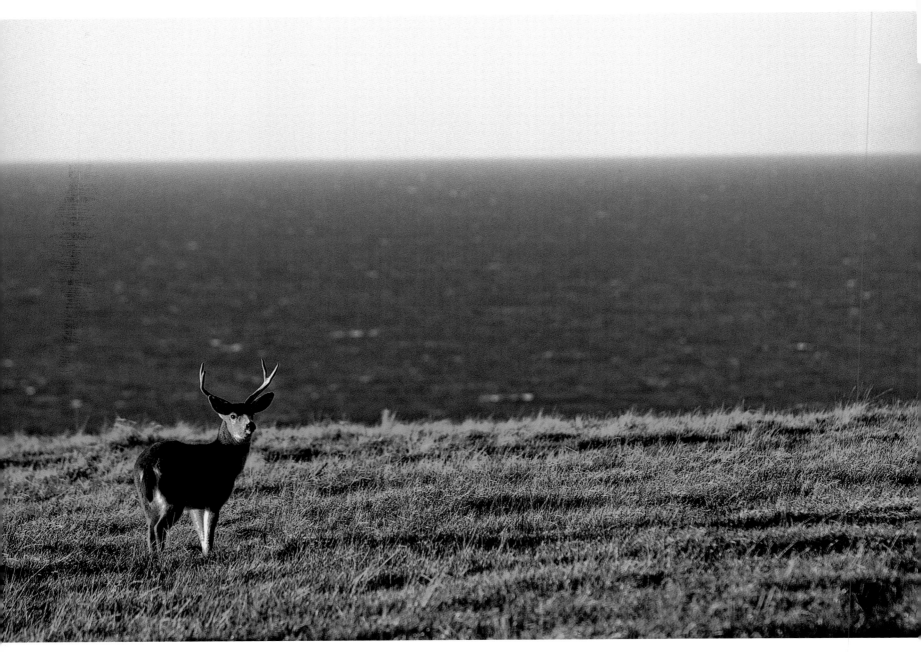

Free to roam.

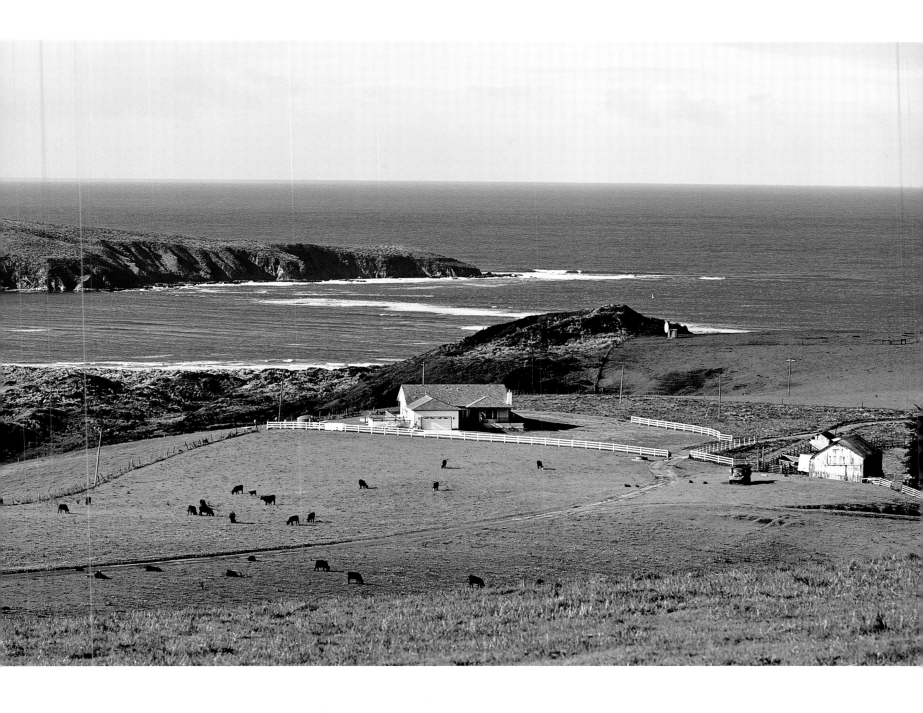

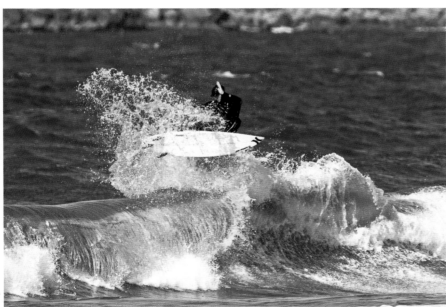

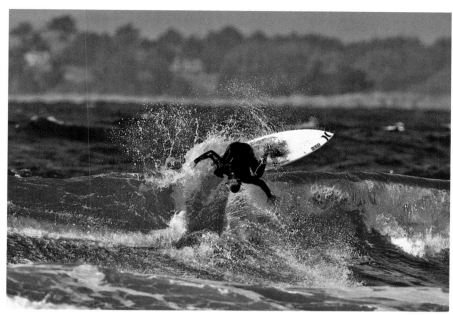

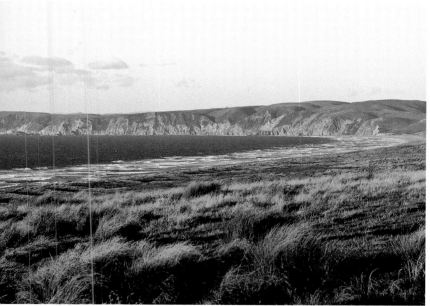

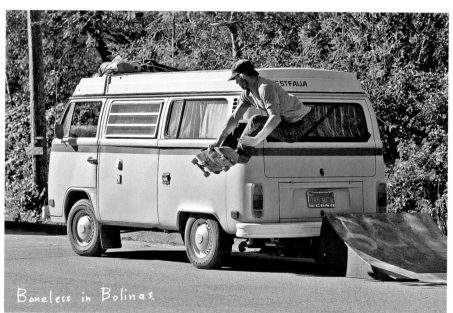

Boneless in Bolinas.

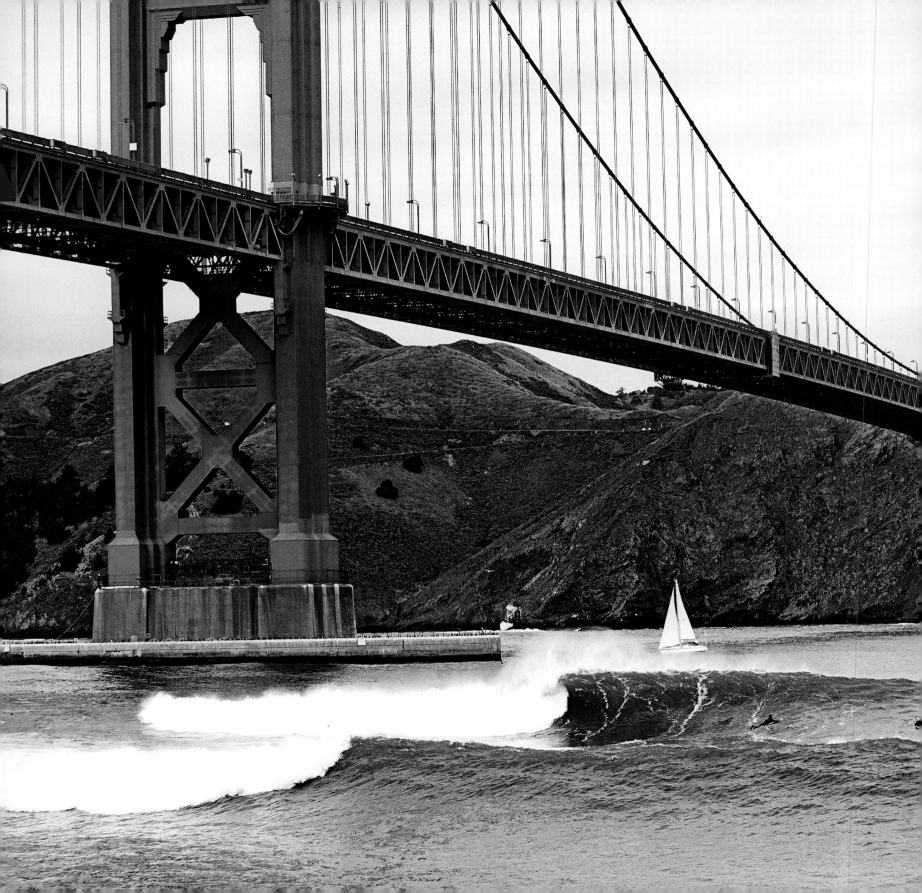

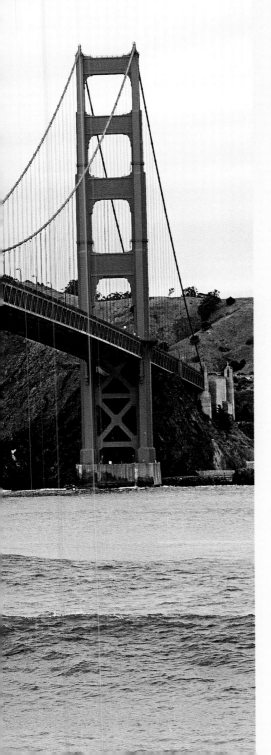

SAN FRANCISCO

We had been on the road for twenty-some-odd days and I think it was pouring rain for about fifteen of them. While I enjoyed the empty campgrounds and lonely turnouts on the northern coast, by this point I was excited to be heading for the city.

The bus clanked southbound. Our CV joint echoed loudly as we entered a long dark tunnel. The faster I drove the quicker the tunnel lights flickered and the quicker the flicker, the more persistent the clank. I sped up until the flicker and clank synchronized and at that very moment, the bus was ready for time travel. We were ready to land at the birthplace of "flower power," where engineering genius and tie-dye peacefully dwell together. Where bums sleep on the steps of mansions, and hotels are so elegant that they make our bus look like a cardboard box on wheels.

We popped out of the tunnel and my daydream was overpowered by a sweeping view of the Golden Gate Bridge. The art deco orange bridge is over a mile long and is an international symbol of San Francisco. Within seconds, we were suspended high above the bay, engulfed in its swooping cables and massive towers. It was a beautiful clear day and the city shimmered in the distance.

As we pulled up to Ocean Beach, the waves were firing and I quickly put on my wetsuit. As I was waxing up, a giant, naked bum walked up to me. He was wrapped in a wet sleeping bag screaming, "I will kill my dog if my dog hurts your dog!" Luckily we didn't have a dog and I ran to the ocean leaving the bum behind. The waves were going off and I surfed until sunset. In the evening, the city buzzed with energy. Street musicians jammed, bouncing their beats off buildings; suits talked to their earpieces; lunatics and tourists wandered aimlessly—every walk of life swirled about. We got lost in it all but after four exciting days, it was time to keep on keeping on.

Fort Point

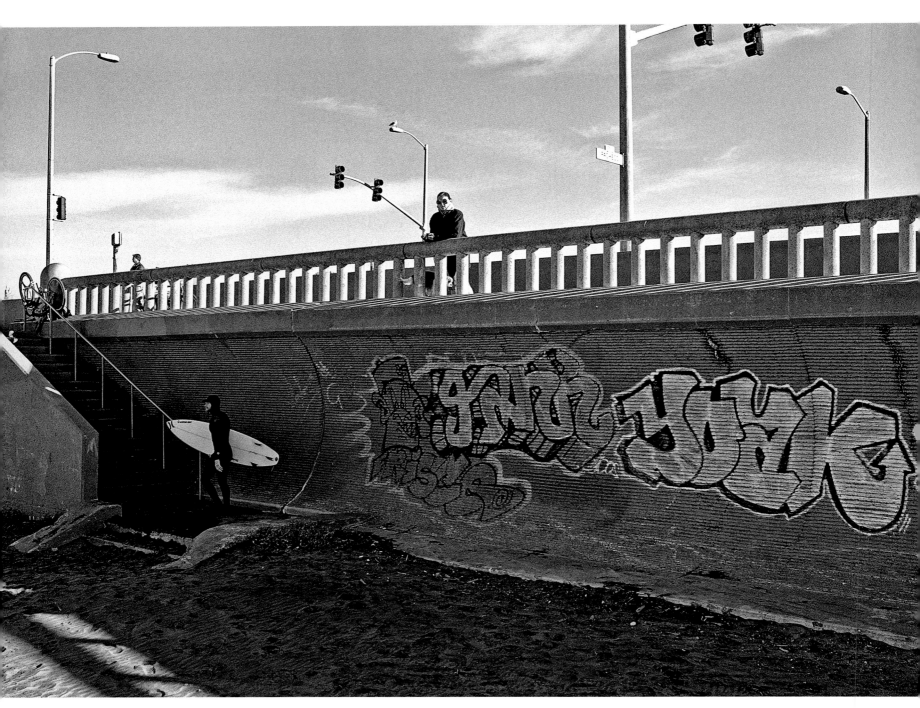

We hit the city.

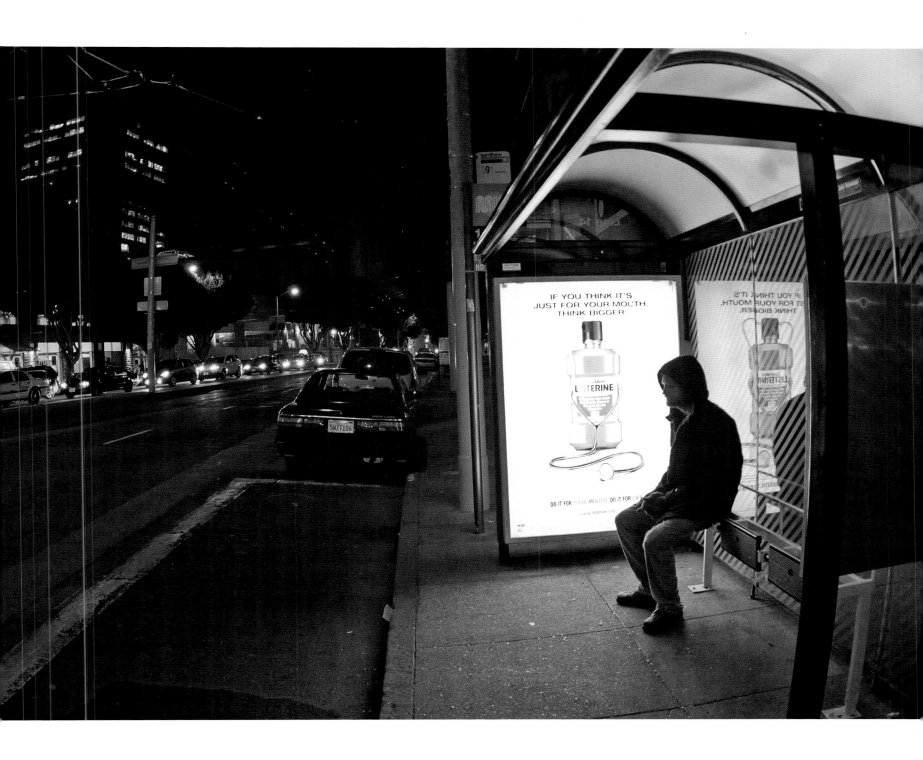

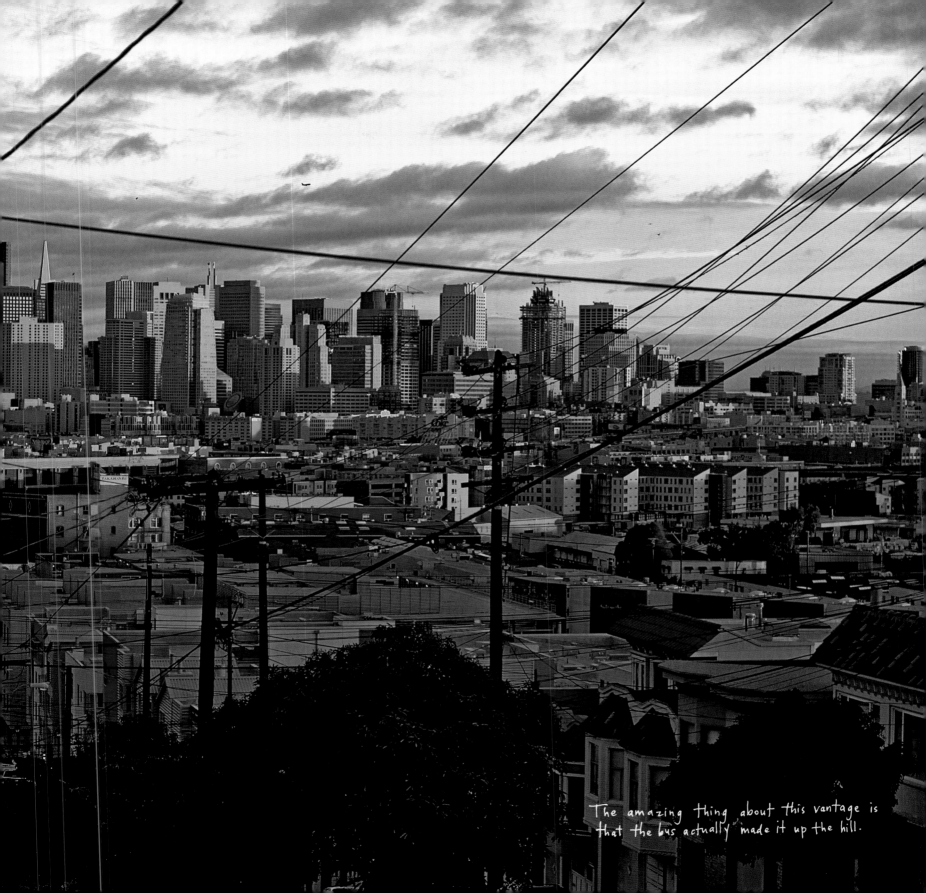

The amazing thing about this vantage is
that the bus actually made it up the hill.

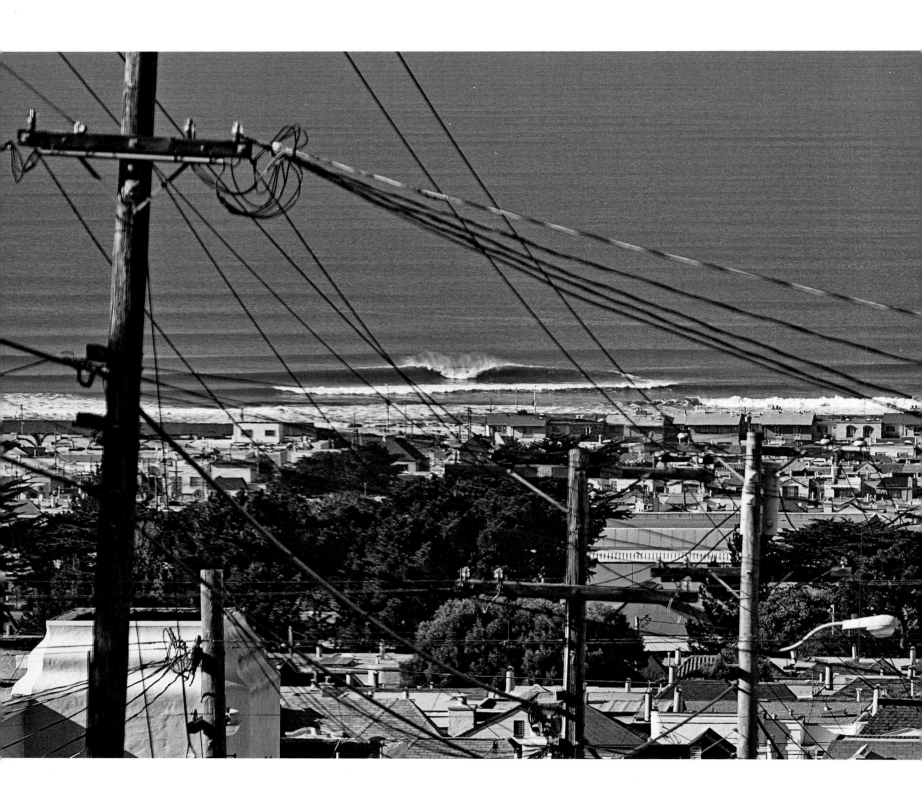

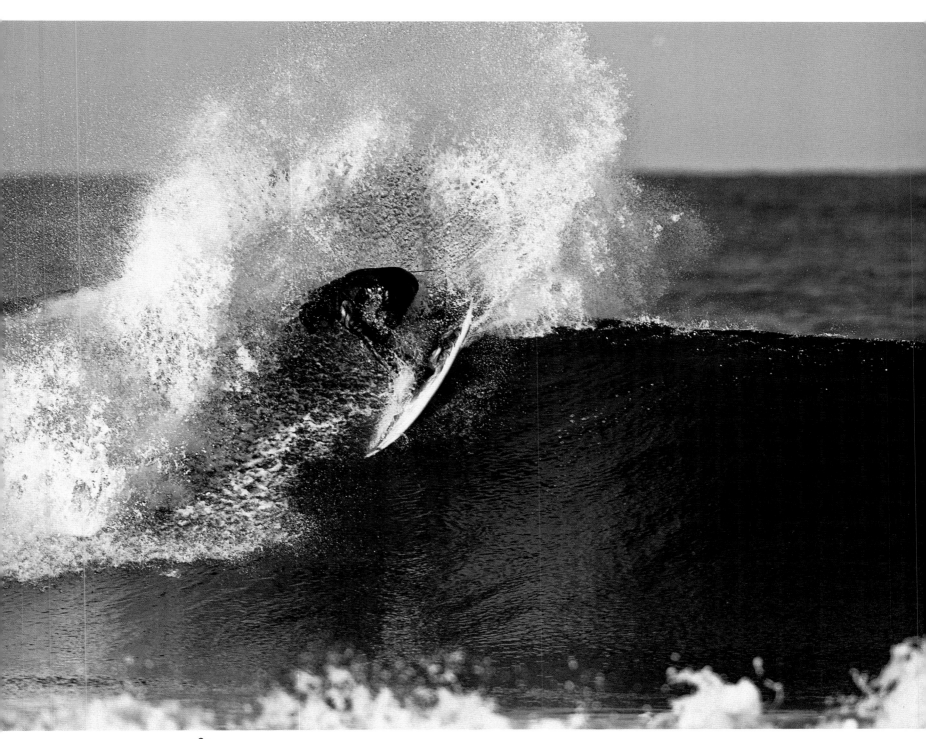

The waves were going off;
 it was hot and offshore for days on end.

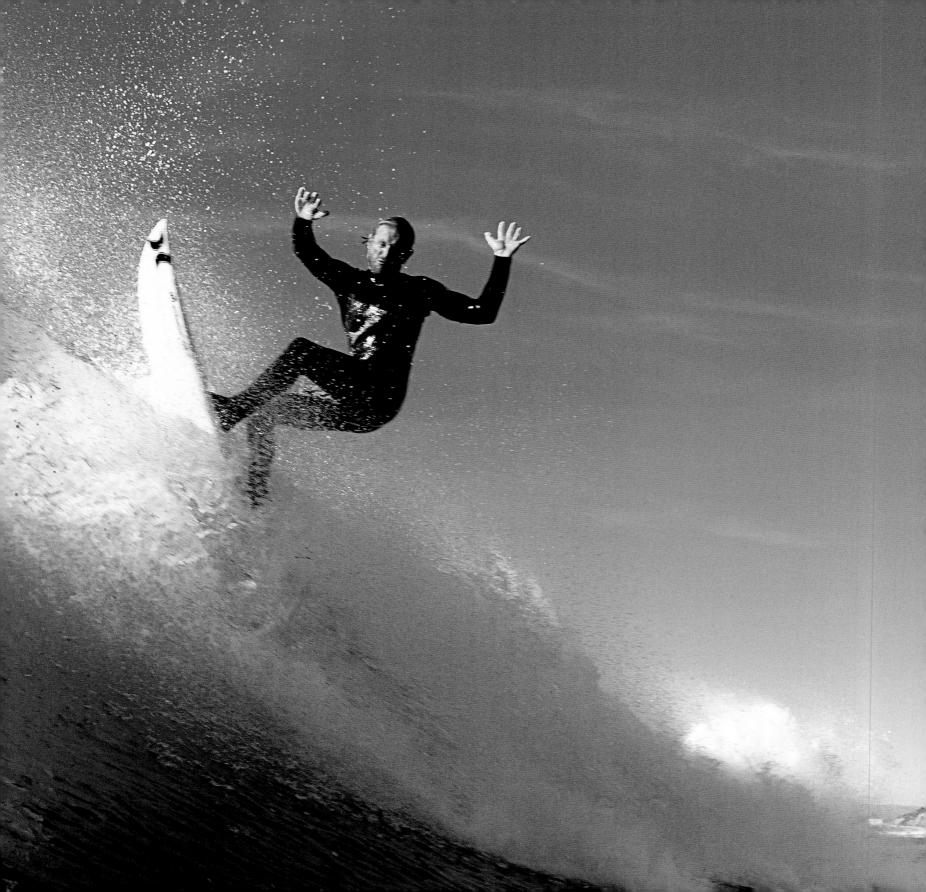

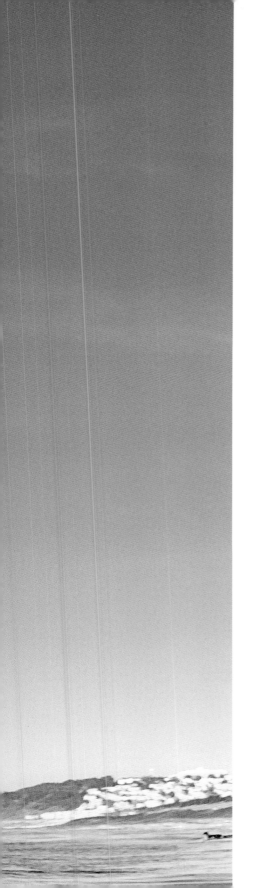

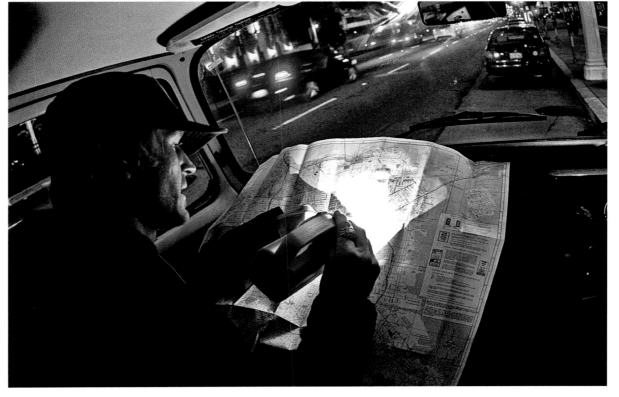

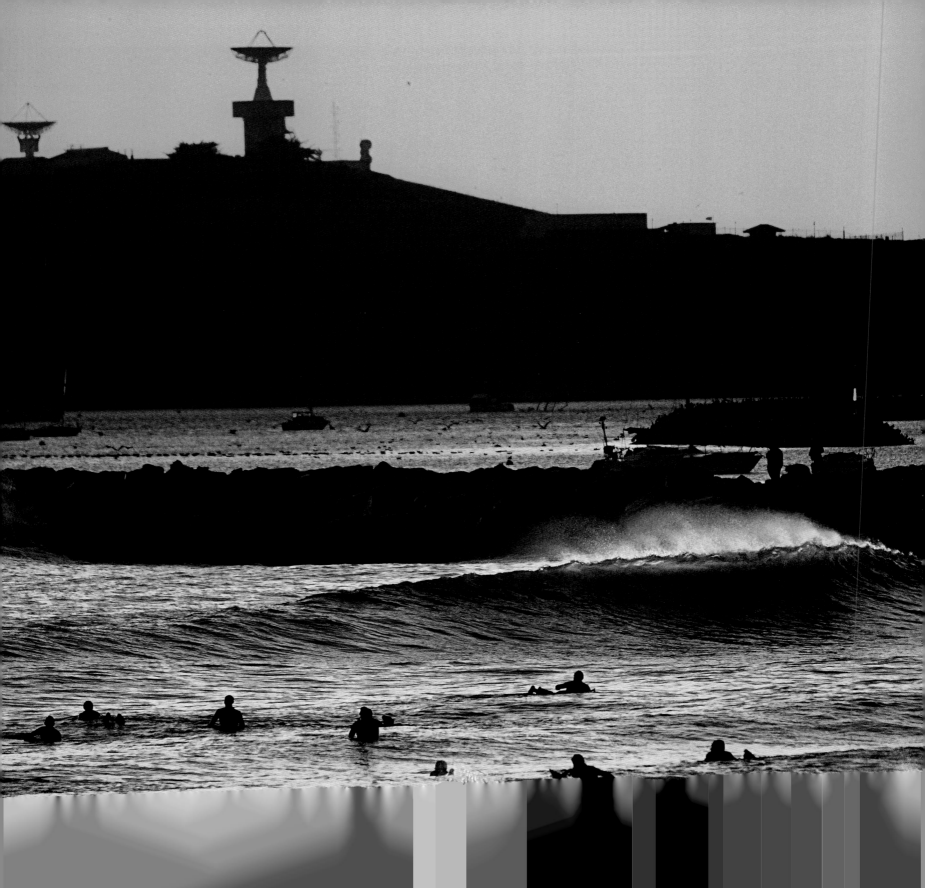

SAN MATEO

As we headed south of San Francisco, the bus started to complain more. The hills were steep and I had to rev the engine way beyond its liking. Also, I'm not sure if it was Burky or the wetsuits, but things were getting a little stinky. We lacked the convenience of a warm shower and up to this point, I had been washing my hair in the ocean. I told Burky if he didn't go for a swim soon, I was going to hose him off in someone's front yard. The bus was getting sloppy and I found myself sleeping on surfboards, shoes, or some random rock I found. Then I would roll over onto a tripod— enough was enough.

We pulled into Pacifica on a nice sunny day and it looked like a mellow spot to reorganize. We hung everything out to dry and got the van all styled out. On the bench next to us a group of older fisherman were admiring a Samurai sword. Since I had only a pocketknife I made a mental note to try not to hit any fishing lines. I surfed a little bouncy right that was peeling off the pier. It felt good to get wet and we wandered south.

We pulled into Half Moon Bay and Maverick's was eighty feet! Not really, it was actually dead flat, but I could imagine what it would be like. Half Moon Bay is pleasantly rural, with horse stalls and farms.

Highway 1 follows the coast and here the ocean seemed untamed. The beaches were wide open with lots of wind and chop, so we were stoked to be heading toward Santa Cruz, where there are more nooks and crannies that hold the wind better. We logged another night in the bus and spent the whole next day on the beach. The surf was so fun—this weird little right was spinning off a bluff and I surfed until I felt like a reptile. Back in the bus, we crawled to Santa Cruz.

Half Moon Bay.

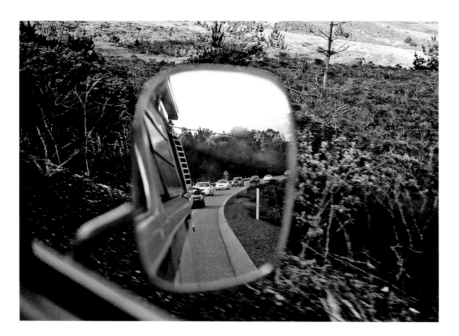
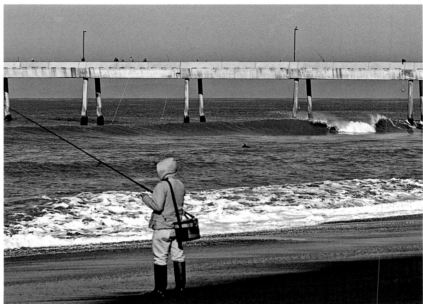
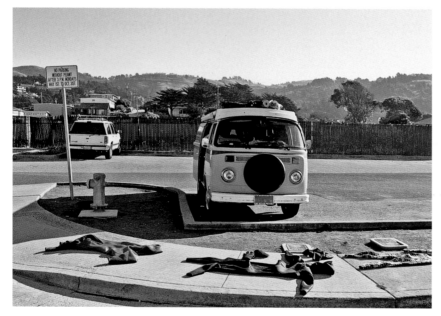
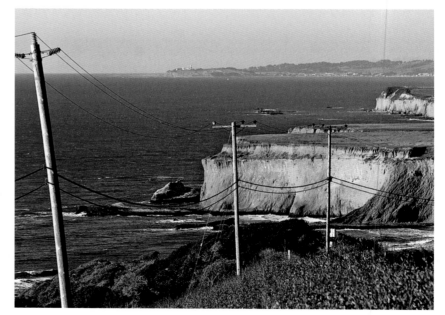

The scenics were beautiful and the bus gained
quite the following.

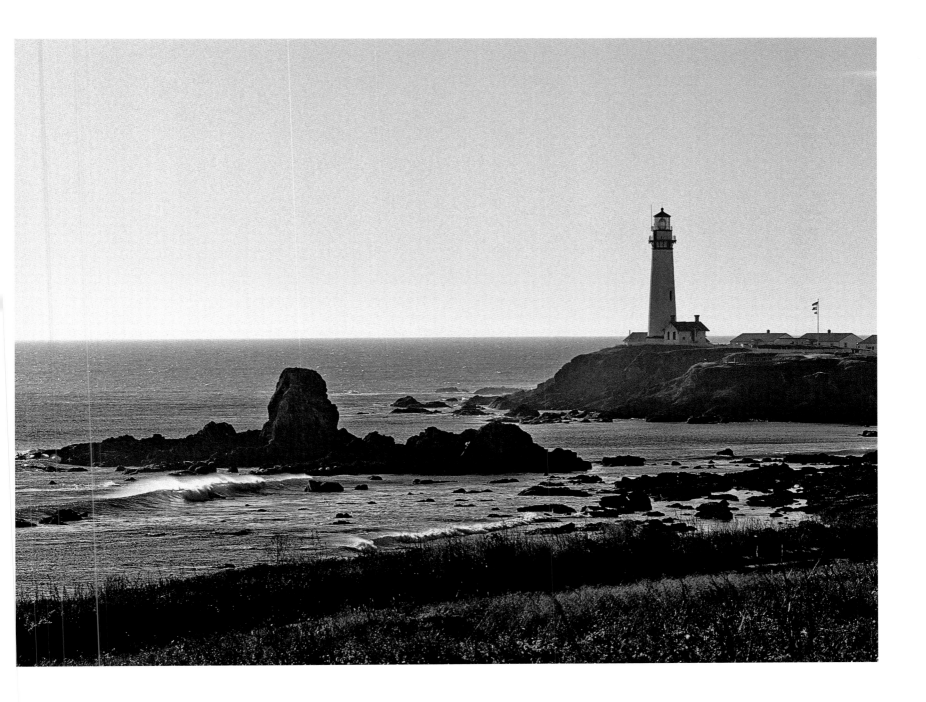

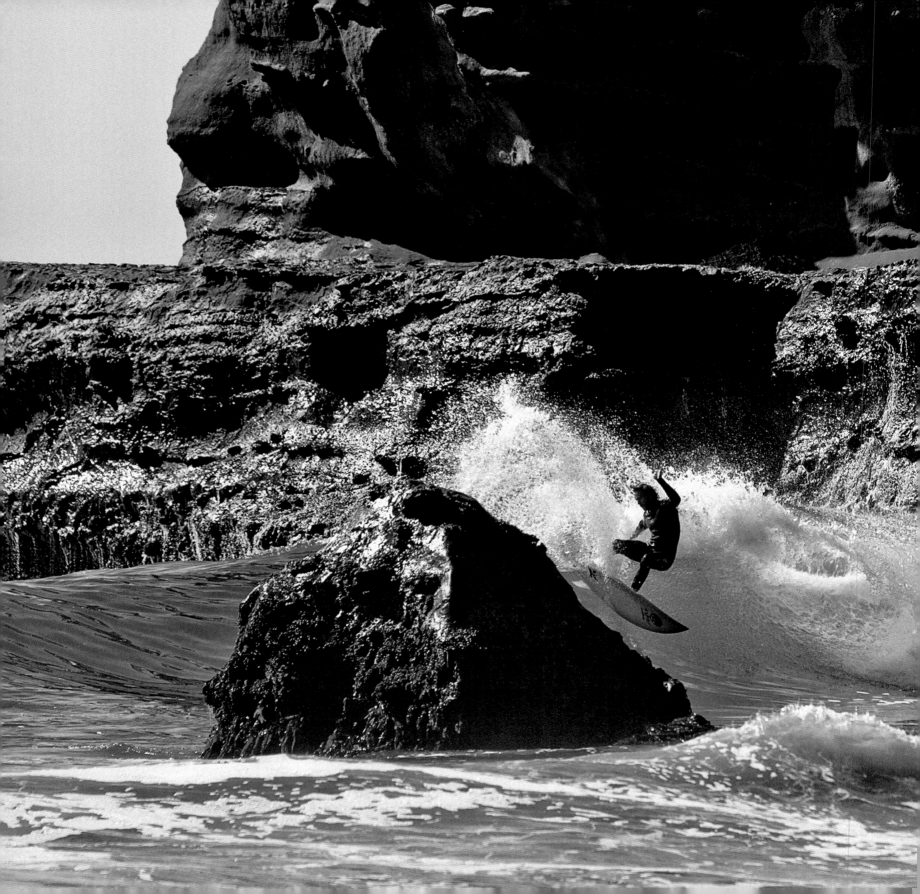

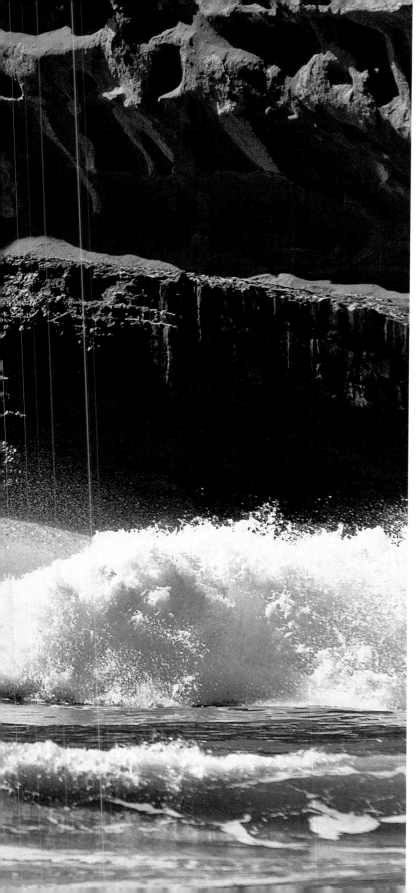

Go spray a rock.

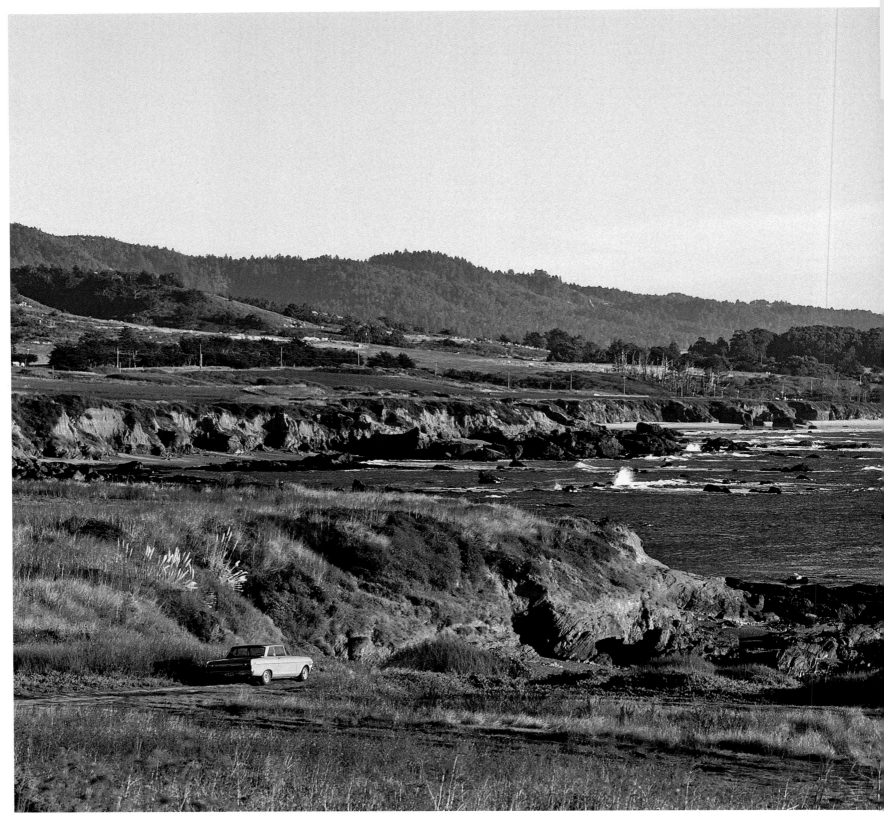

The lone nova.

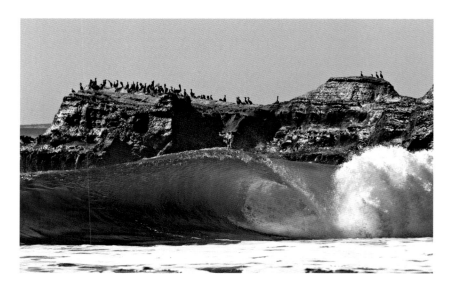

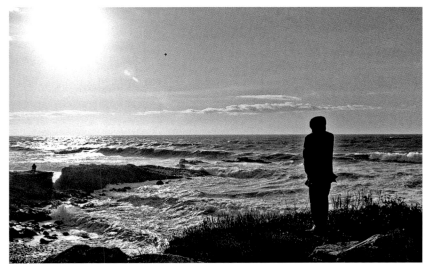

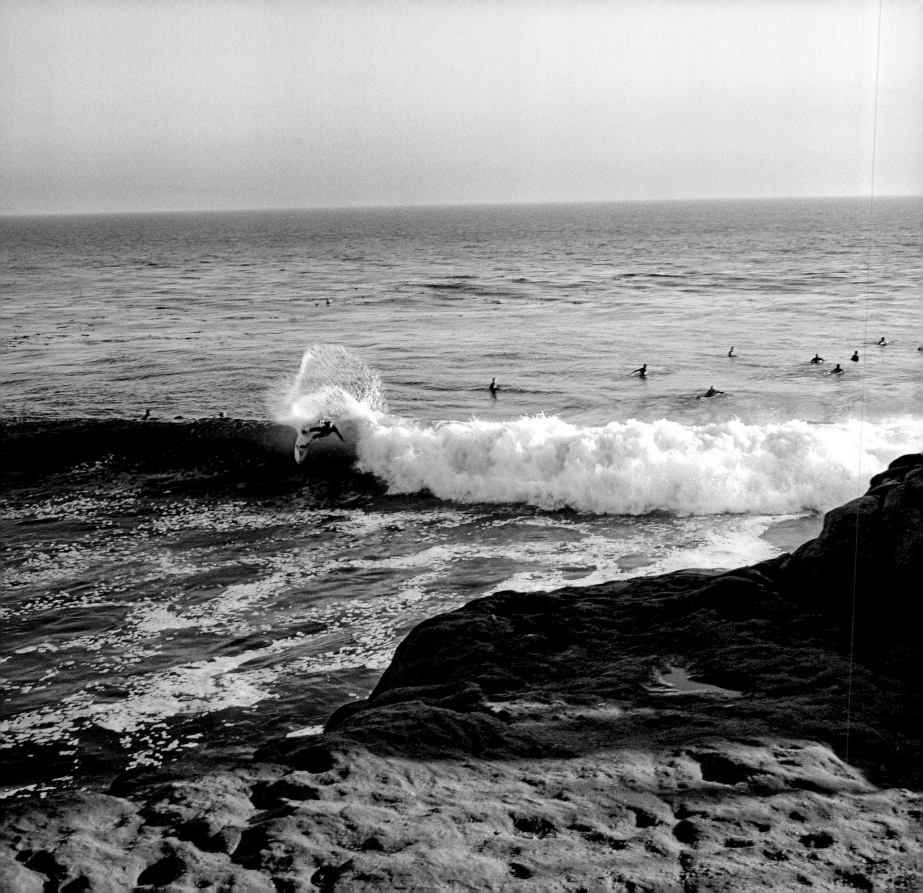

SANTA CRUZ

Santa Cruz is where things got interesting. We tried to sleep near downtown and there was some kind of bum party stirring by our bus all night. These guys were feeling it: swapping clothes, big dreams, and bubbling 40s. The world was their oyster and we parked right in it. After hours of sporadic outbursts and arguing, it finally went silent. But right when I began to doze off, more madness ensued. It continued like this all night until I was beginning to feel crazy myself.

After finally getting to sleep, I awoke to a parking violation. It seemed unfair to pick on the quiet guy in his bus, while the emotional roller coaster bums rule the world. I guess it could have been worse—someone could have broken in to cuddle. I learned my lesson and next time I'll park farther from town.

Thankfully, there were waves and I surfed all day until I was a zombie. That evening we listened to folk music at a pleasant little coffee shop and later slept by the silent redwoods. It was the polar opposite of the night before and reminded me how diverse Santa Cruz is. You have the northern vibe, the southern vibe, the huge valley behind you, the college, the vagabonds, and the surf scene, which is a world of its own. We tried to slip in between cracks for a few days and it proved to be quite entertaining.

The fish bowl.

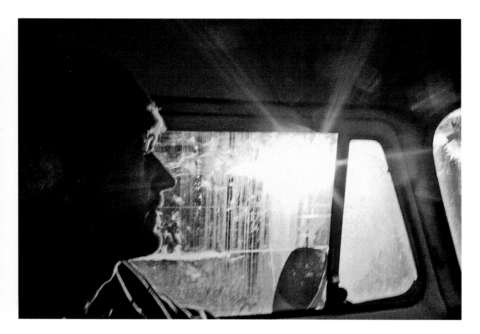
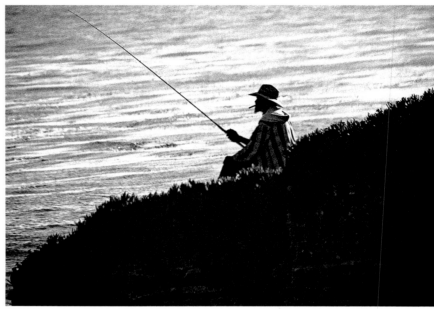

A bit of the northern mystique was gone and we were back in familiar territory. There was plenty of sunshine and we spent the next couple of days soaking it in.

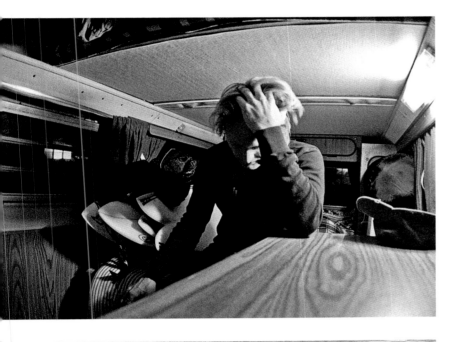

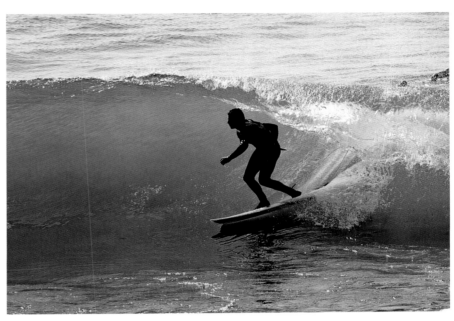

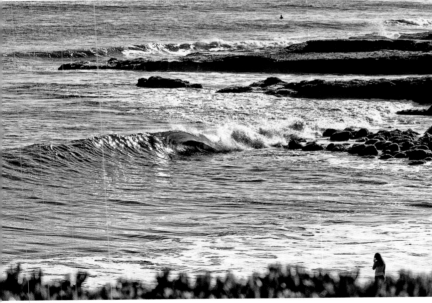

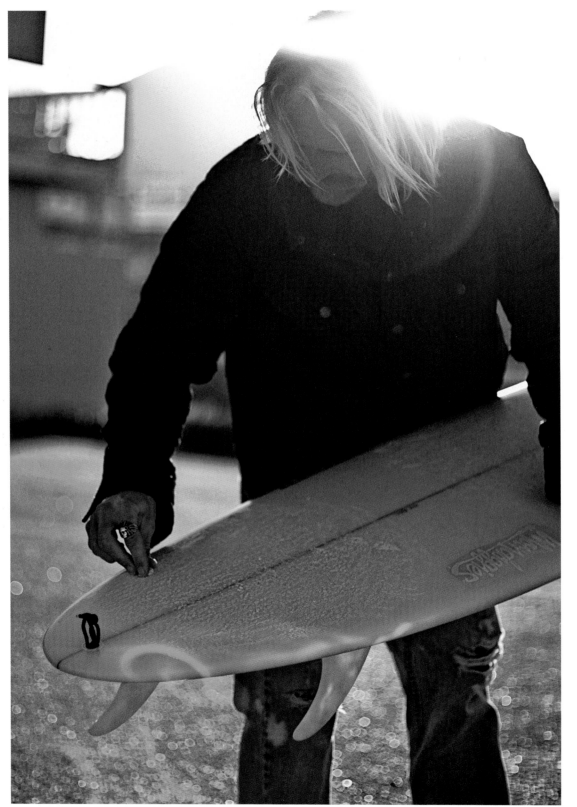

Morning glory.

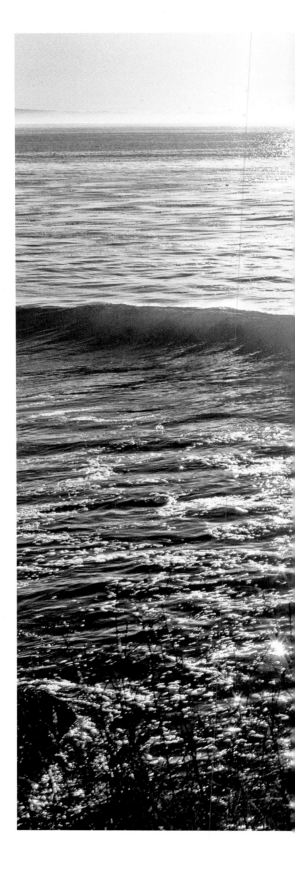

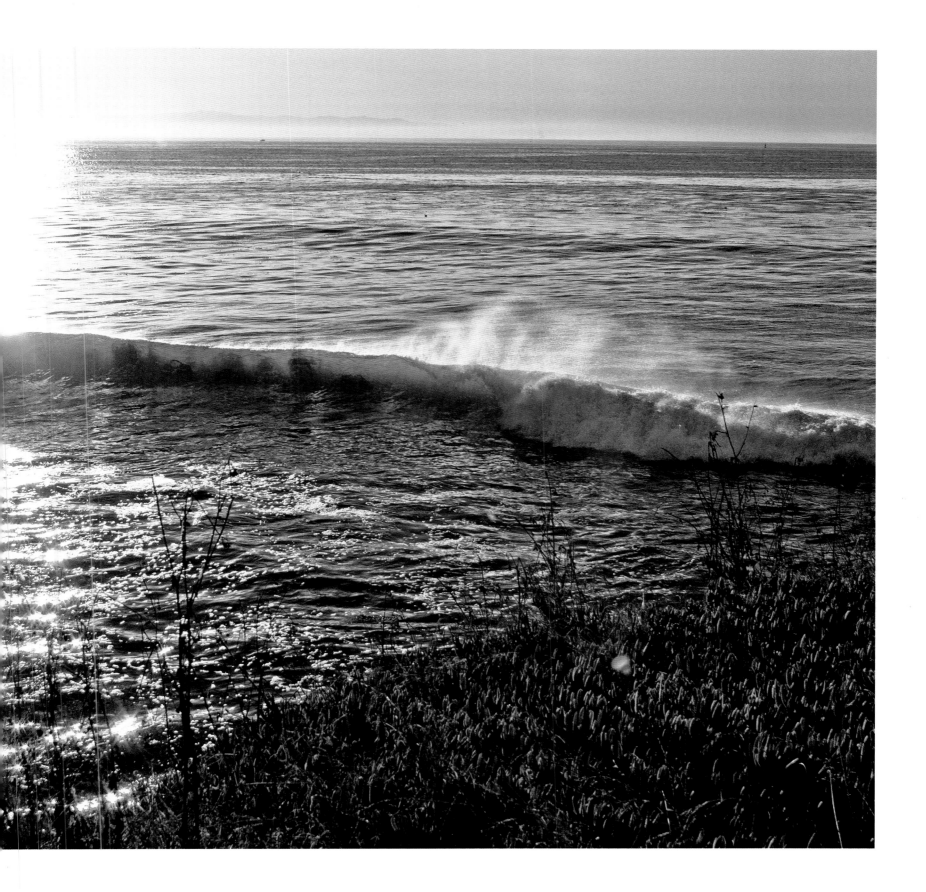

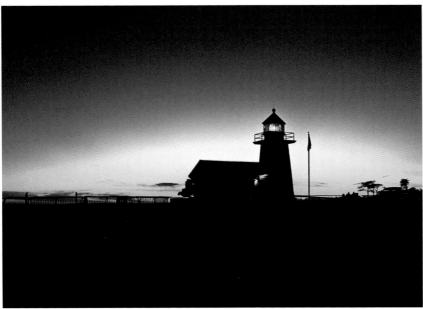

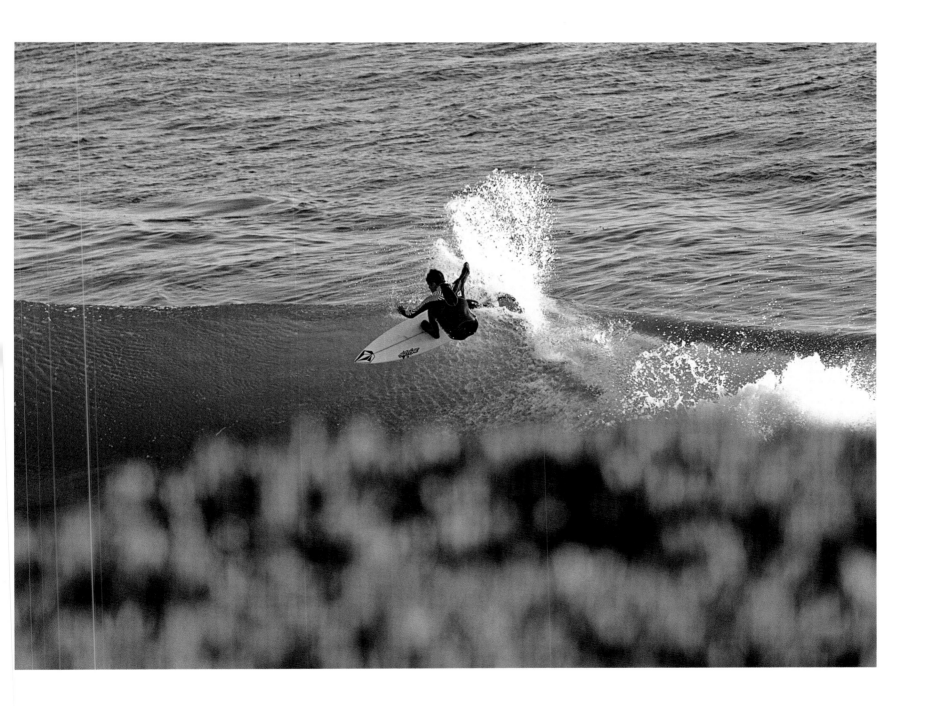

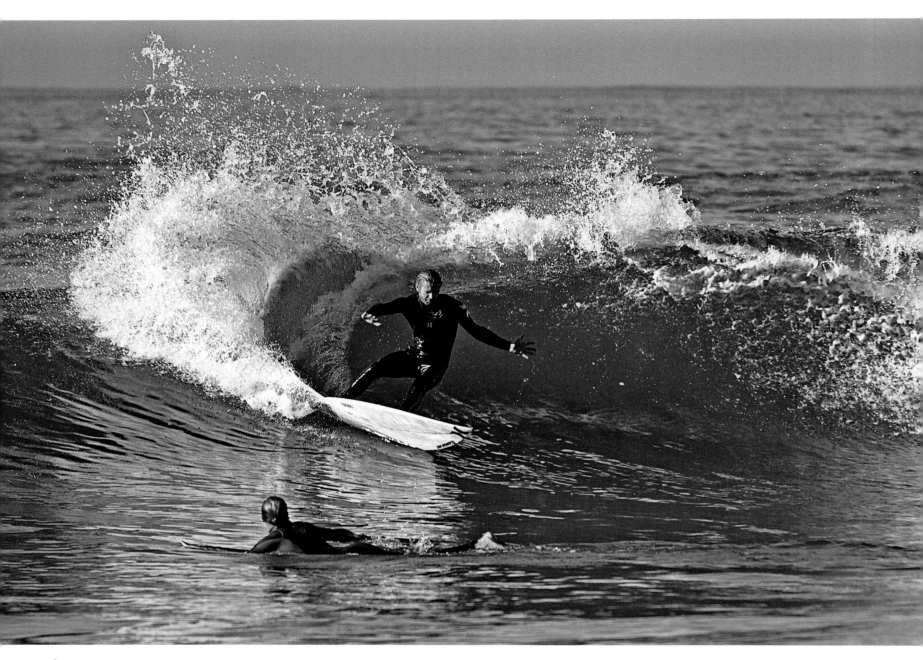

It felt great to stretch out a bit. The waves were
rip-able and I spent some long days in the ocean.

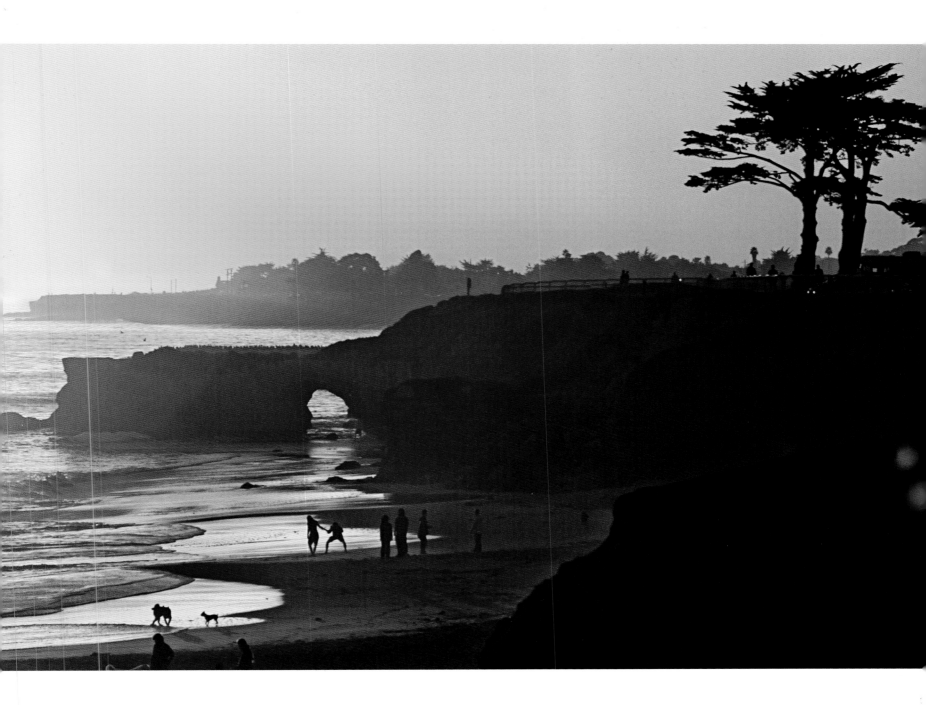

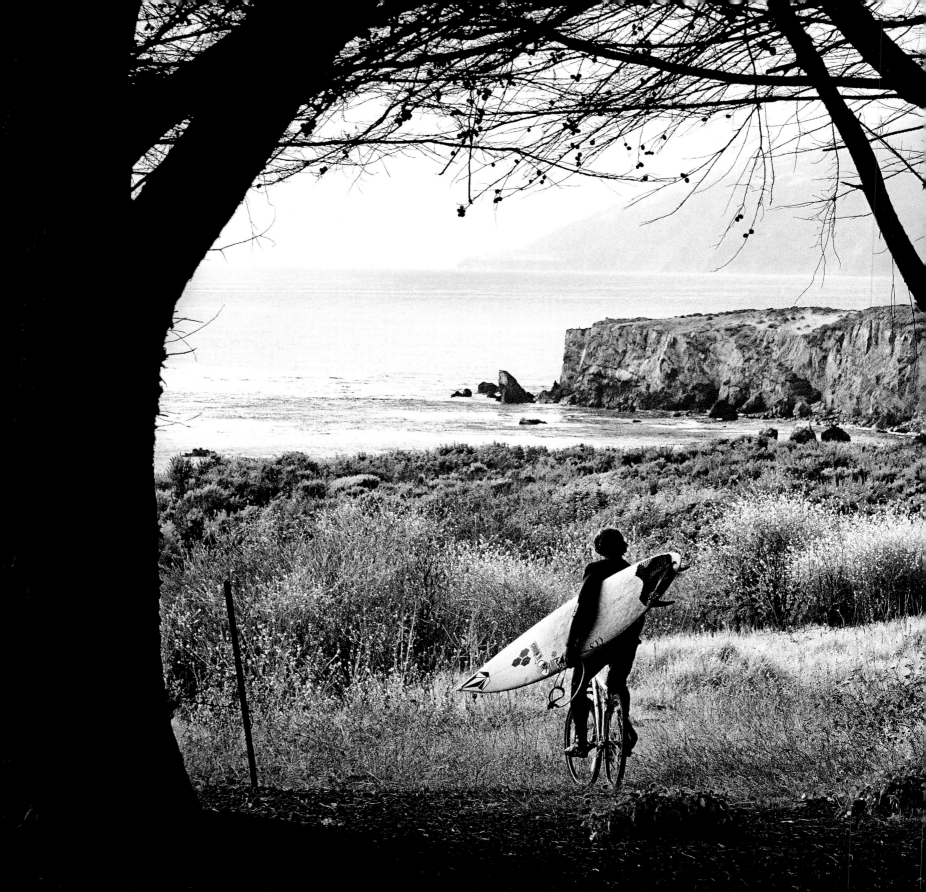

MONTEREY

17-Mile Drive was accidentally discovered by Bronson Monterey III when the Onstar in his Rolls Royce told him to go right instead of left. It's been caviar, diamonds, and gold ever since. Not really, but wow is it beautiful, and very much spoken for. The ocean water was the clearest I had seen yet, and I was awed by the white sand and cypress trees in all the cliff-lined bays. 17-Mile Drive has seen many talents: Steinbeck wrote about it, crazy Kerouac liked to speed through it, Jimi Hendrix rocked it, and now our dreaded bus crept through it.

We tried to meet up with a friend, but no luck. Maybe he saw us pull up in our jalopy and sped off in his Beemer. We had more crap on our roof than ever, including a board broken from getting worked south of town (my favorite board, of course).

We pulled into Carmel trying to fly under the radar, which wasn't really working. As I got out of the bus, I was greeted by a timeless Hessian blaring Slayer. He threw me a hand gesture and a hair whip. Tourists were giving him a wide berth. Pocket poodles and brand-new Diesel buns fled in all directions. He shouted over the music, "Want to burn one?" It was tempting but I figured we were already making too much of a scene. Carmel is not exactly the place to just pull up, pop the top, and go to sleep. The last thing someone wants is a hippie van by their house, which prompted our most creative camping spot yet. The Bat Cave, as we called it, was an abrupt little turnout nestled in the trees, a county hideaway with a giant bark pile and retired work equipment. Right next to the highway, a grocery store, and a residential area, it's hidden in plain sight. From our hideaway we sat in the dark watching everything stir around us.

We continued to camp down the coast of Big Sur and words can't describe its beauty. We met up with some friends and scored waves for the next couple of days (our friends were also useful in fighting off the food-thieving raccoons). Our last night in Big Sur was unusually warm, and we camped atop a fire road. The full moon made it possible to see far into the distant hills and we hiked around late into the night. The night felt alive and as we arranged our beds, I heard a pig rooting around our bus, an owl hoot, and then a loud squeal. If I wasn't mistaken, that owl nabbed a baby pig. It was a long trippy night and at first light our hunger was the deciding factor to leave paradise. It had been four days since we were near a store and we were on our last rations.

Dec. 5 - Big Sur

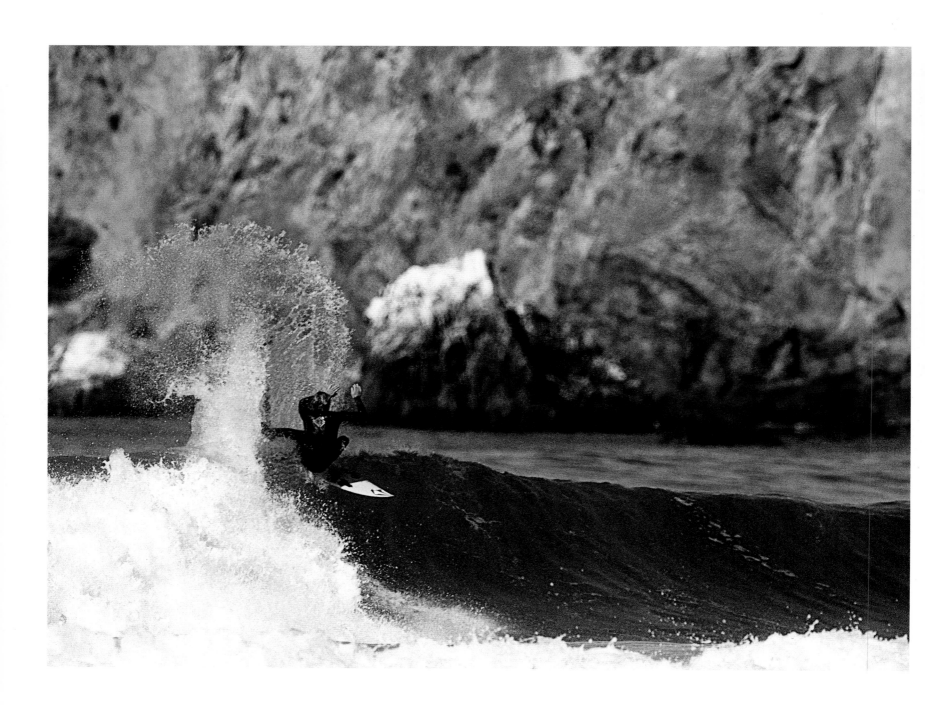

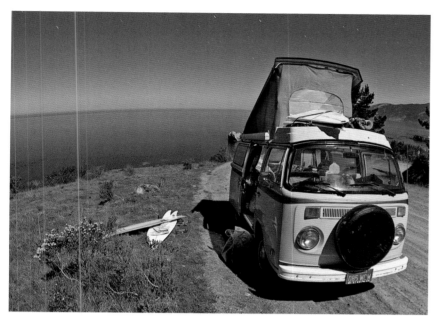
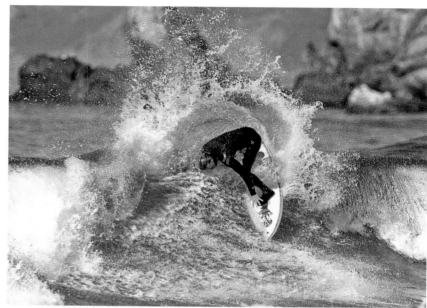
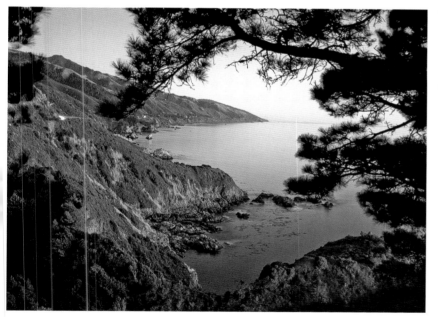
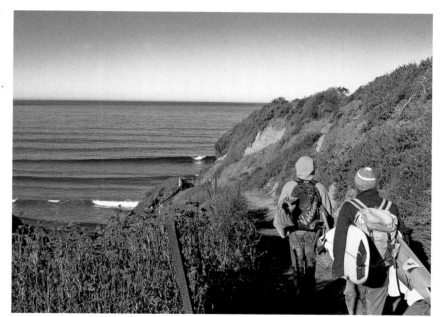

My friend Nate Tyler met up with us for a good old fashioned camp-out.

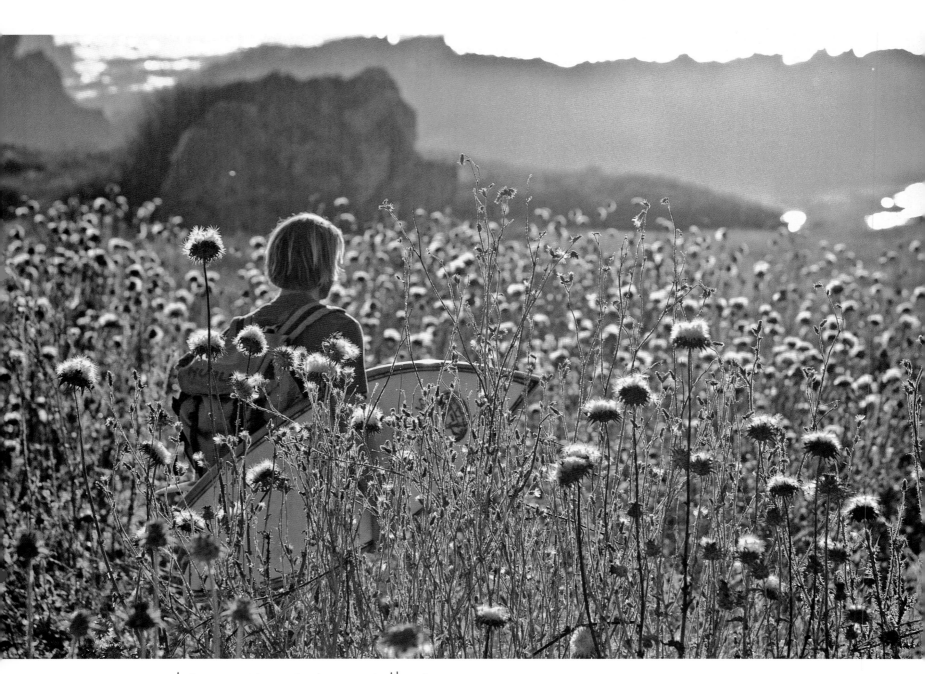

The beach was so hot you could see heat waves in the air,
and there was a rare warm glow in the ocean.

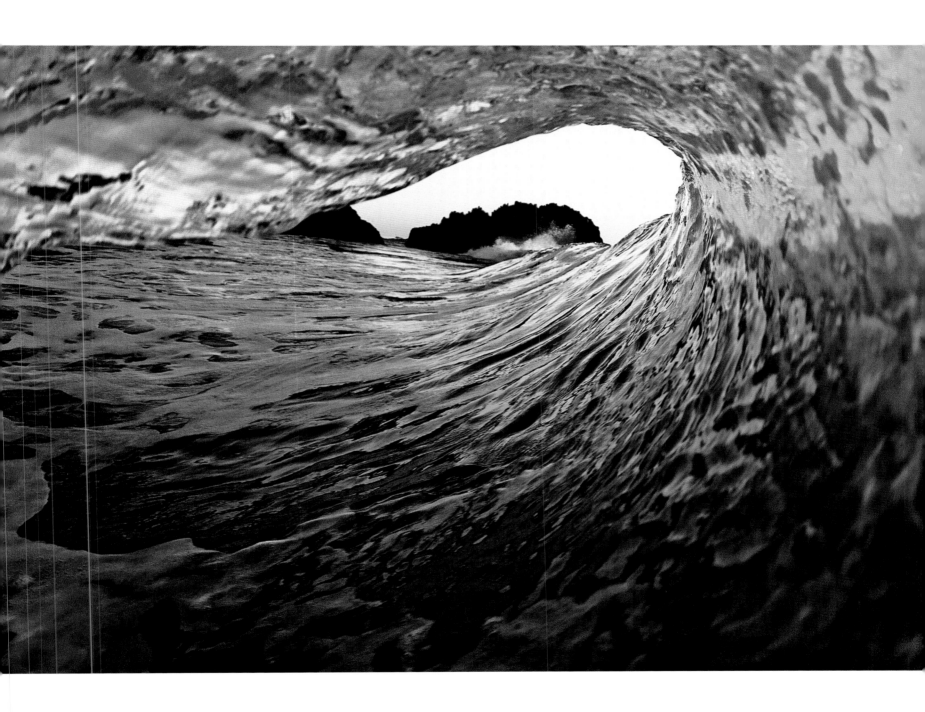

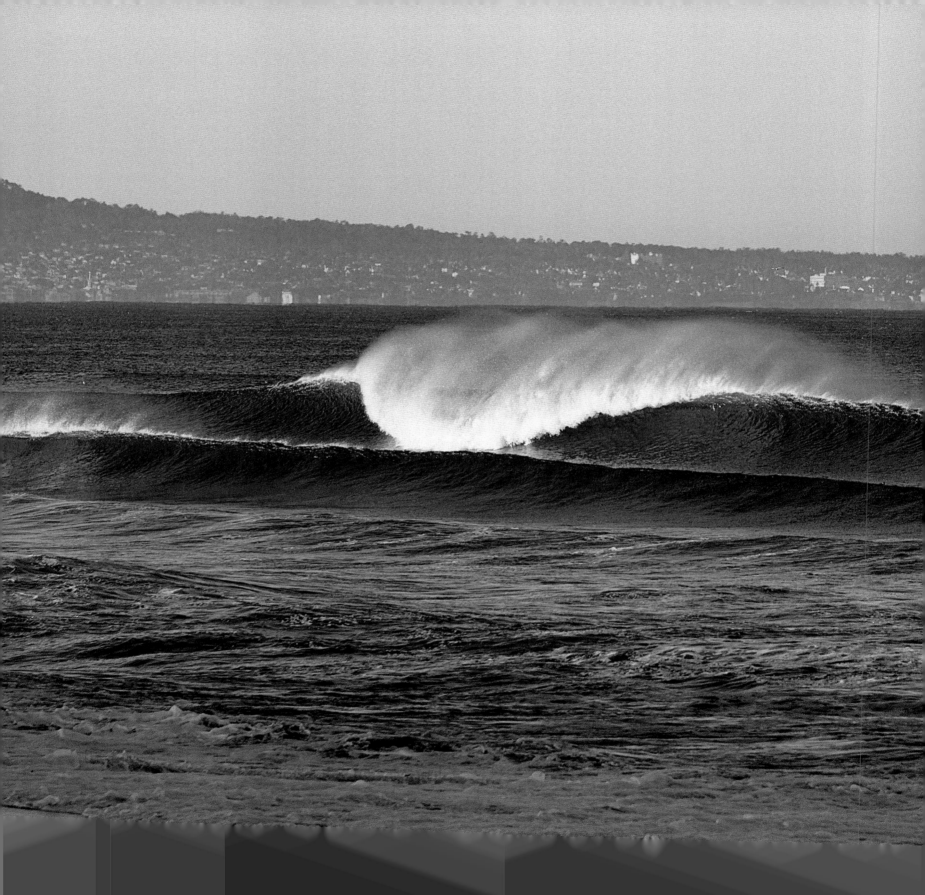

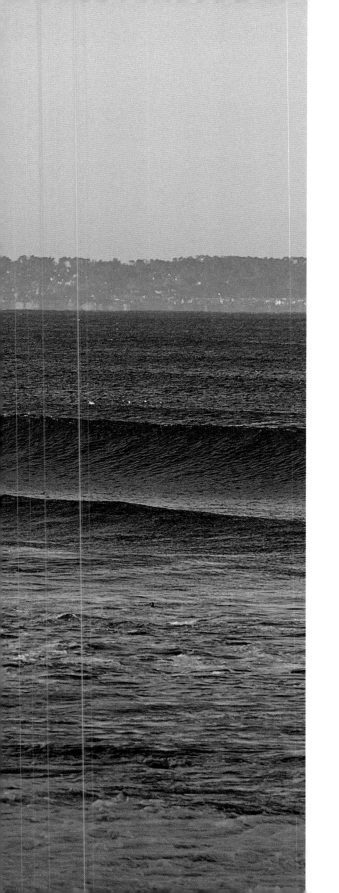
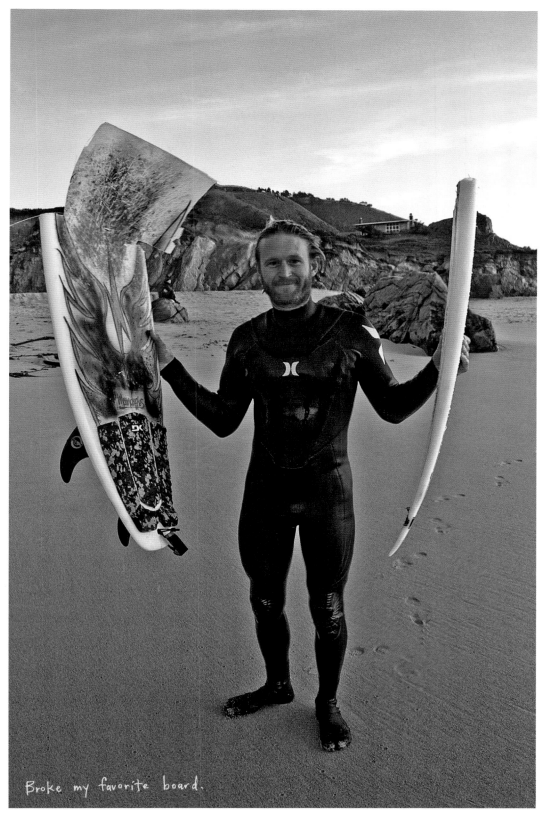

Broke my favorite board.

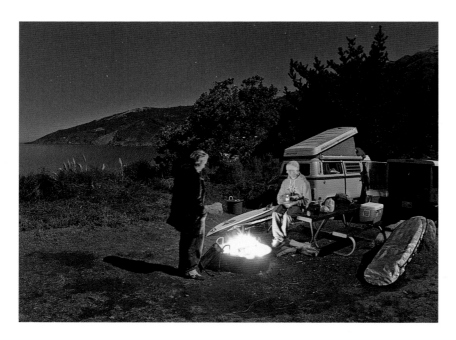

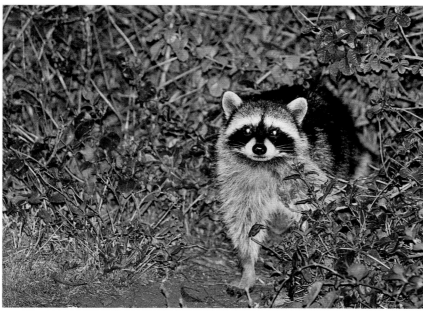

Me, Nate, and a filthy varment.

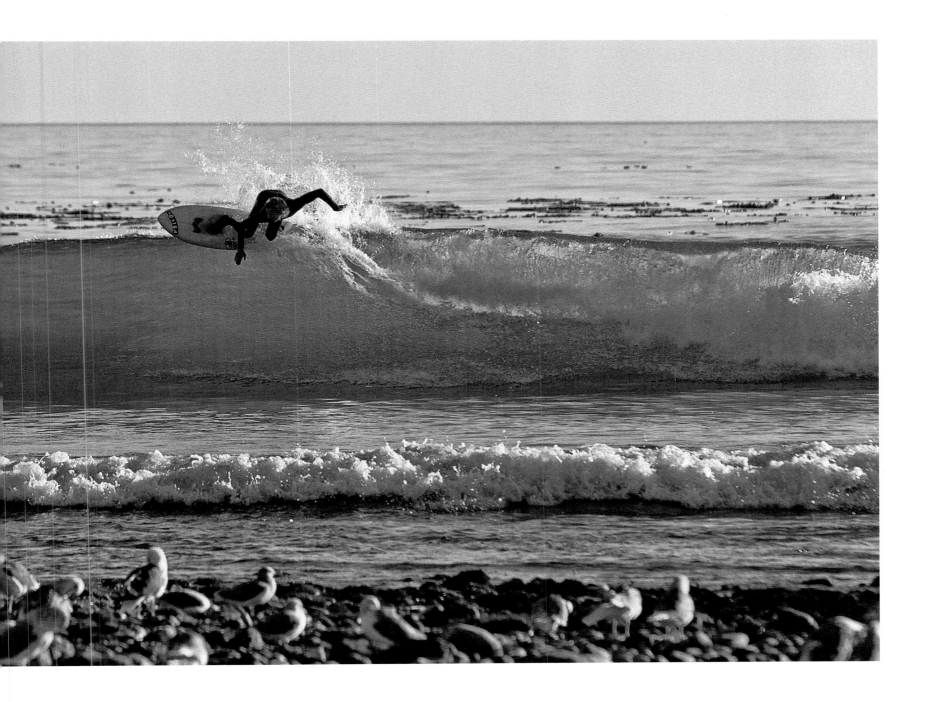

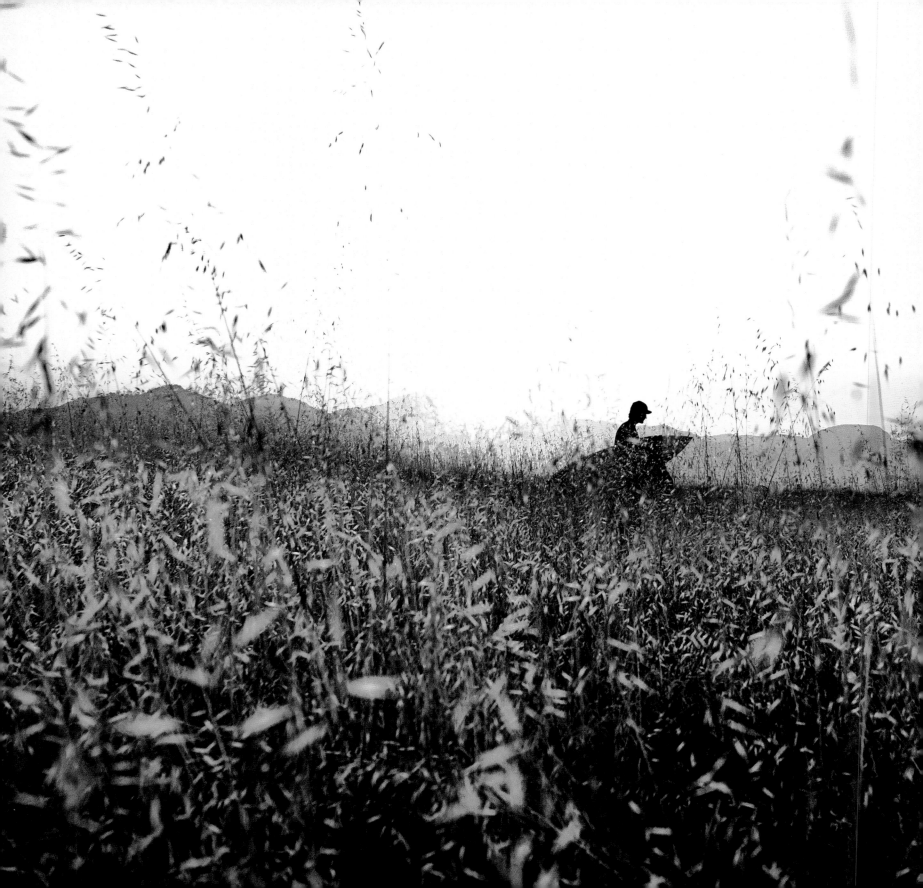

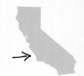

SAN LUIS OBISPO

The morning began with the bus not starting. We were on a steep road and we pulled off a super-sketchy roll start. Once running, I was a little hesitant to turn the bus off, but the waves looked good so we were on it.

My welcome-home surf consisted of dodging elephant seals and thinking of sharks. It was kind of like going to the zoo, intermingling with the creatures and hoping that nothing gets upset. When I came in from surfing, Burky didn't look so well and told me he was sick.

"Nutella sick or flu sick?" I asked. We had eaten the last of our food that morning: a jar of Nutella and piece of potato bread.

"Flu sick," Burky answered.

I knew this was a critical point in the trip, so we made an agreement. We would rest at home for two days. Forty-eight hours to recuperate and fix the bus, and then it was back on the road whether we liked it or not. I dropped Burky off at his house. He was locked out, but insisted I leave. When I drove off, he was laying facedown in the dirt, sick as a dog. I felt bad for him but it was good to be home. On the agenda: 1). See if my girlfriend remembers me. 2). Kick the vagabonds out of my house. 3). Take a hot shower.

But it was only a matter of hours before Burky called: "It's going to be perfect tomorrow, we're on it first light." It was a twenty-foot swell with a huge interval and Burks was freaking to shoot tow-ins. I thought, "You're sick man, give it a rest." I told him to do his own thing and I would do mine. Of course, I didn't take it easy. I ended up going out on the town and got stuck sleeping in the damn bus again.

The following morning was massive with extremely clean conditions. I paddled an 8'6" into some of the biggest waves I had ever surfed and I still get butterflies in my stomach when I think about it. I couldn't believe how slow motion and surreal the waves looked that day. Driving home through the rolling hills, checking out the farm fields and the red tail hawks, everything felt very special.

Later Burky told me he scored this crazy slab up north. We laughed at the dumb luck of stumbling into these conditions and made plans to piggyback this swell into Santa Barbara.

San Simeon

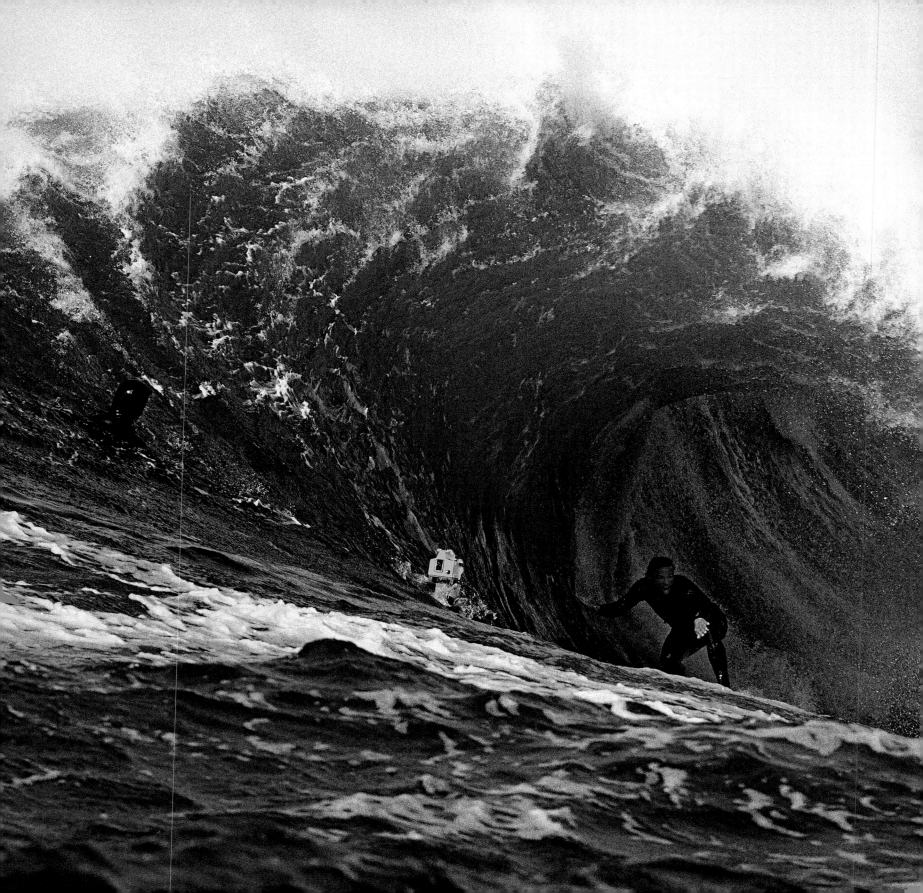

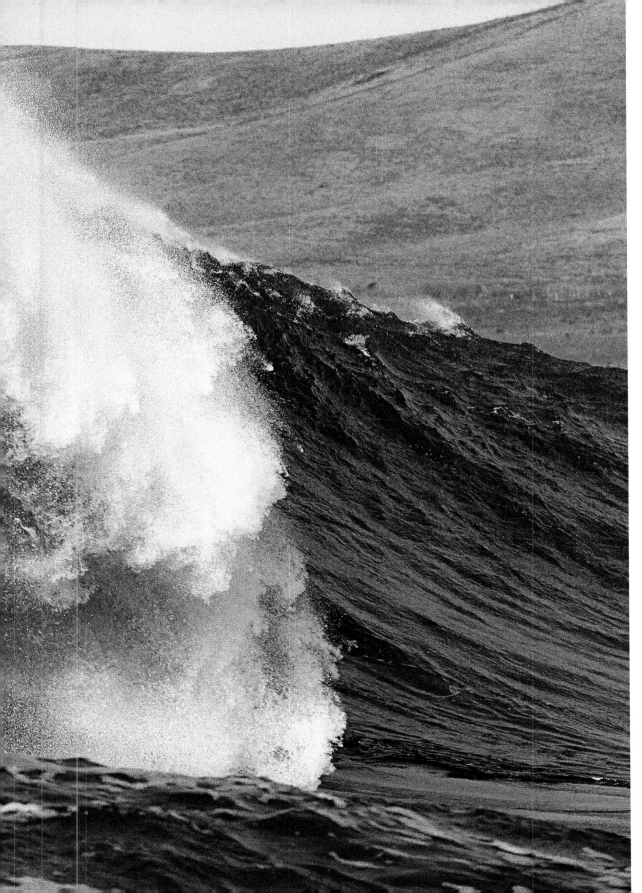

Van Curaza and heavy water.

As if the Elephant Seals aren't scary enough, there are even bigger sharks that eat them. I do my best to not think about them.

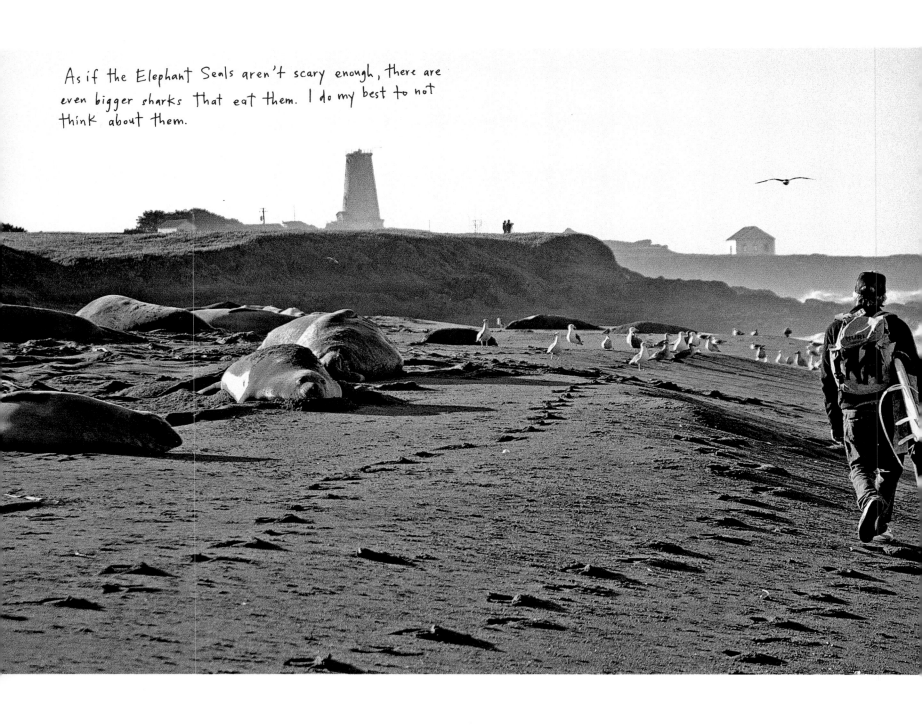

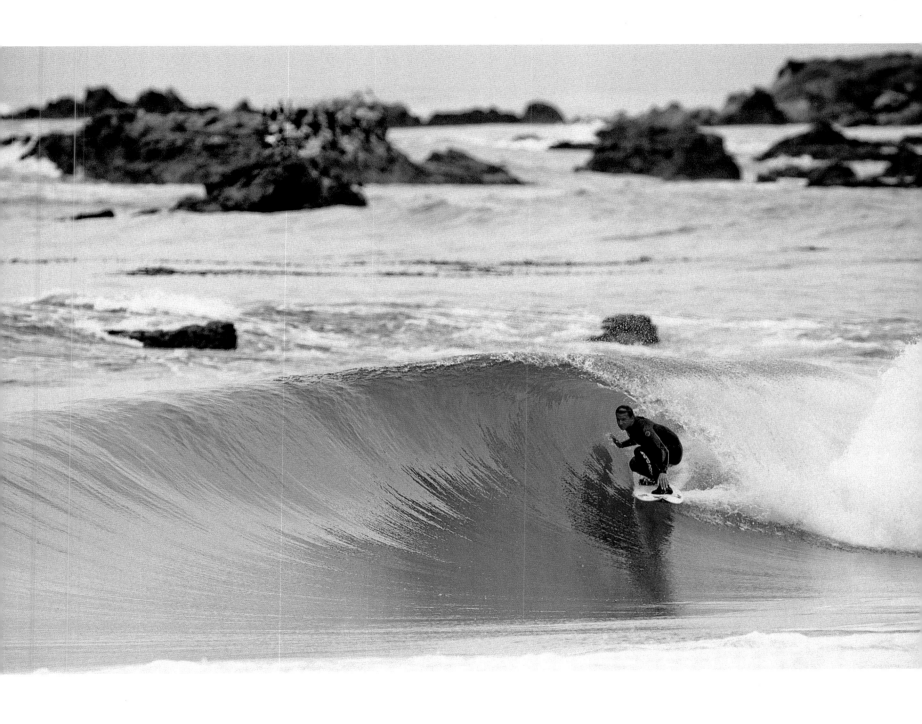

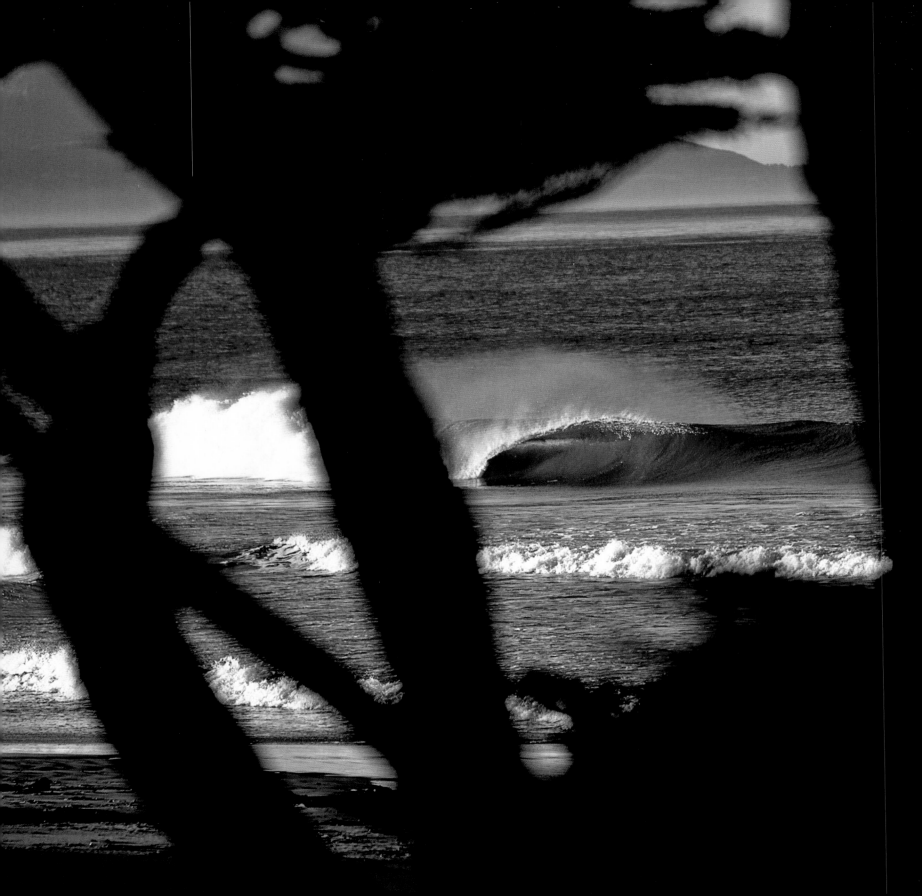

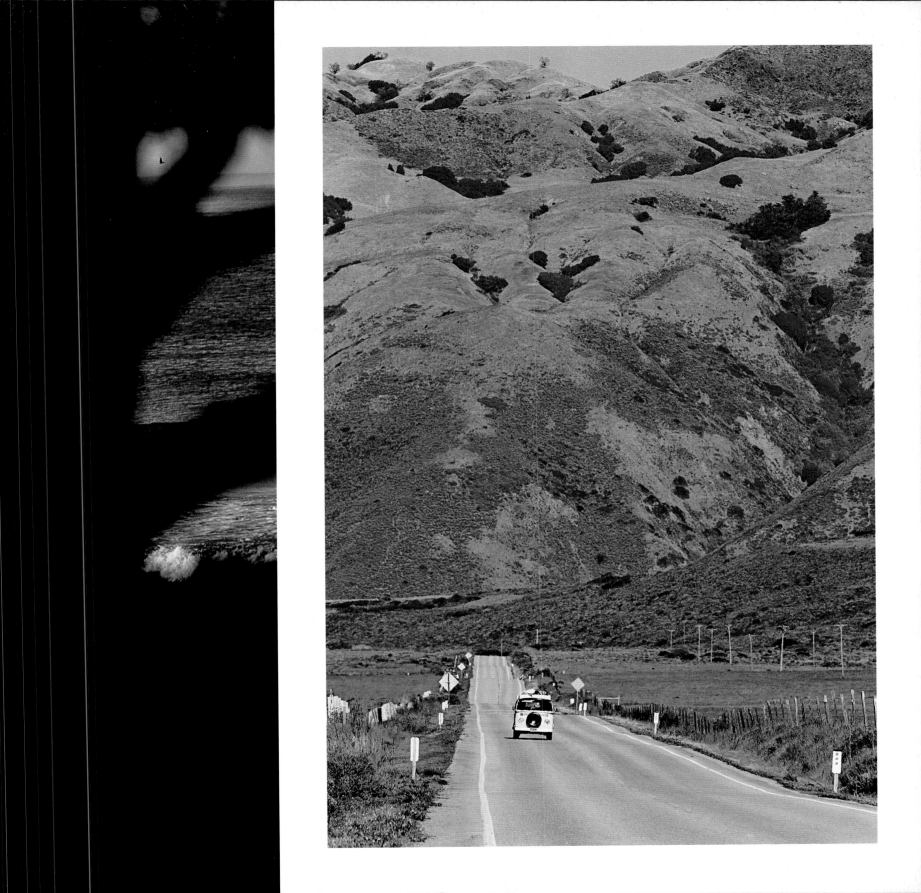

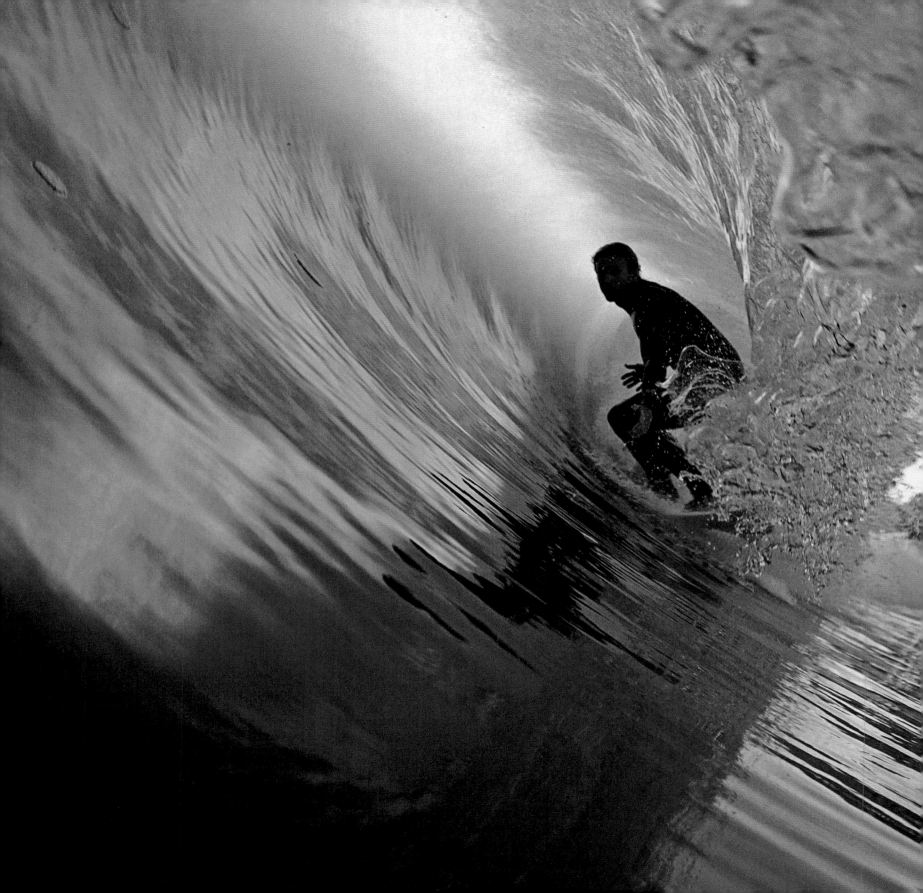

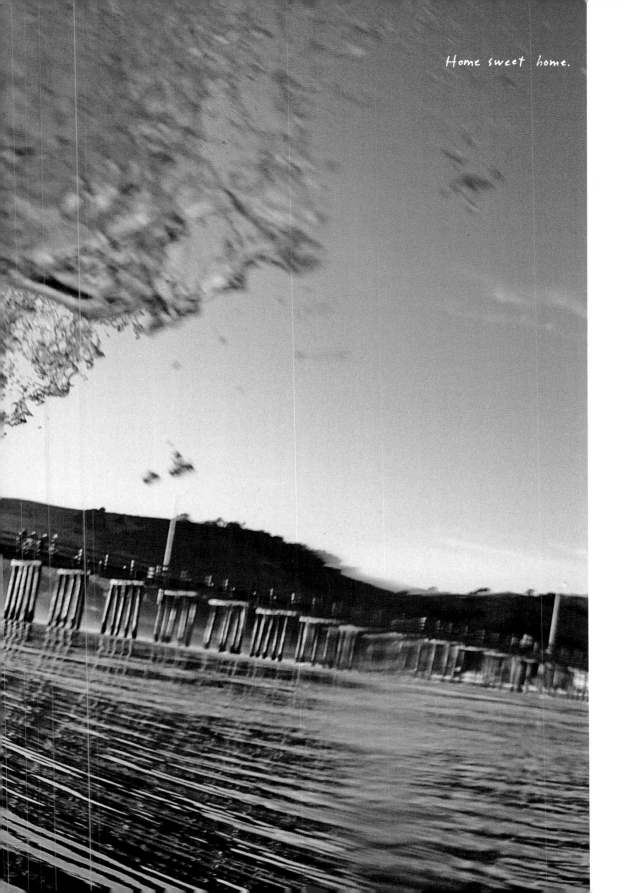

Home sweet home.

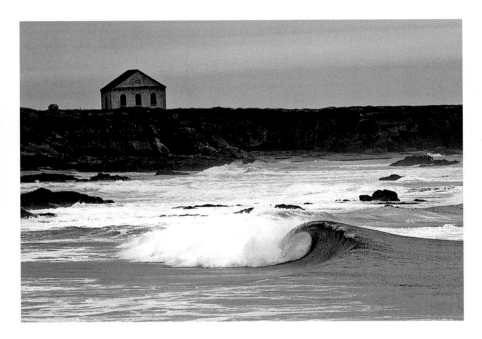
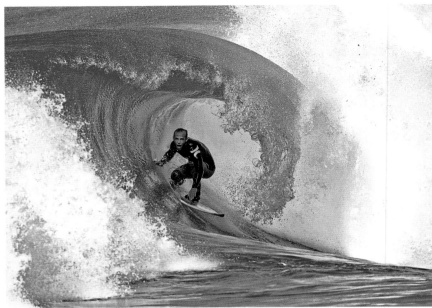
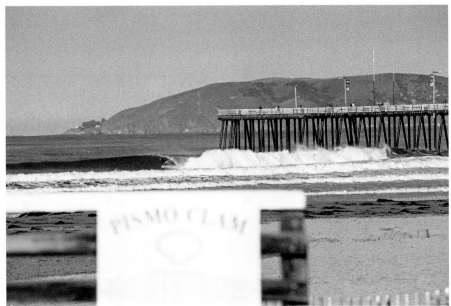

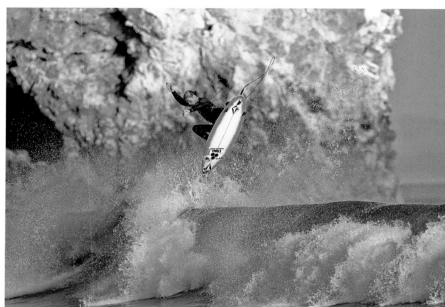

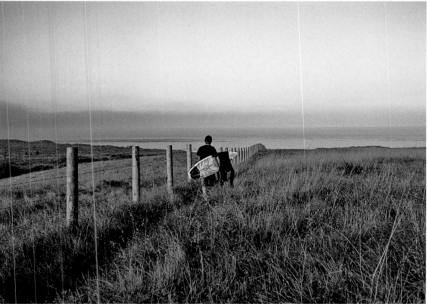

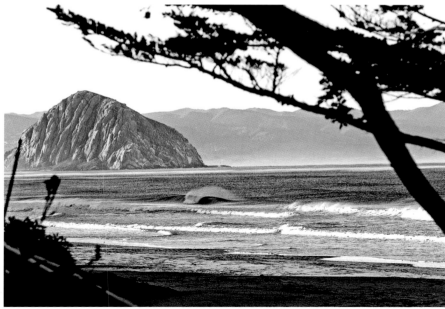

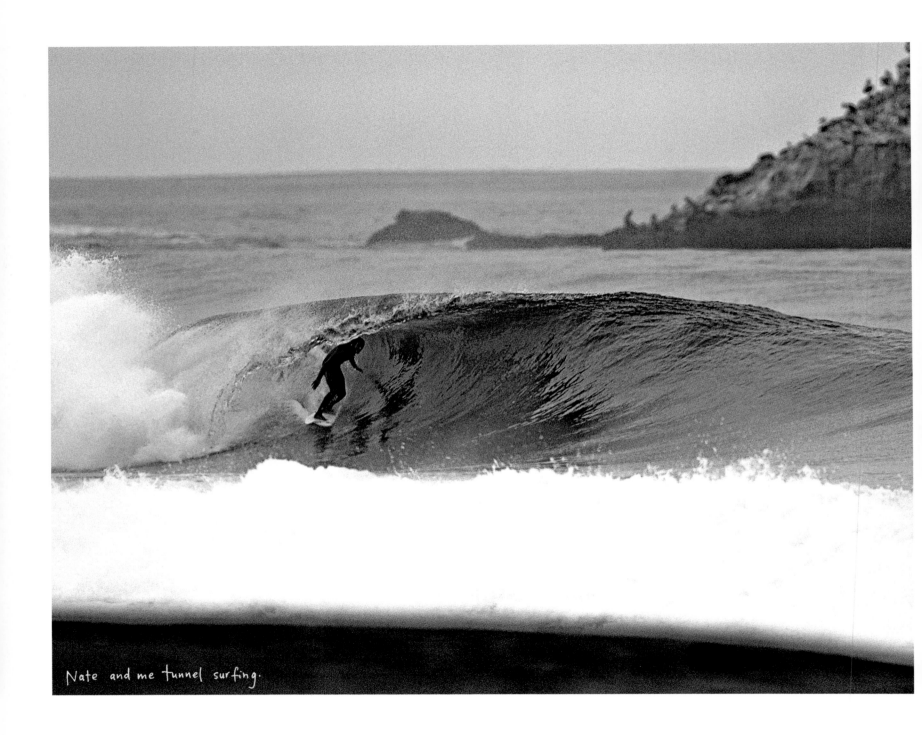

Nate and me tunnel surfing.

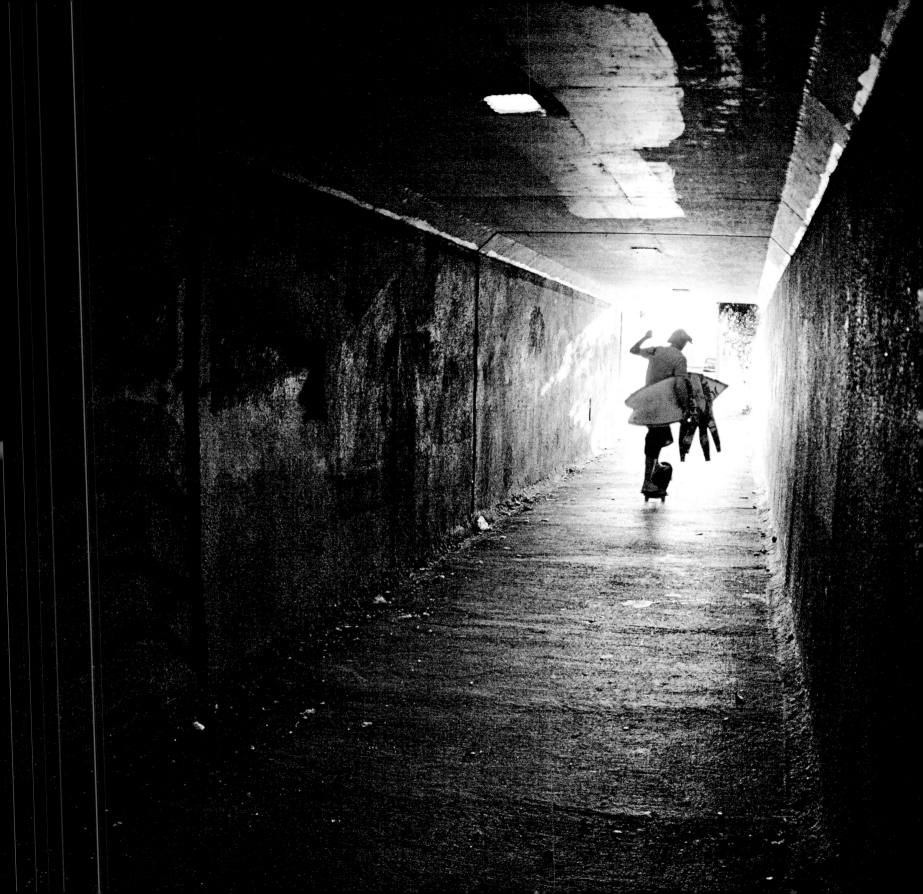

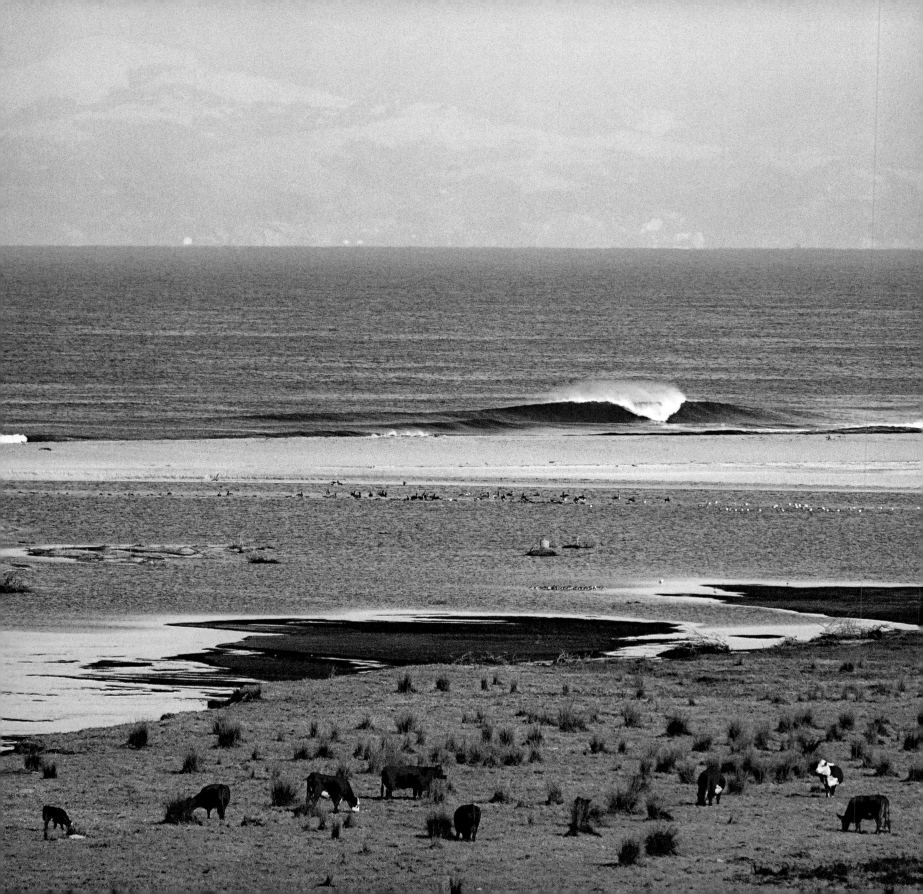

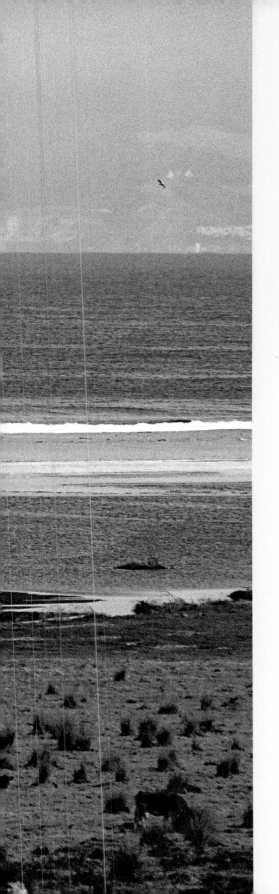

SANTA BARBARA

After a couple of days at home, I picked up Burky, bursting his domestic bubble. In my deepest thunder voice I screamed, "Born free, born to ride!" The bus had a repaired CV joint, we had a full tank of gas, I had no job, and we were road bound. We headed south through the farm fields, stopping to check out some soulful murals and give tribute to Mother Guadalupe. The tides were good for the points and we continued south toward Santa Barbara.

When Santa Barbara's good, I generally surf until my arms feel like they're going to fall off. It's a good example of the spirit is willing, but the flesh is weak. Everyone has noodle arms but can't get enough. You'll be paddling out and look over and see some salty old man that just won't stop paddling. The set of the day will come and you're thinking, "He's going to fall, and I'll get it." Then you'll witness the most graceful turn of your life and think, "He's not going to fall, that's Tom Curren." That's why I love Santa Barbara, and this was one of those days.

Heavy locals grazing.

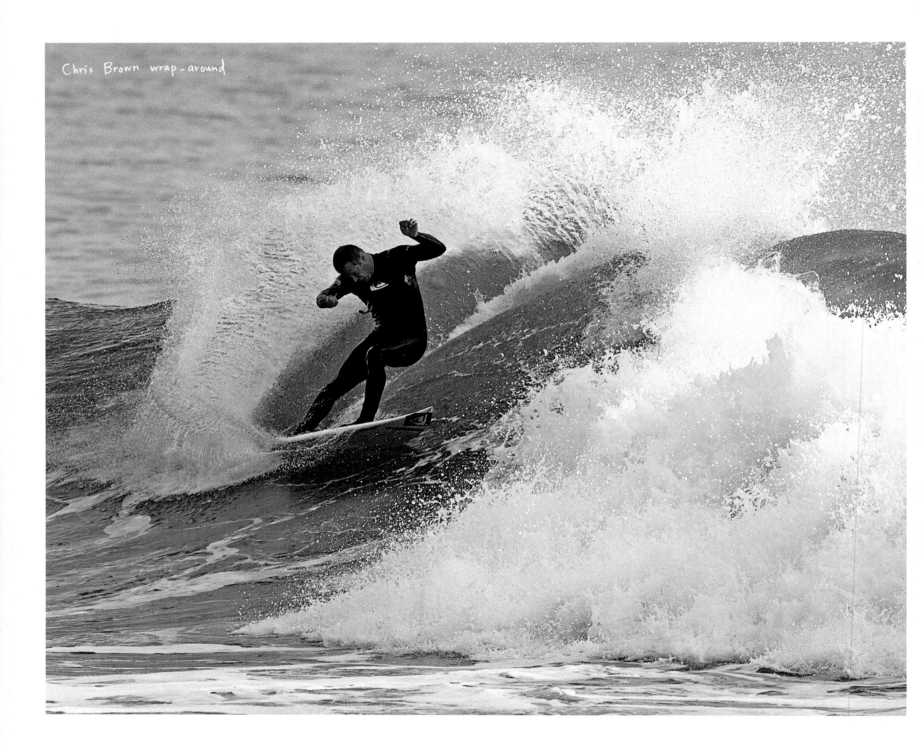

Chris Brown wrap-around

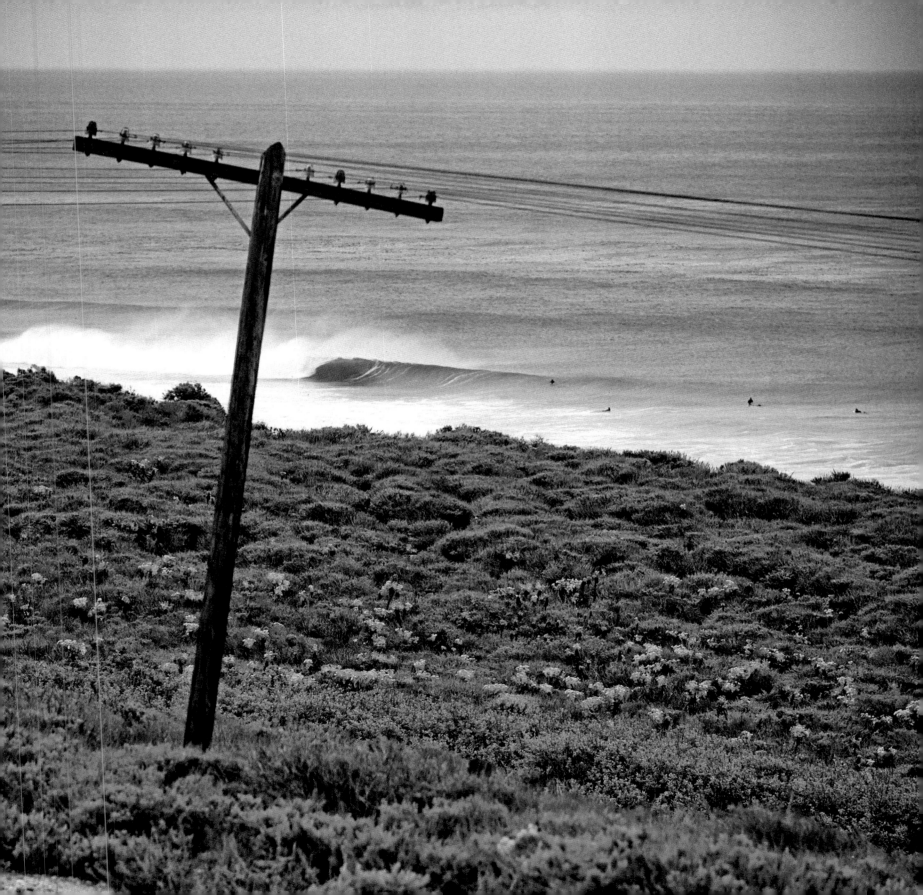

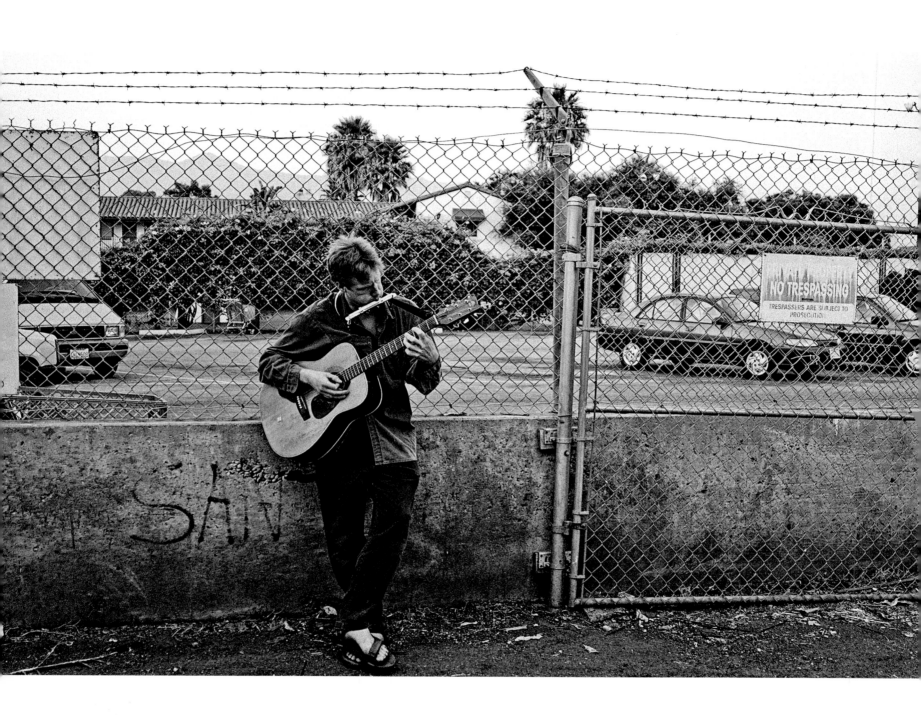

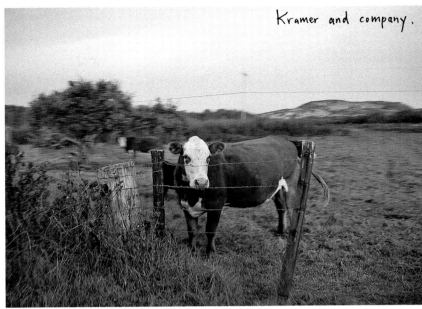

Kramer and company.

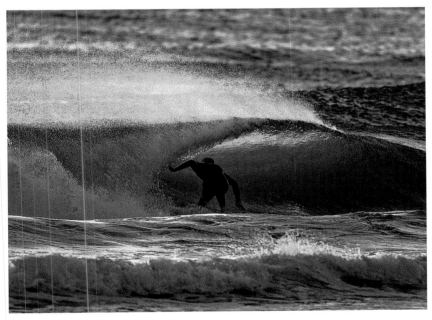

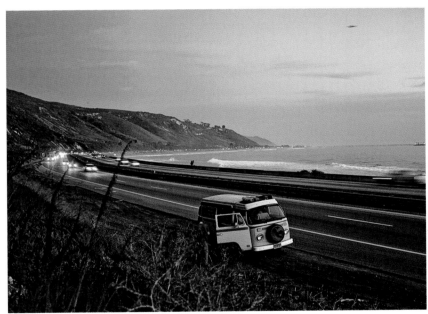

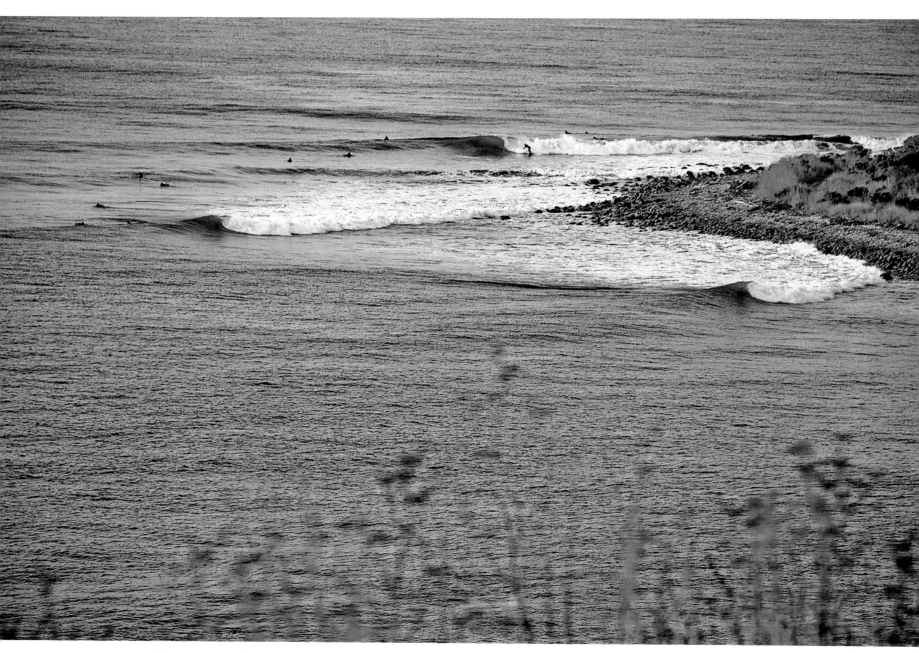

Magic point/flying Columbo.

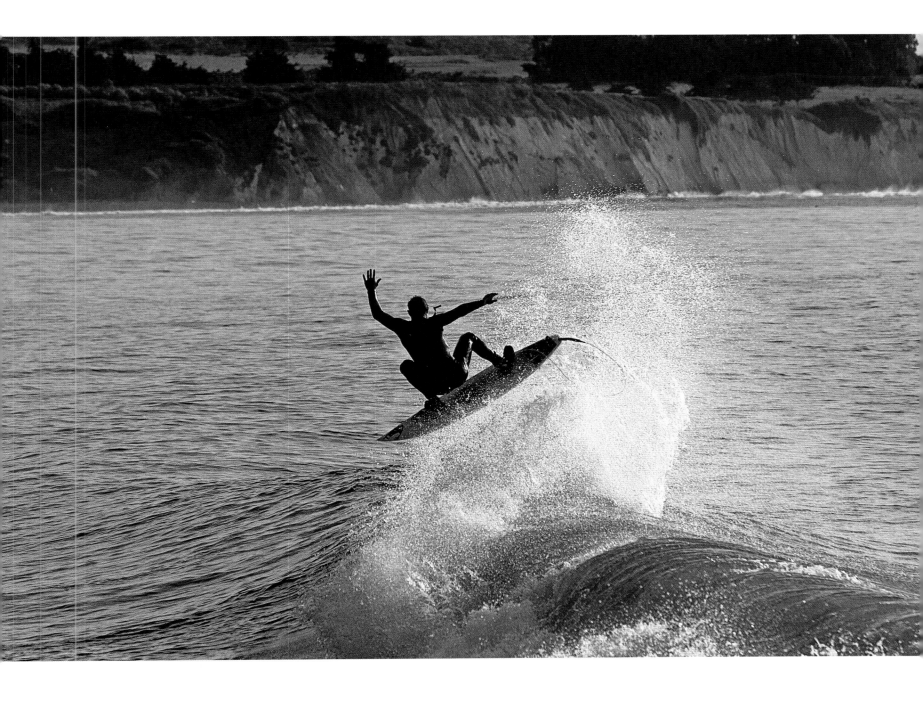

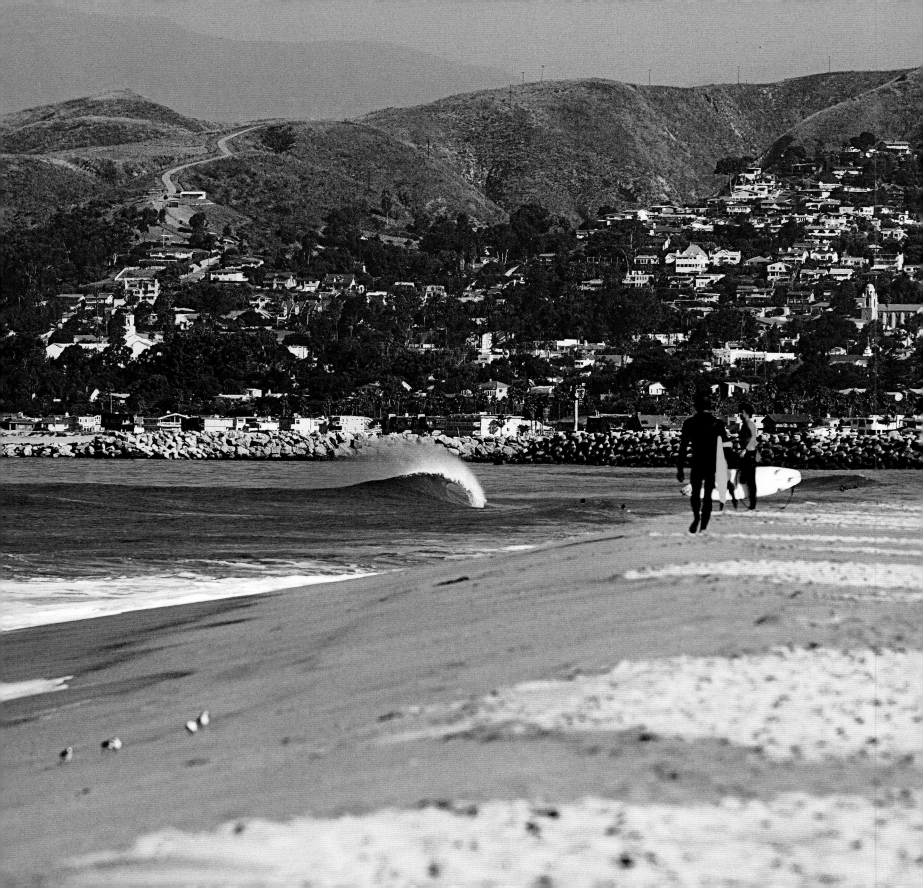

VENTURA

I was completely surfed out when we arrived in Ventura, pulling up to C Street at sunset.
The whole sky glowed pink and you could see the silhouettes of swell marching in: a beautiful night and a good sign for the morning. I was tired and not in the mood to get hassled over where to sleep. Luckily, my friend Guy was in town and said we could park at his place. Guy has a creative warehouse in the industrial part of Ventura and we parked in its corridors. We had a bonfire in a barrel and enjoyed a good night's sleep.

The following morning was hot with offshore winds and I surfed like a lazy sunburned reptile. I got to surf with Dane Reynolds and watch him tear apart every wave that came near. We ate breakfast together and as we were leaving we pulled up next to Dane at the stoplight. Burky and I had been looking for an opportunity to race someone and I knew it was our time to shine. I revved the bus's engine and we put on our imaginary leather racing gloves. Burky shook his fist at Dane, the light turned green, and we were off. We took him at the start, and then Dane gunned it and flew past us in his Darth Vader–black station wagon. We were left in the dust, but defeat was instantly replaced by the realization that we were going in the wrong direction.

Later that afternoon we figured we should shoot some photos of the town. I unfortunately gravitated toward the steepest hill in Ventura. Twenty feet from the top, the bus stalled and we started rolling back. A car behind us layed on its horn with no mercy, but the bus couldn't make it. I waved the car past and attempted to roll back into a three-point turnaround. However, when the bus isn't running, the brakes get stiff and do not work well. So, as we rolled down the hill, we gained too much speed and when I cranked the wheel, I swear we almost rolled! I still cannot believe we pulled it off. I took this as a parting gift and we headed south to L.A.

Dec. 11 – Ventura.

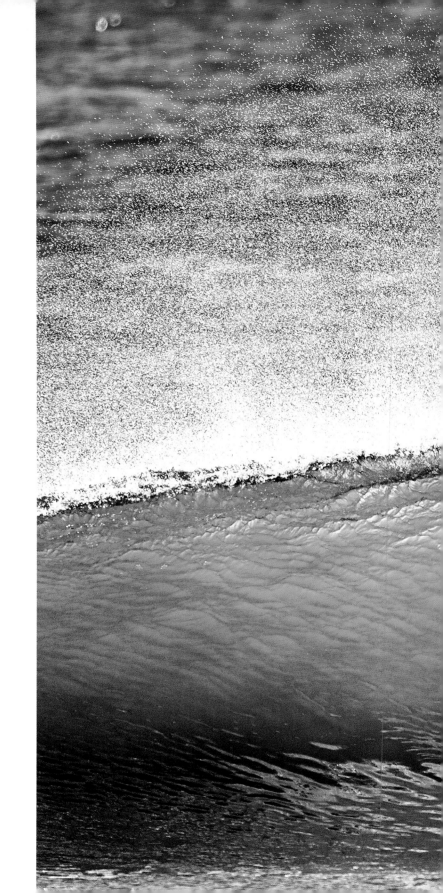

Dan Malloy, 1983 — timeless.

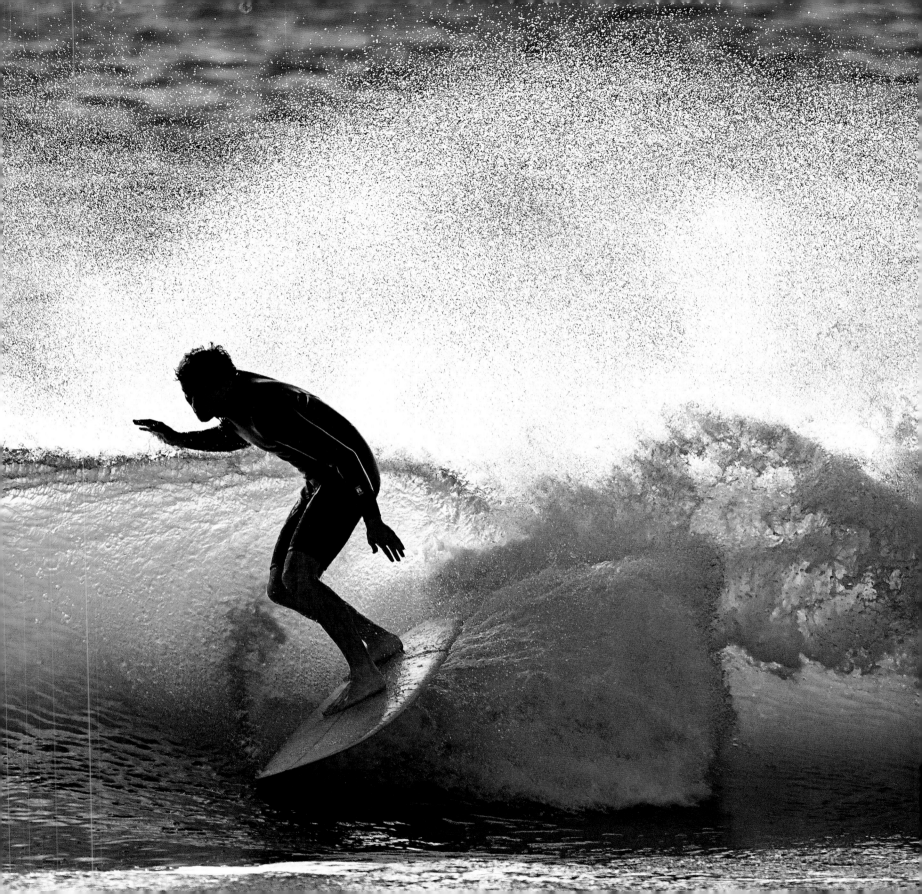

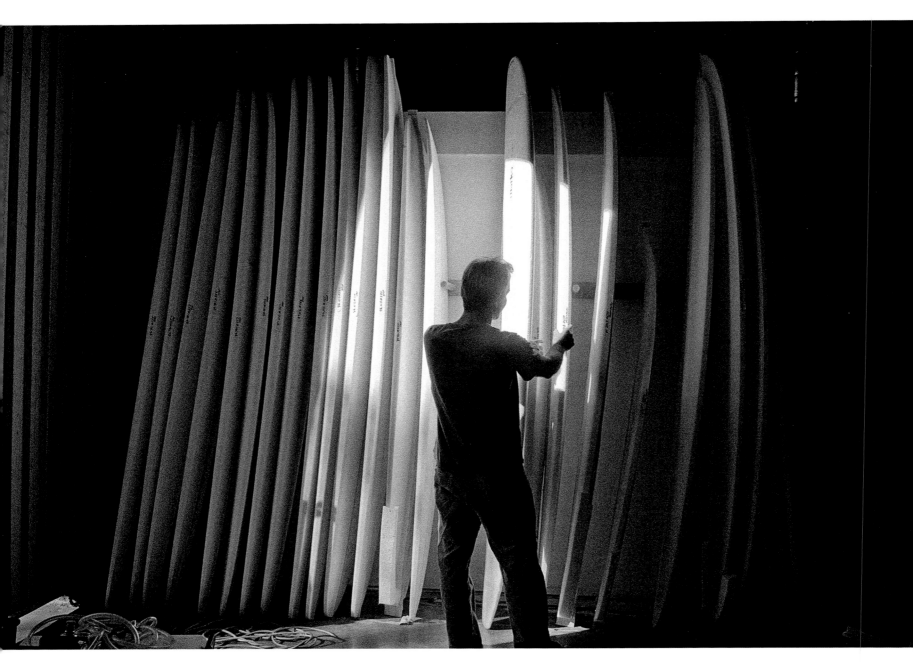

Dan's a fortunate man with great wave riding skills
and legendary wave riding tools.

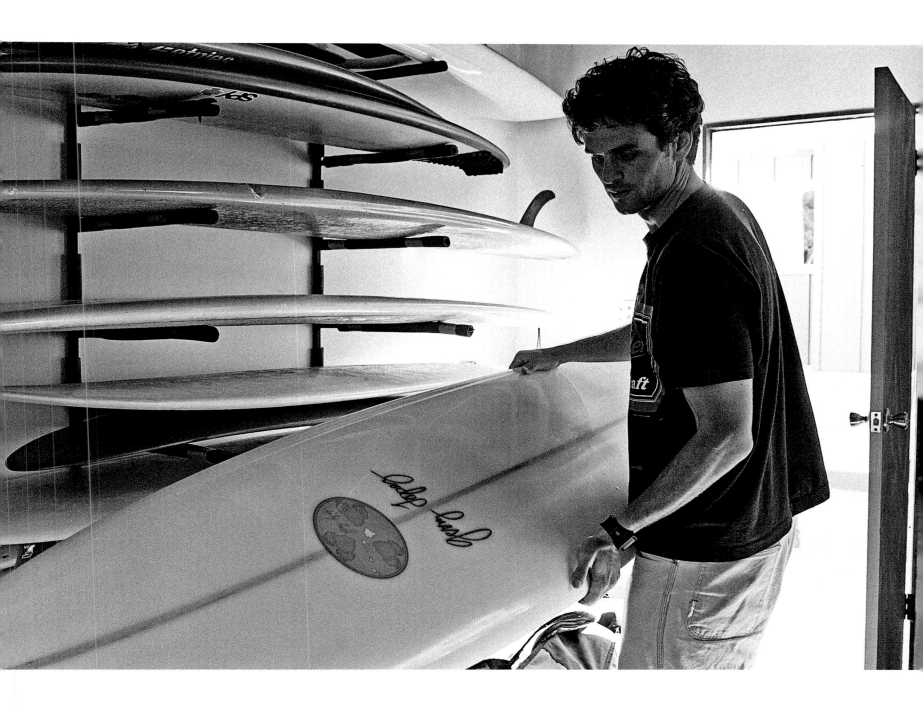

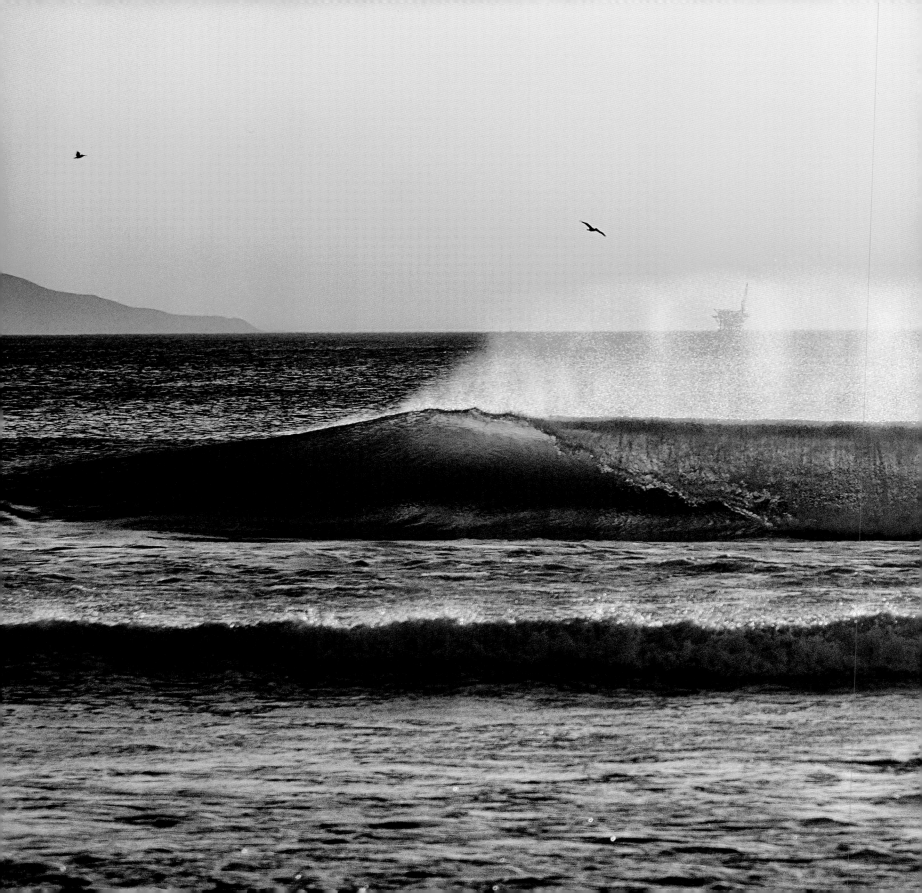

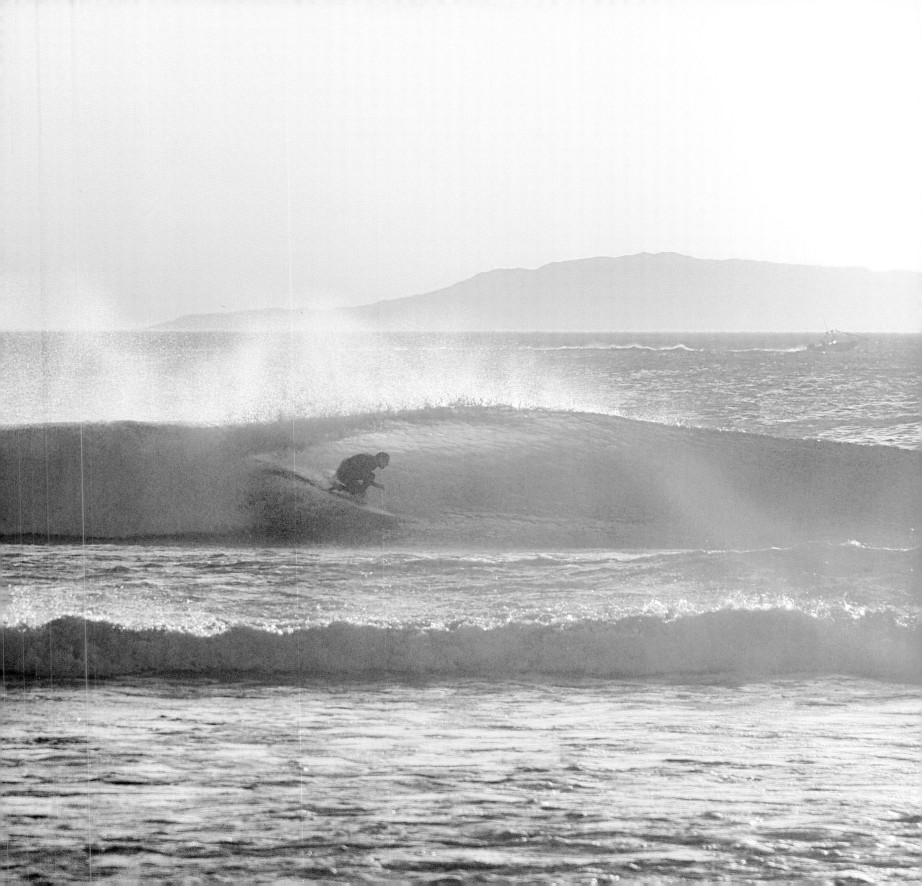

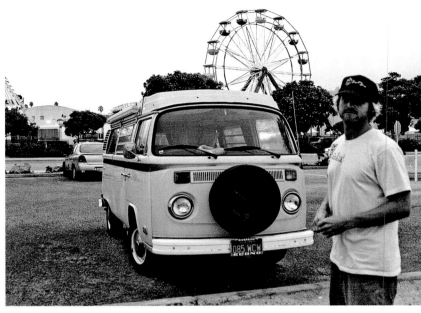
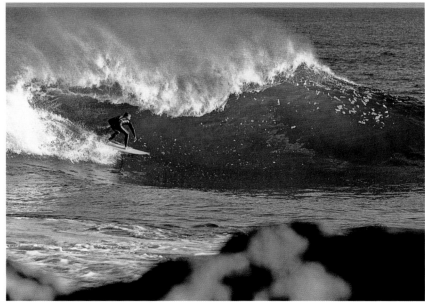

Rich in resource.

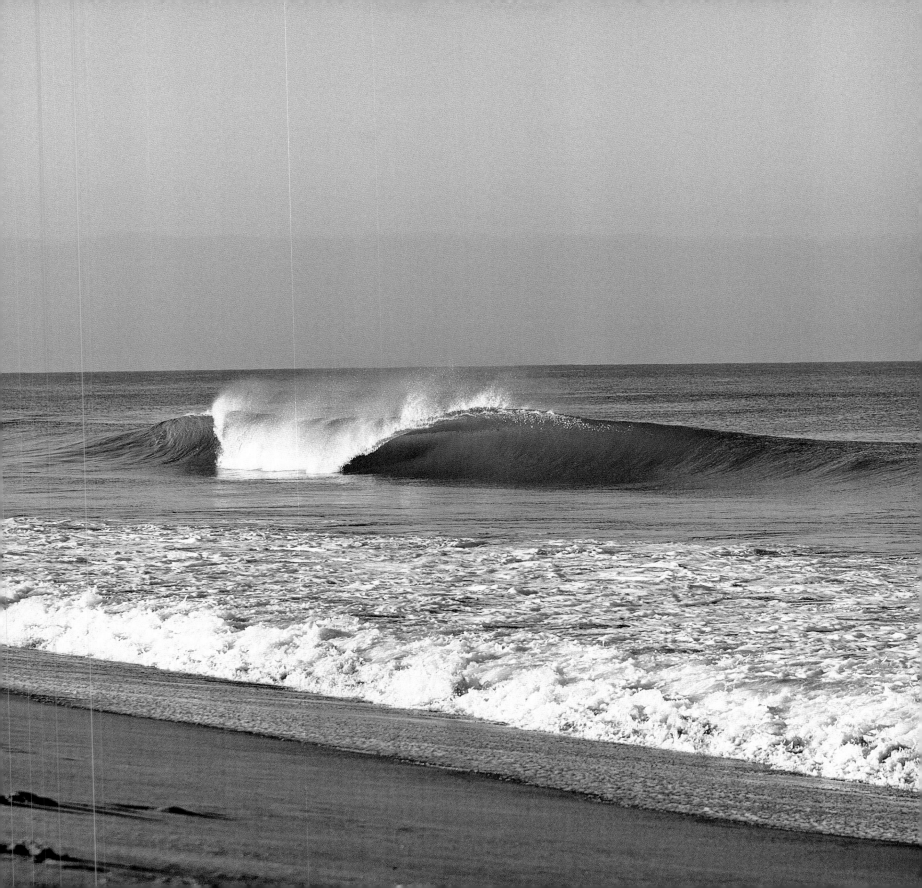

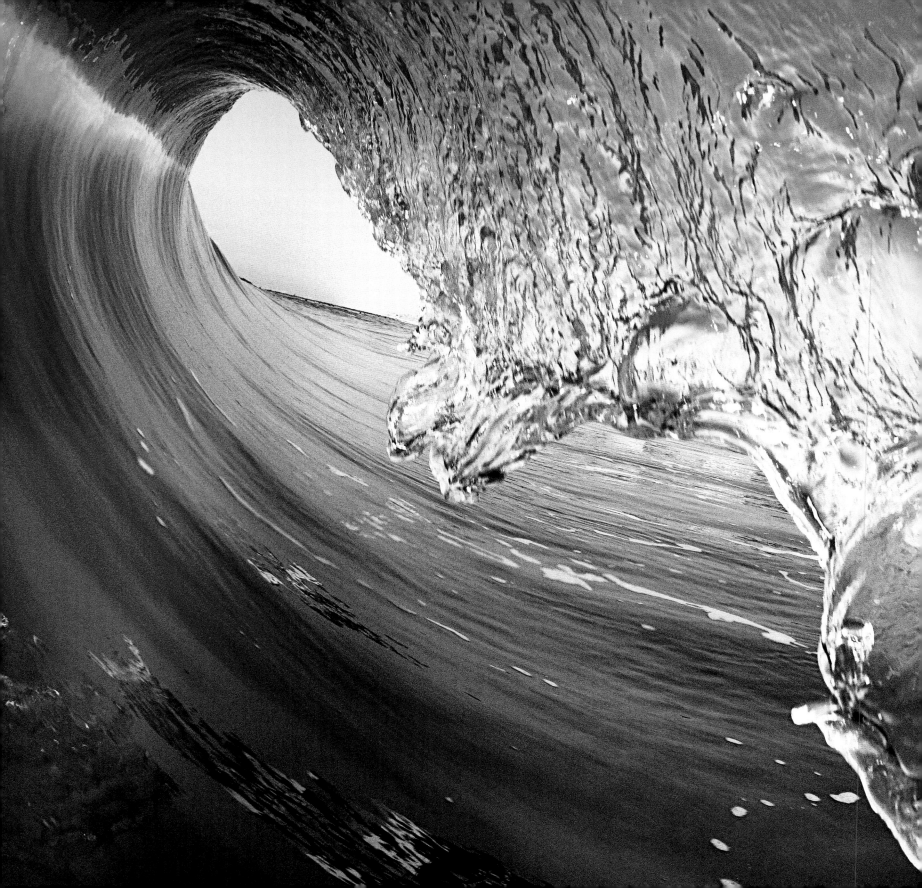

LOS ANGELES

We pulled up to County Line and the waves looked fun, but I couldn't stop looking across the street at that poor Neptune's restaurant. I was thinking of all the cheesy movies that were filmed there. If I am not mistaken, Patrick Swayze and Keanu Reeves bro it up there in *Point Break,* which inspired me that Burky and I should film the sequel, *Point Break II,* starring the not-so-handsome Sody in place of Bodhi and Burky as a wider, equally quick, and always believable Special Agent Utah. Straight to DVD, only available in Hong Kong on Sundays: *Point Break II* . . .

The laughter ended with a flat tire at Santa Monica pier. I had no change for the parking meter and chose to stay with the bus to avoid another ticket. I was sitting in the back of the bus when this shady car pulled up. There was a screaming match going on and a guy jumped out. He lunged forward and started barfing right next to my car. At this point I thought, "Screw the ticket. I'm going for a walk." I saw Burks photographing some old chess players and I continued walking down to the ocean. There was a waist-high right spinning off the pier under the giant Ferris wheel and roller coaster. I had to give it a shot. I ignored the polluted water signs and ended up kind of scoring. The surf changed my whole frame of mind. I no longer wanted to strangle Burky and we were able to get the tire fixed. There are some cool spots in L.A., you just have to slow down and take it for what it is. But after a few nights we came to the realization that it's not the best place to try to live in your car, so we continued south.

Dec 12 — Molecular breakdown.

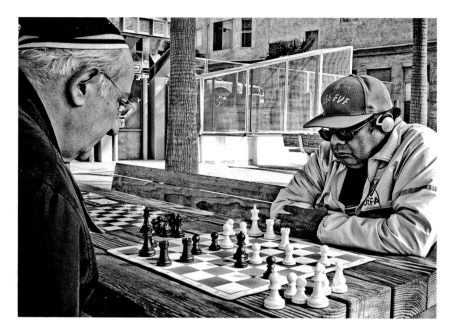

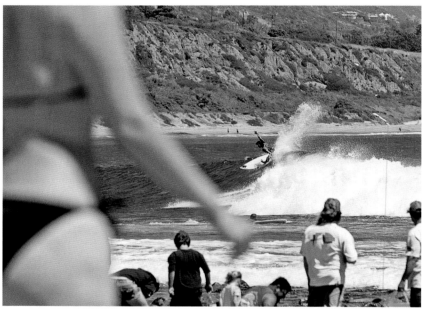

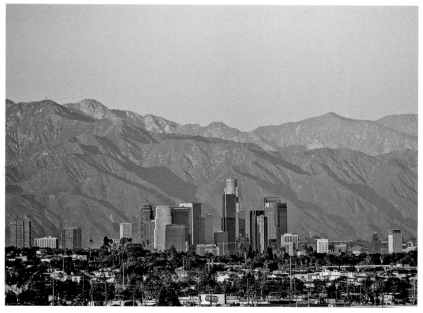

Power lines replaced the trees and parking meters were considered native shrubbery.

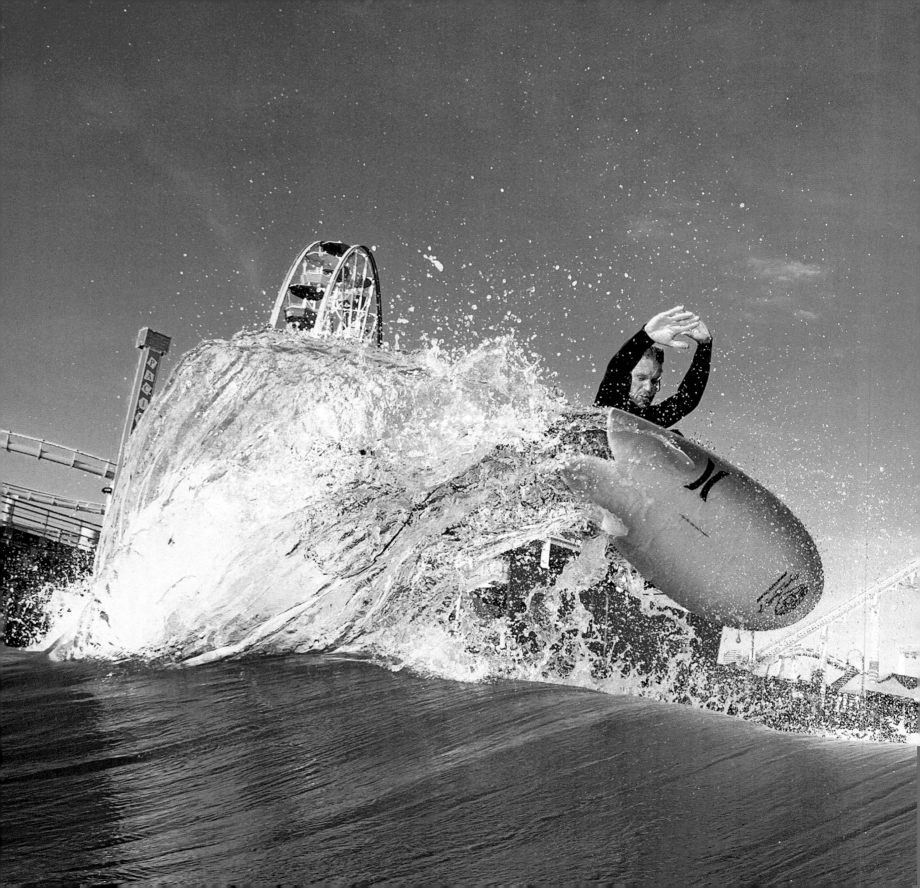

Santa Monica, circus music, and the flying fish.

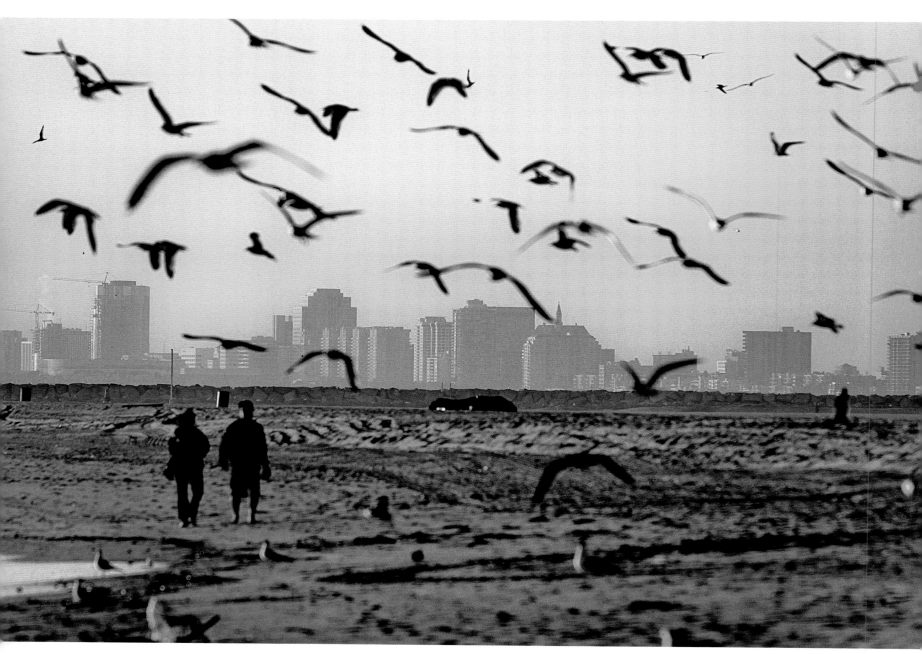

Flocking city.

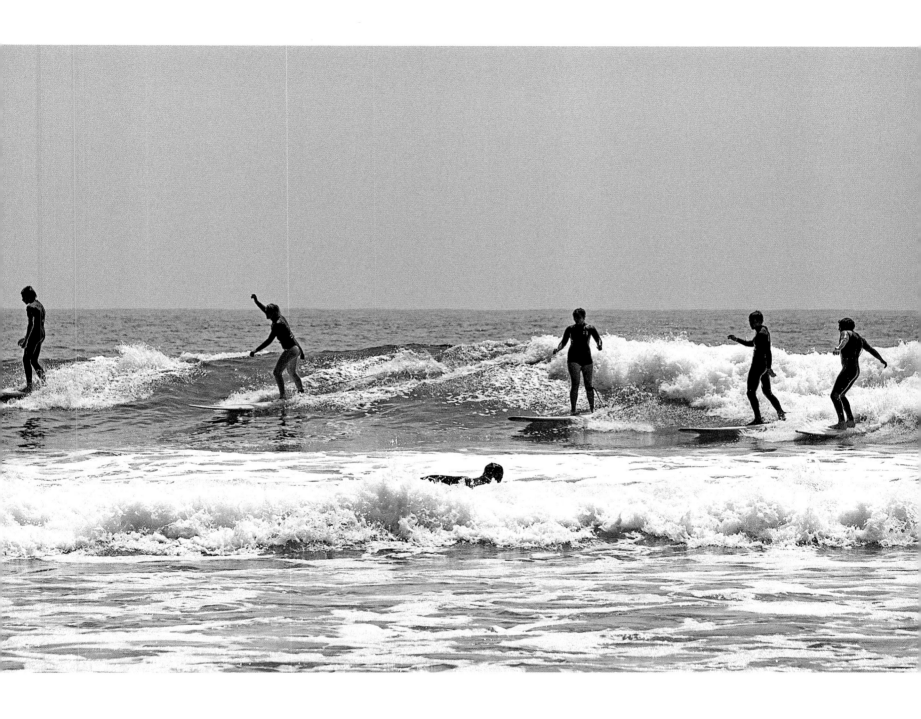

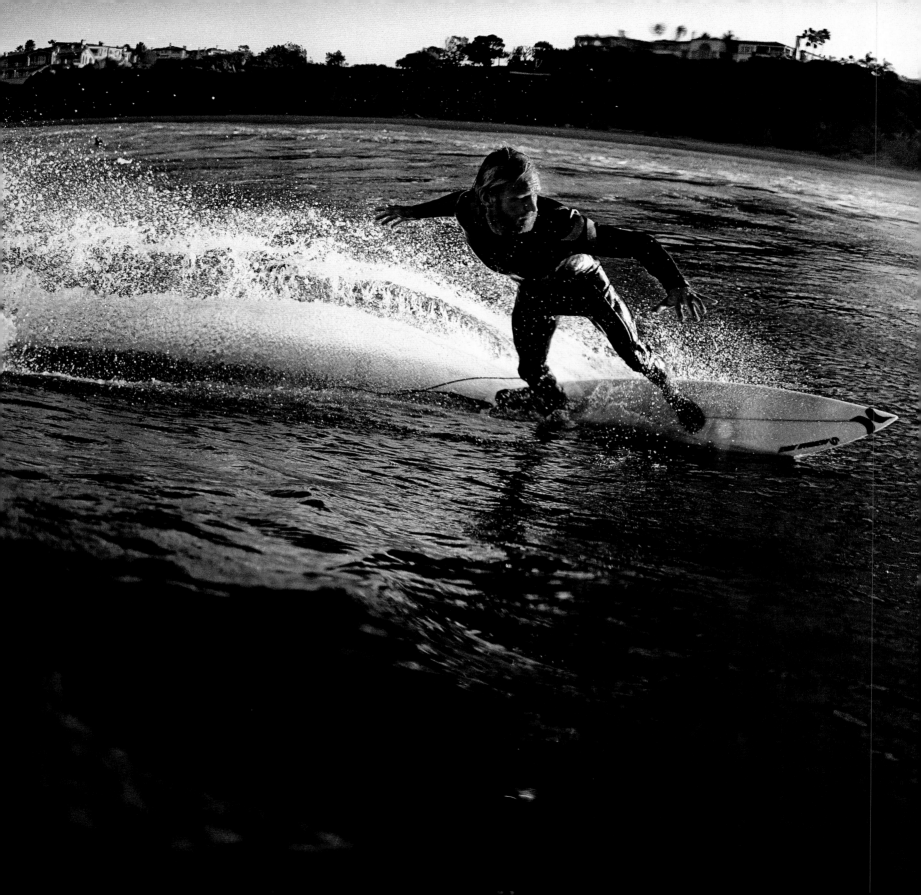

ORANGE

We started our day off by stuffing a parking meter full of change and surfing good old Huntington. There was a fun left going into the pier, but the whole time I was surfing, I was dreaming of an omelet. I called it quits, stuck my arms out in the direction of the Sugar Shack café, and began marching like a bacon-crazed zombie. On my way through Surf City, I could have sworn I saw a life-size Barbie walking a pitbull.

We met a friend at Newport and a machinelike right was spinning off the jetty. It was close to shore and extremely rippable. Unfortunately when I came in, I had another parking ticket, but at this point I was getting used to them.

That night we headed toward King Basses where my friend K. Stew was working. Kevin slaps a stand-up bass like no other, and I'm always down for music. From there we heard a rumor of food at Quiksilver's Christmas party and Burky's nose led the way. The kid loves a free meal more than anyone I know. We got into the party after a short security stint. In the entrance were these big clear balls that you were supposed to get your picture taken in, with these buff guys dressed as Santa with no shirts on. Yikes! I squirmed passed the shuffle and made my way through the dance party to—nothing. Red Bull vodkas as far as the eye could see, but no food in sight. That was our cue and like cavemen, Burky and I grunted our way back to the bus and the streets we roam. After three or four days of groveling we scored some of the best waves of the trip. On the last night in San Clemente, the police slammed on our window and told us to beat it, so we did.

Salt Creek, 6:30 AM.

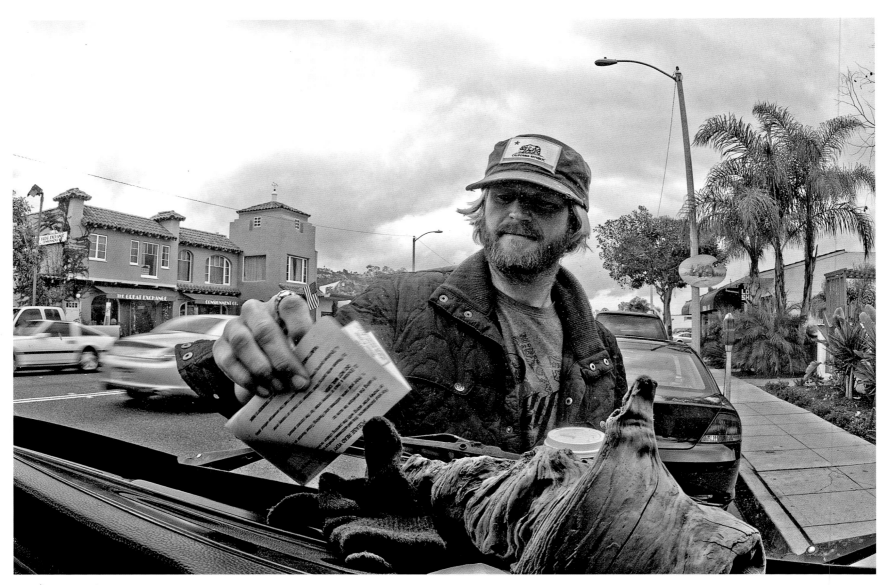

Laguna love note.

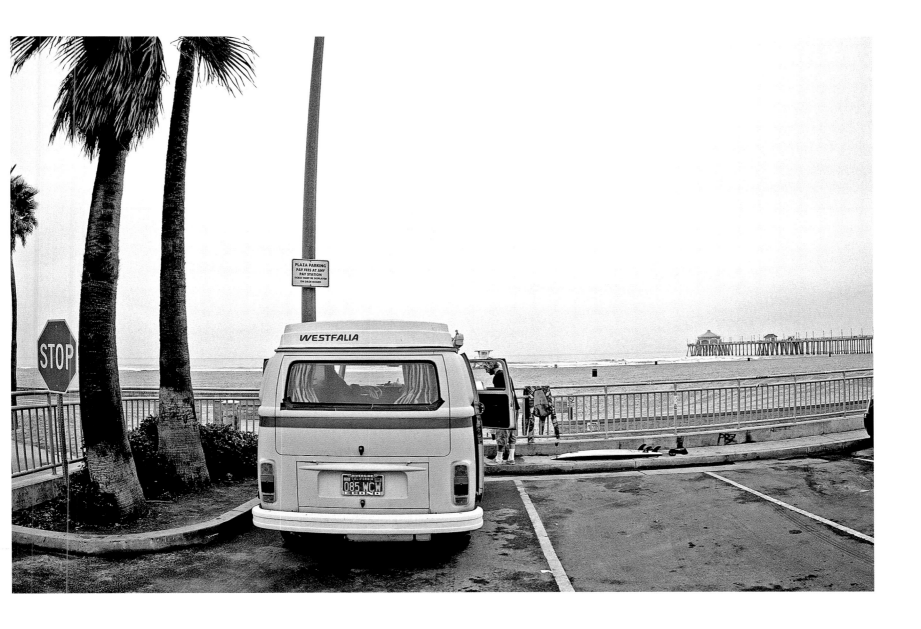

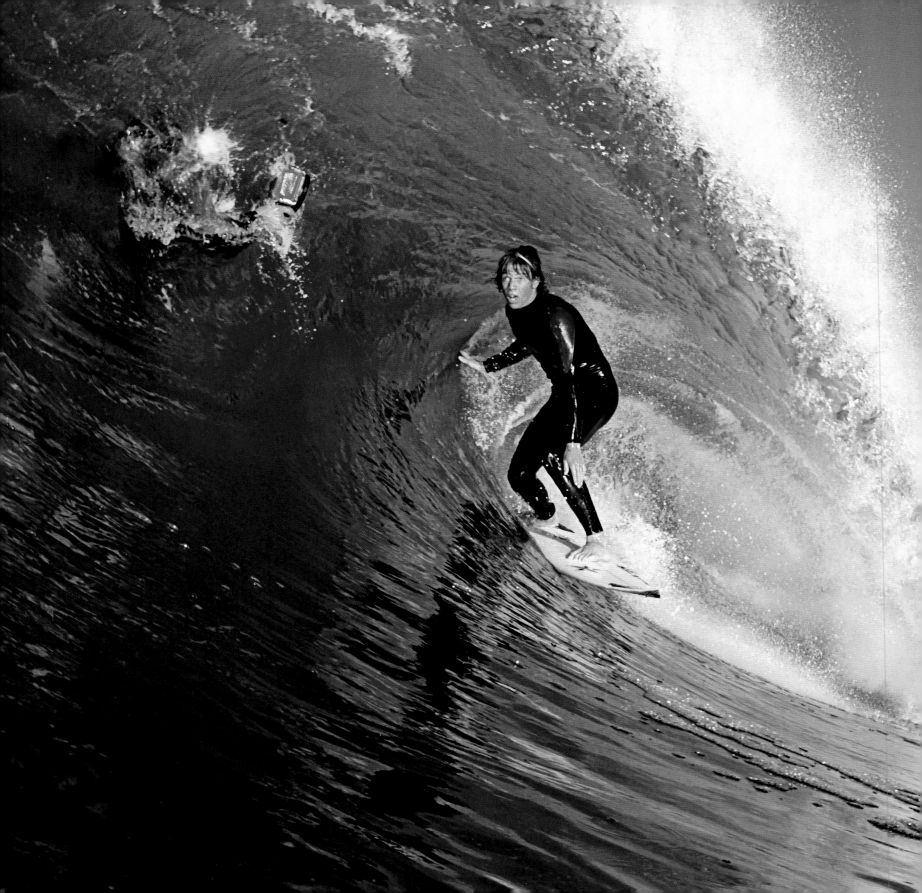

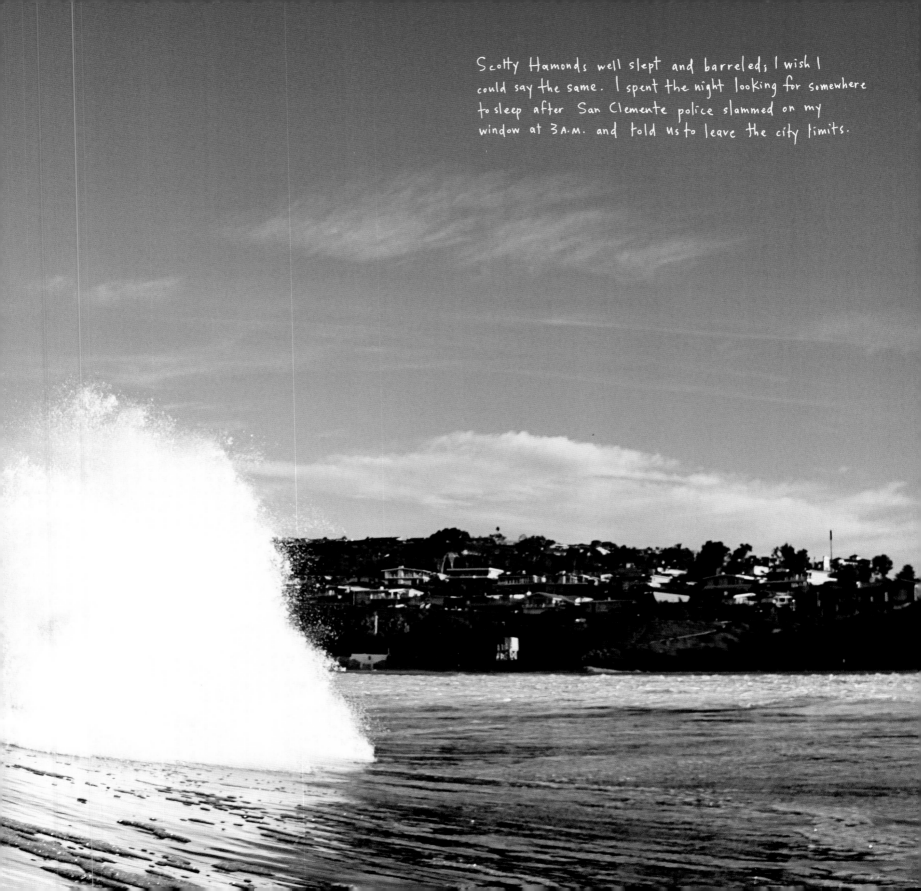

Scotty Hamonds well slept and barreled; I wish I could say the same. I spent the night looking for somewhere to sleep after San Clemente police slammed on my window at 3 A.M. and told us to leave the city limits.

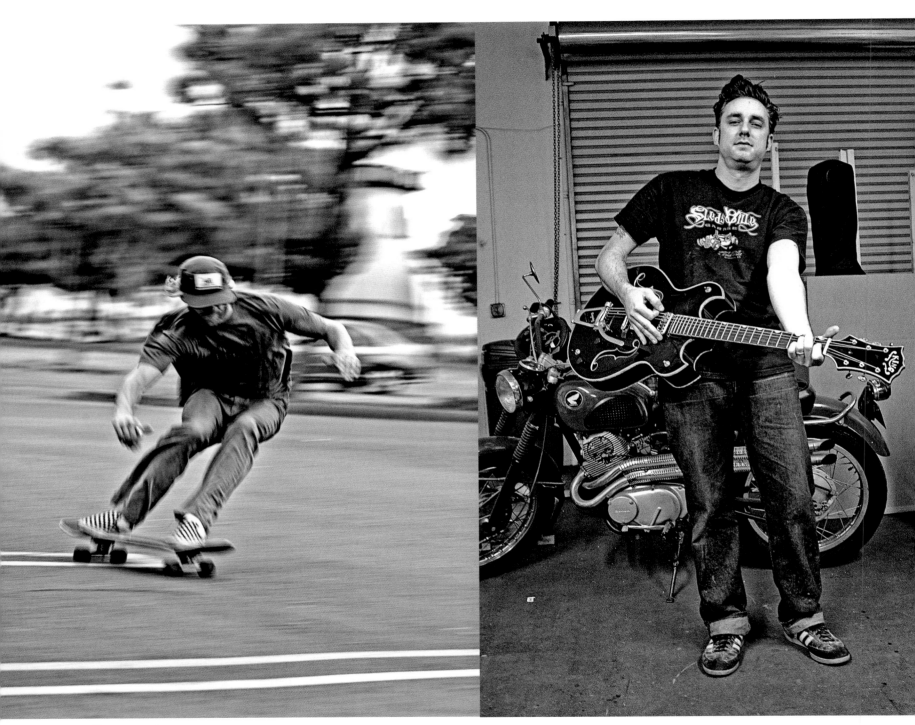

Me, Jason, and Warren.

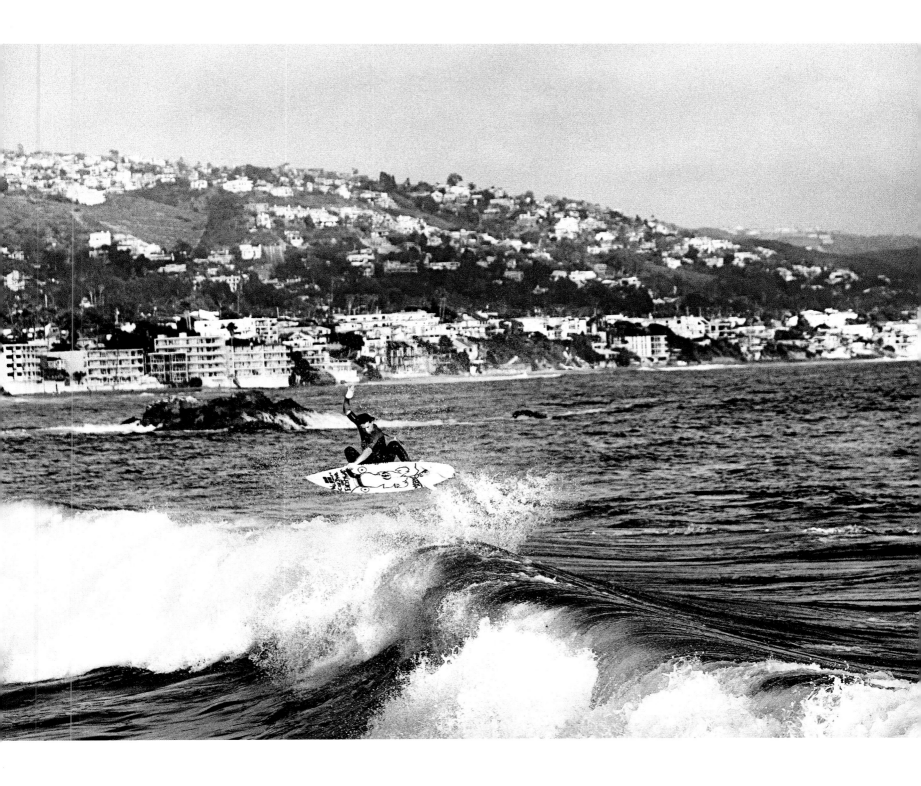

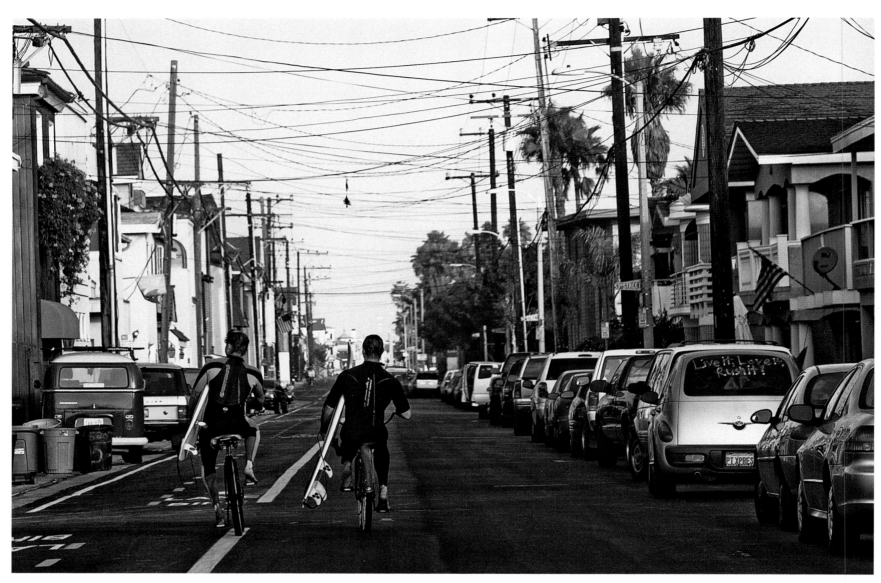

Scenic route.

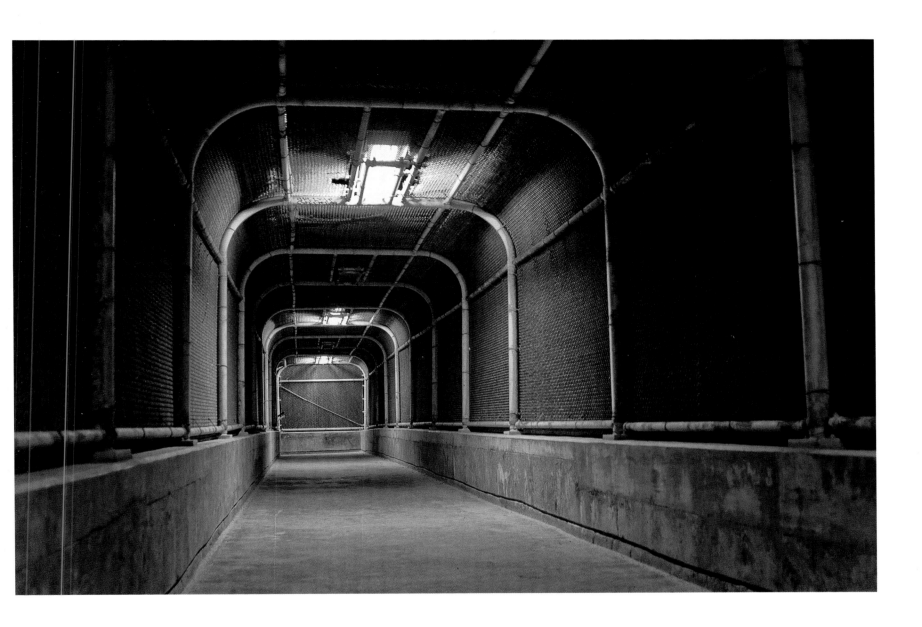

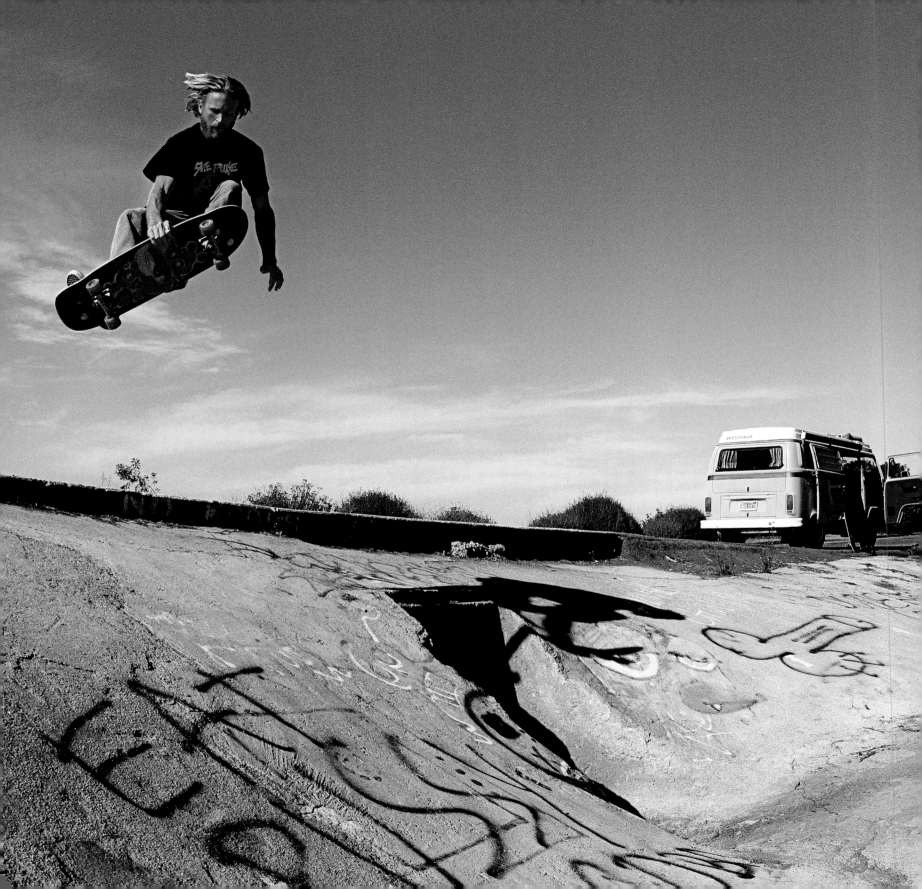

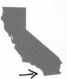

SAN DIEGO

Ah, San Diego was so pleasant! From the highway you could see perfect A-frames wisping offshore and stacking out the back. These conditions held for nearly a week and I surfed my brains out. I felt like a grom again, surfing and skateboarding all day. After a surf at Blacks we got to skate a pool in La Jolla Heights. We were on top of the world in our own little playground. My best friends live in Del Mar and they made it all too easy; for a second I almost forgot we were living in a van. At this pace, I considered trading my hideous beard for a leisure suit and hanging out at the horse track.

But Burky and I looked like bums and the unknown road lay ahead. I think Burky prefers the raw energy of the streets with all its hidden surprises. So we agreed to head south, and it didn't take long to run into trouble. At a scenic lookout, tourists gathered as my bus was boxed in by four police cars. I stood there eating cereal while a handful of Navy Police demanded my hands in the air. They thoroughly searched my whole vehicle, patted me down like a criminal, and after a forty-minute investigation told me I was free to go. Turns out we were checking waves on a navy base. They told me if I would have stepped foot in the ocean, I would have been arrested, boards confiscated and vehicle impounded.

To calm my nerves and keep the journey alive we went searching for the Washington Street skatepark. We found it under the freeway, but it was locked with twenty-foot barbed-wire fences around it. I was feeling a little defiant and announced I was breaking in. I scaled the twenty-foot fortress and jumped down into skate heaven. As my sneakers touched down, Burky yelled, "Someone's here, jump out quick!" Three cars of skaters pulled up and I was caged in. I hid for a minute, thinking I was screwed. They opened the gate and I heard, "Who the fuck is that?!" I approached them like a used-car salesman and talked my way out of it. I guess it wasn't my day—first the govern-machine and now the underworld.

That night we skated until two A.M. in the city. At one point while listening to a street musician, a woman came up and offered us her leftovers. I think she thought we were homeless. The leftovers turned out to be the spiciest Thai food on the planet and I spent the rest of the night sniffling with a runny nose and hiccups.

Dec. 20 - San Diego.

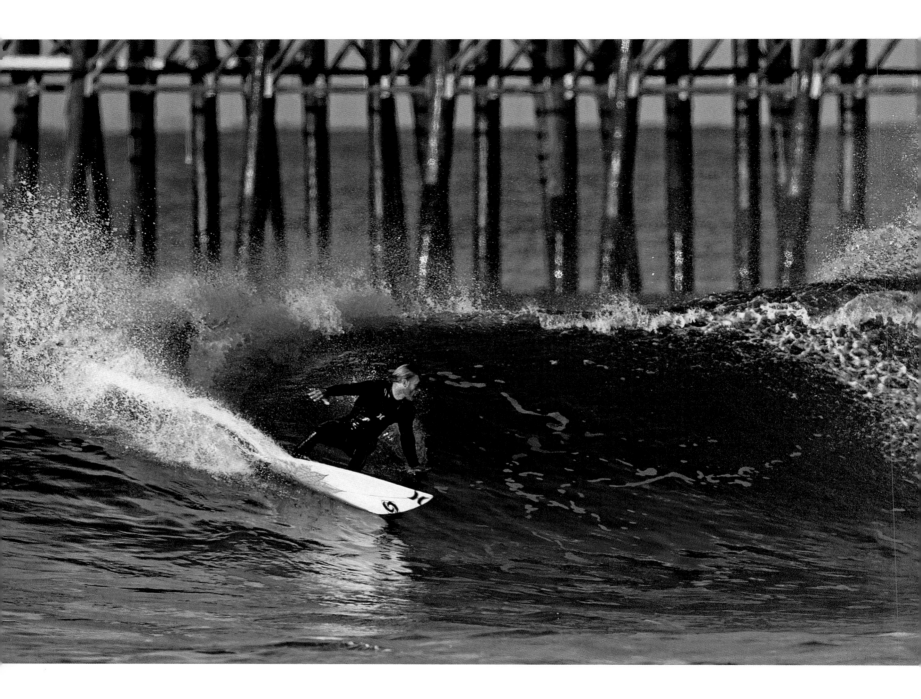

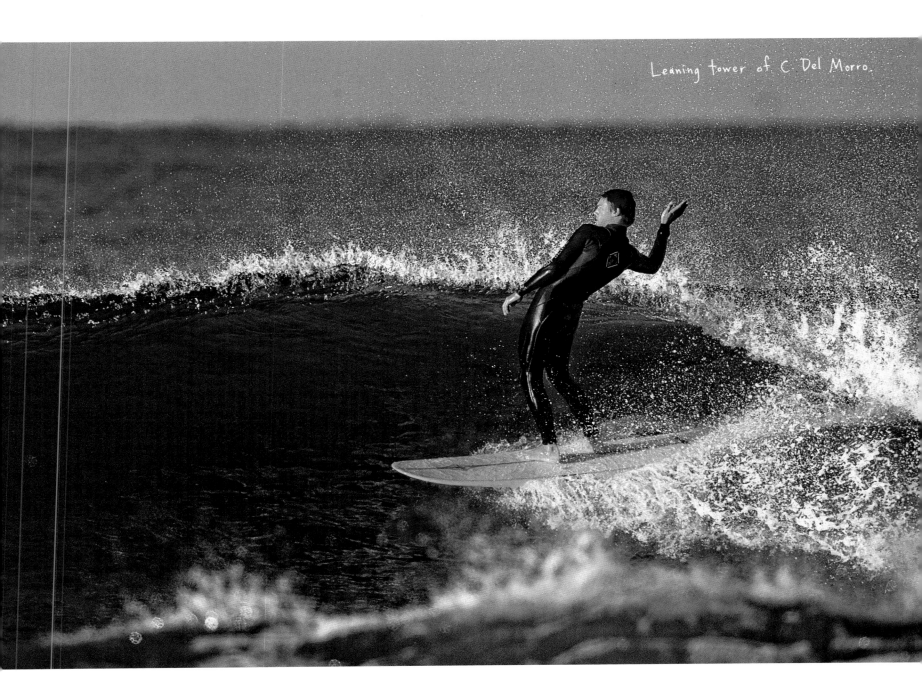

Leaning tower of C Del Morro.

I checked the surf on a Navy base. Three Police SUVs boxed me in and demanded my hands in the air. They searched my vehicle for drugs and told me that if I would have surfed, they would have arrested me, confiscated my boards and impounded my bus. "Pick on me all you want, but leave the bus out of it," I said.

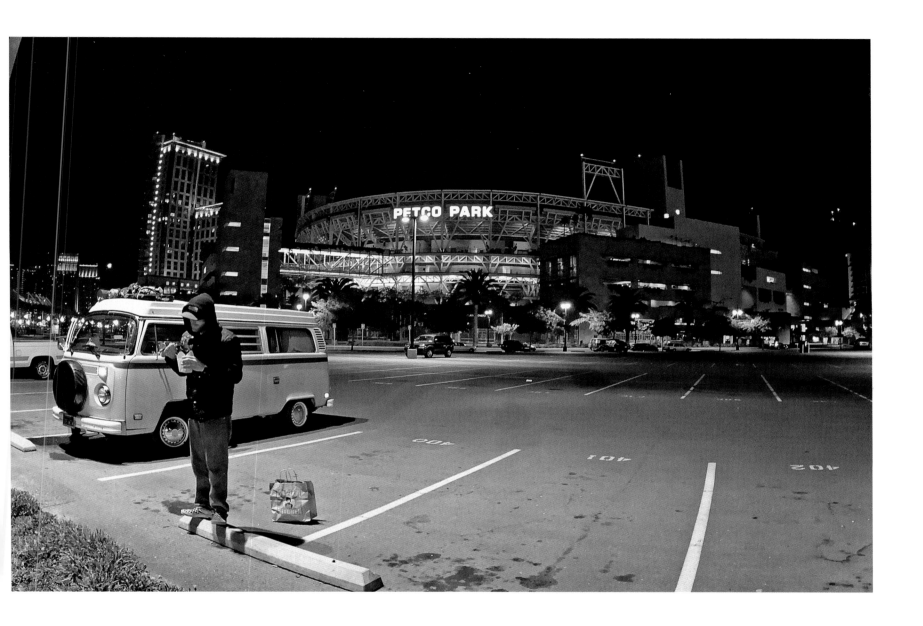

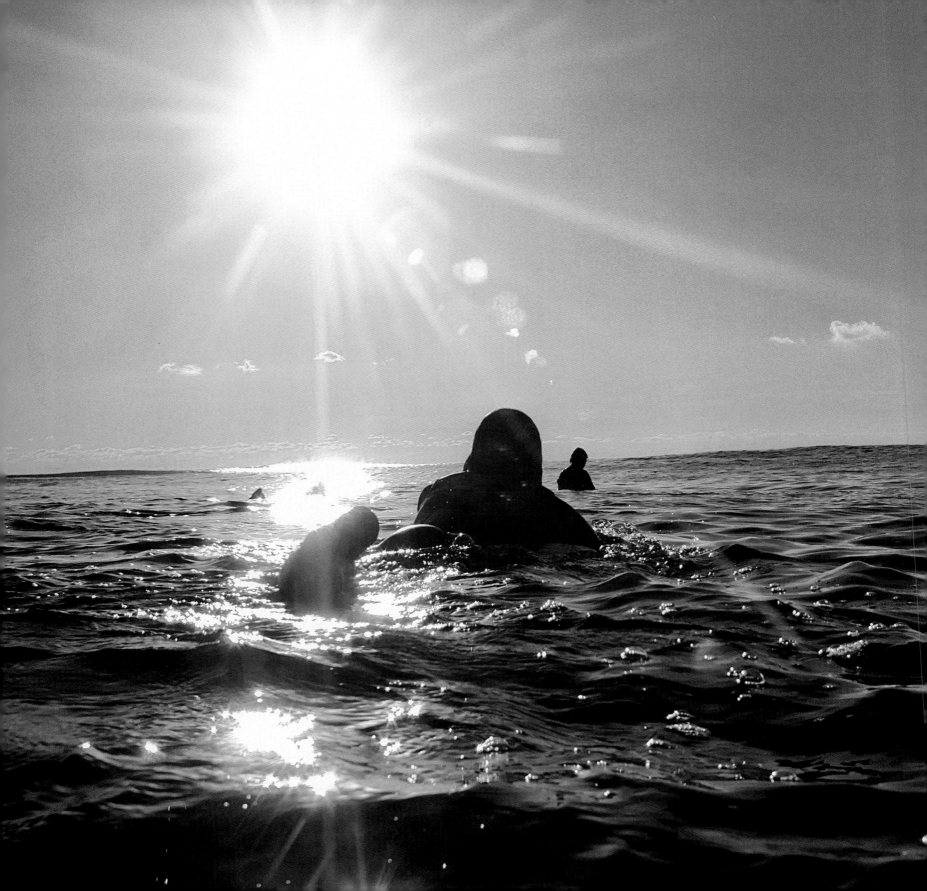

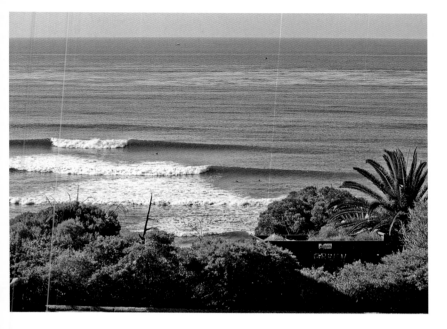

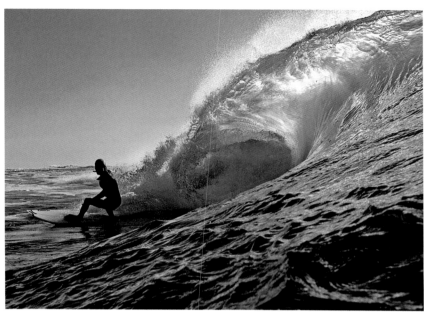

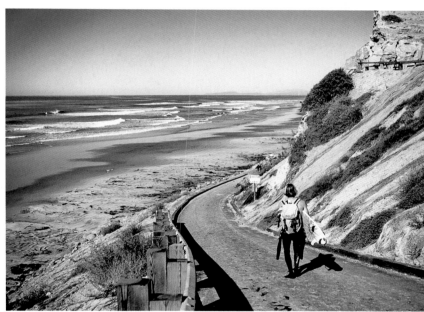

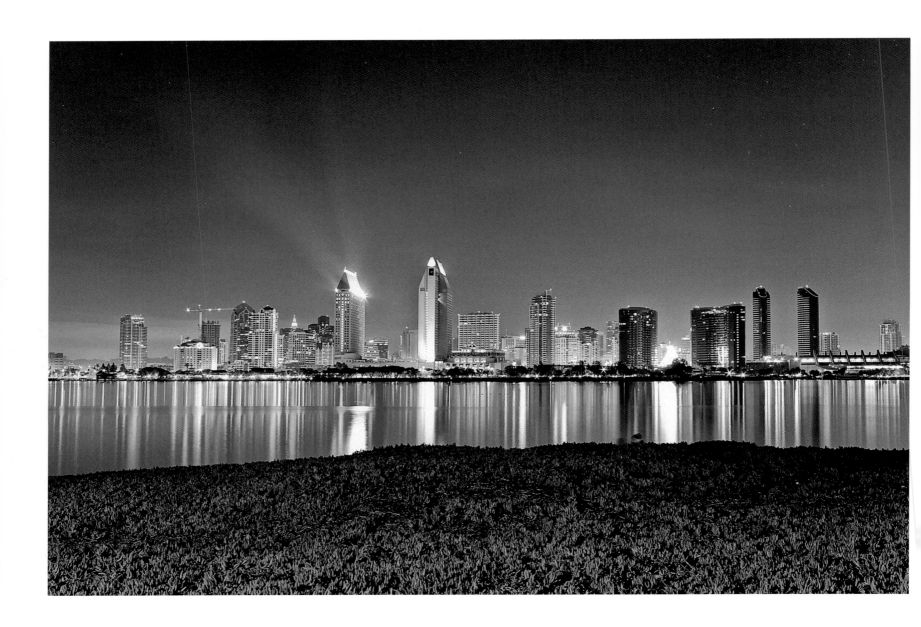

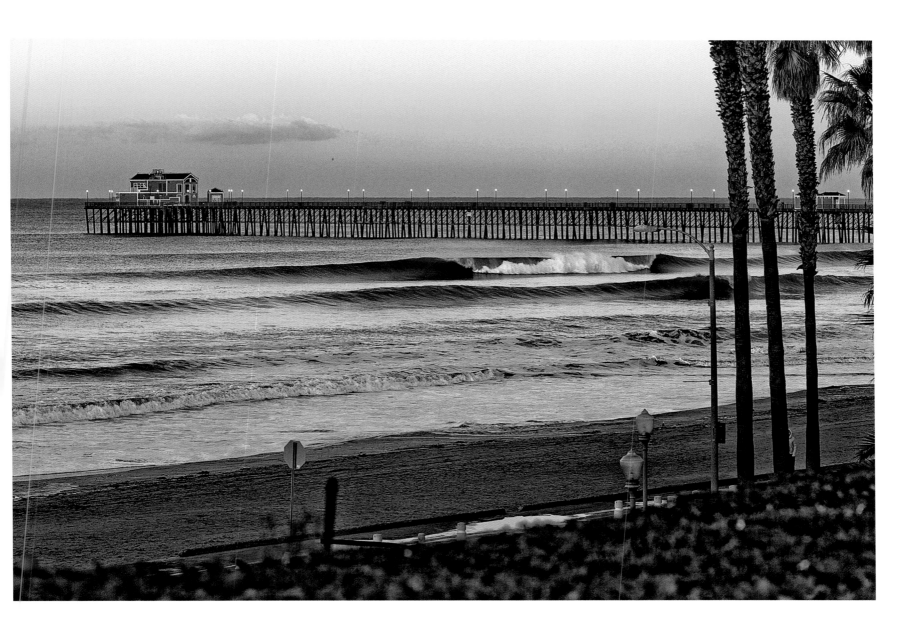

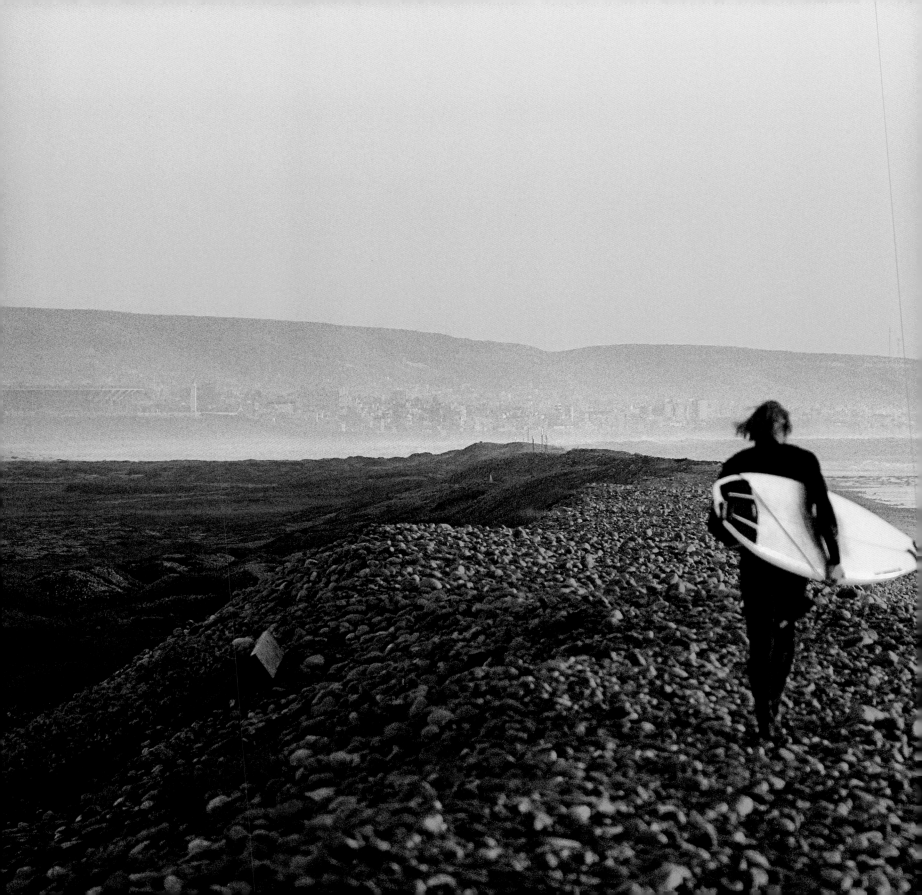

THE BORDER, PART TWO

A storm rolled in and Imperial Beach was a mess. Thick foam drained onto the beach and it started to rain. I ignored the elements and went for a lonely surf. I came in and Burky suggested we go surf the Tijuana Sloughs, but I thought it would be cool to go to Mexico instead.

We got near the border and took one look at the clustered mess and Burky put his foot down. "We are NOT going to Mexico, okay!" And that was that. Burky was right, it was time to give in. It had been nearly fifty days since we left for Oregon. I was dead broke. I knew as soon as I got home it was back to slinging art and a stack of bills, so I had clung to the road as long as I could. Burky's voice broke into my doomed thoughts. "Let's go surf the Tijuana Sloughs."

"Alright," I said, and for the first time in a while we headed north. We pulled up to the sloughs and it was actually beautiful. It's kind of a marshland with red native grasses and a river weaving through. I walked the rocks toward Mexico, the giant bull arena of Tijuana visible in the distance, then I went for my most-southern surf in California.

Burky and I decided we needed a better closing shot of the border wall. I don't know what we were thinking but we drove as far as we could south on a dirt road. At the dead end we parked and there was a narrow dirt path.

"Let's run it and see if we can see anything," I said. Burky agreed and we ran for about fifteen minutes. It was getting dark and there was still no sign of the border wall. Our jog slowed to a walk and now we had gone too far to turn around. We kept walking and walking. We must have walked for an hour and it was pitch black. I was beginning to get a little sketched out. I could see the lights of the bull arena in the distance and I whispered to Burky, "I don't think this is very safe." He answered, "I know, let's turn around."

Suddenly I heard something charging though the bushes. We both froze. Hoof beats were coming right for us. We couldn't see fifteen feet ahead of us. The horseman yelled, "Freeze!" as he pulled back his massive horse. It was the Border Patrol and he had his gun drawn. He got a good look at us and screamed, "What the hell are you guys doing out here?" Burky replied, "We're trying to get a picture of the wall." "My God," the patrol officer responded, shaking his head. "I don't think you guys understand where you are right now." Burky and I were dumbfounded. The officer started laughing. "You guys are on one of the most dangerous drug smuggling routes in California. I'll escort you back to your car, if it's still there." We assumed he was serious and accepted that we had pushed as far south as we could. We knew it was time to let go.

Dec. 23 – Tijuana Sloughs.

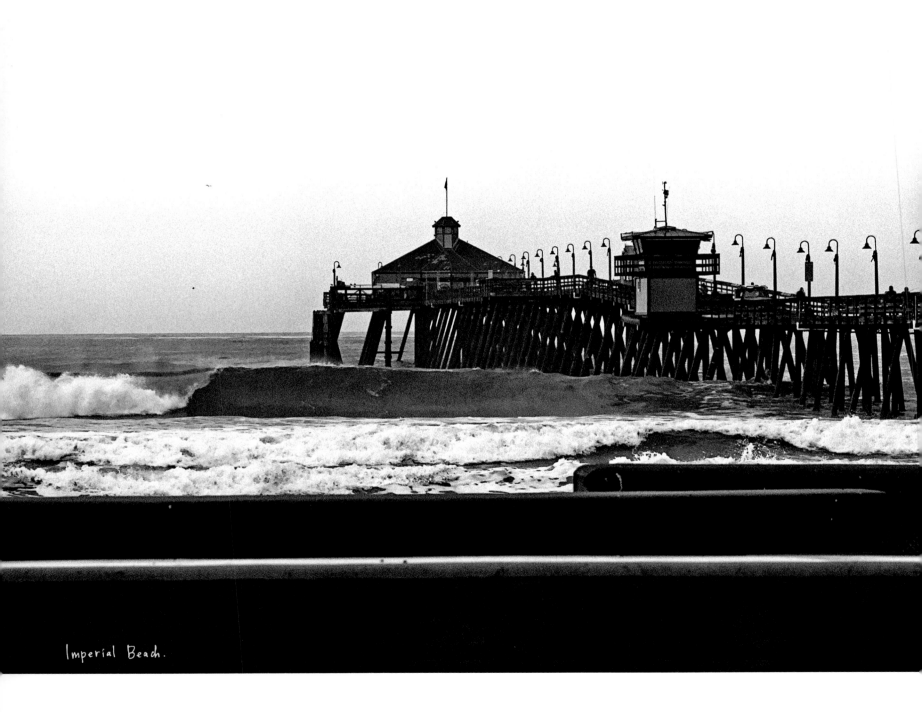

Imperial Beach.

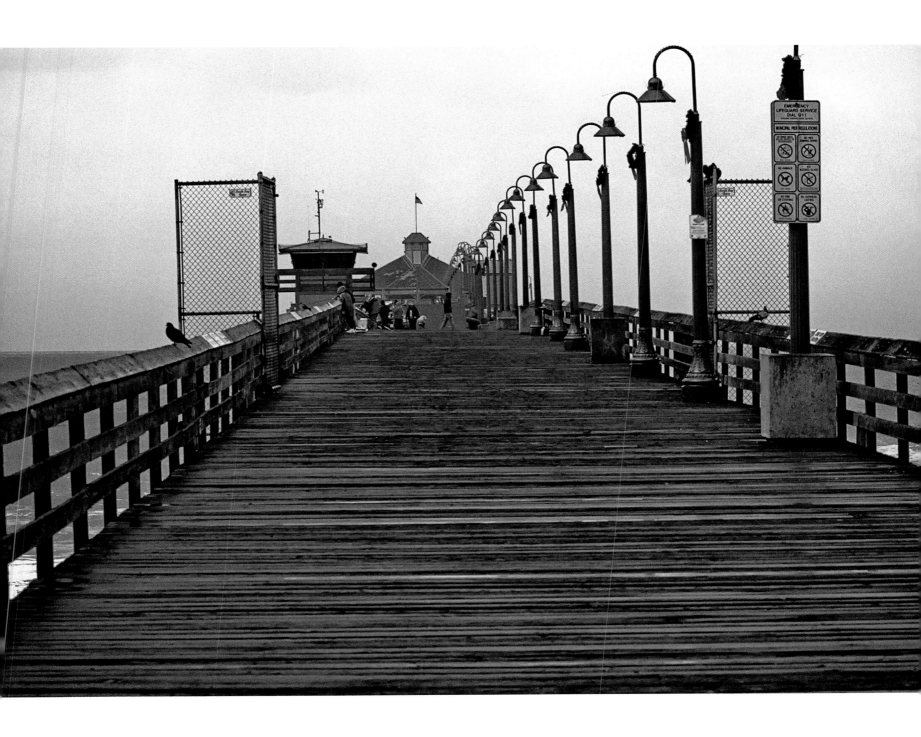

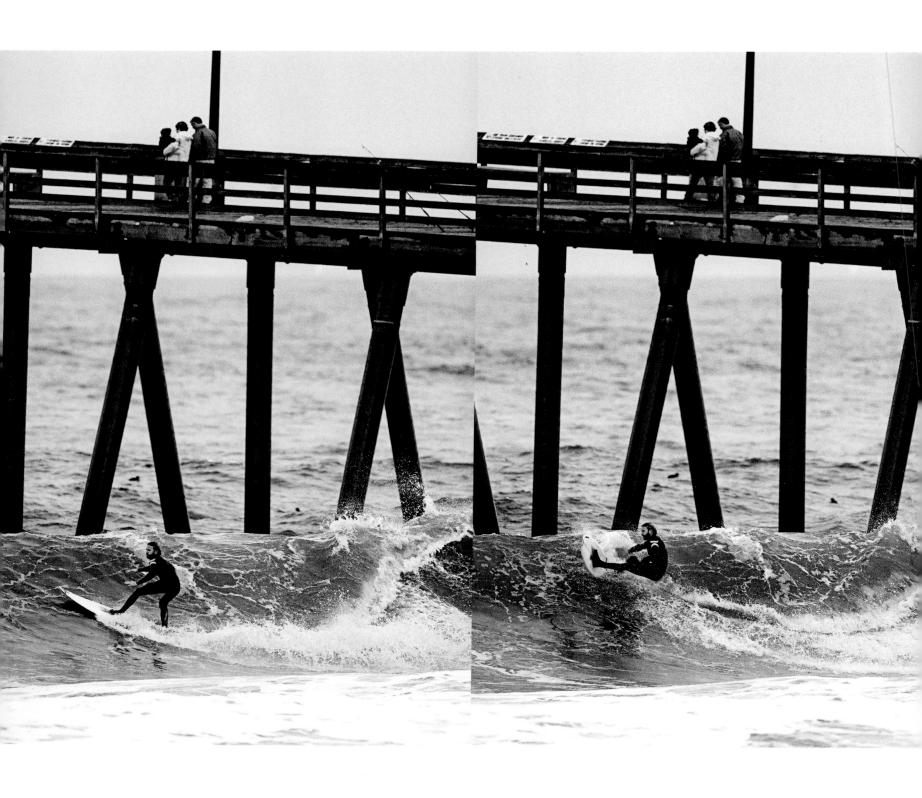

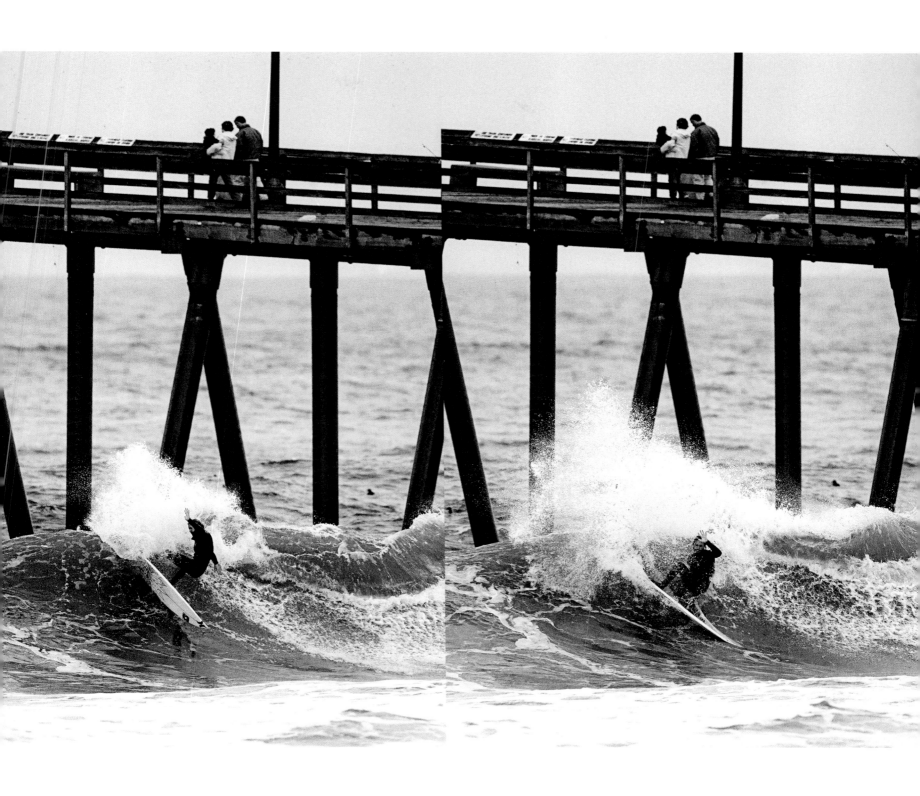

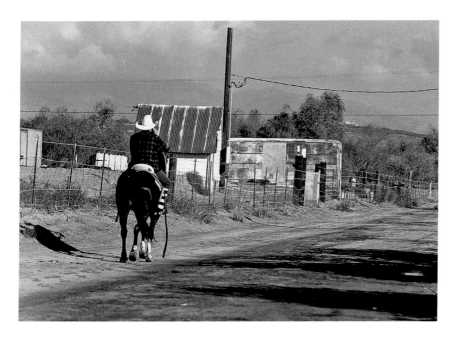

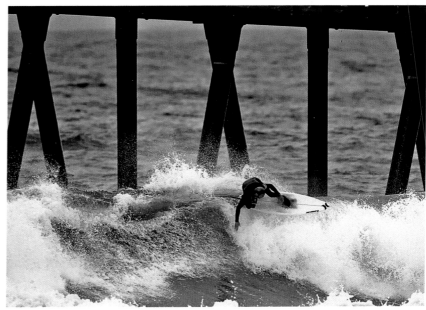

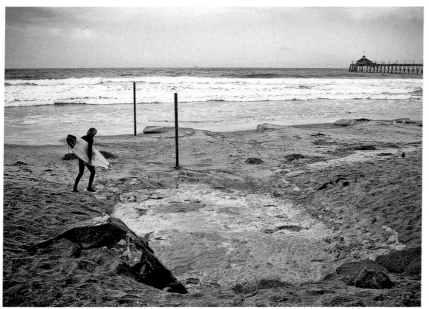

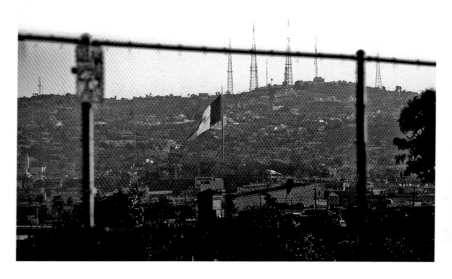

I ran into the Border Patrol, who asked for my name
and Social Security number. They were inquiring about
a dead body floating in the river. I noticed a helicopter
hovering close above. I saw the body but I could have
sworn it was a bloated seal. I told them everything
I saw and they thanked me and let us go.

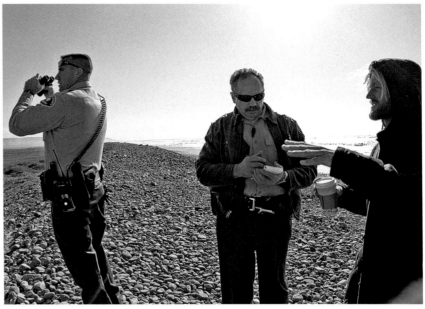

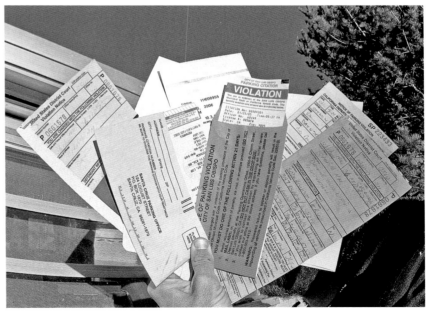

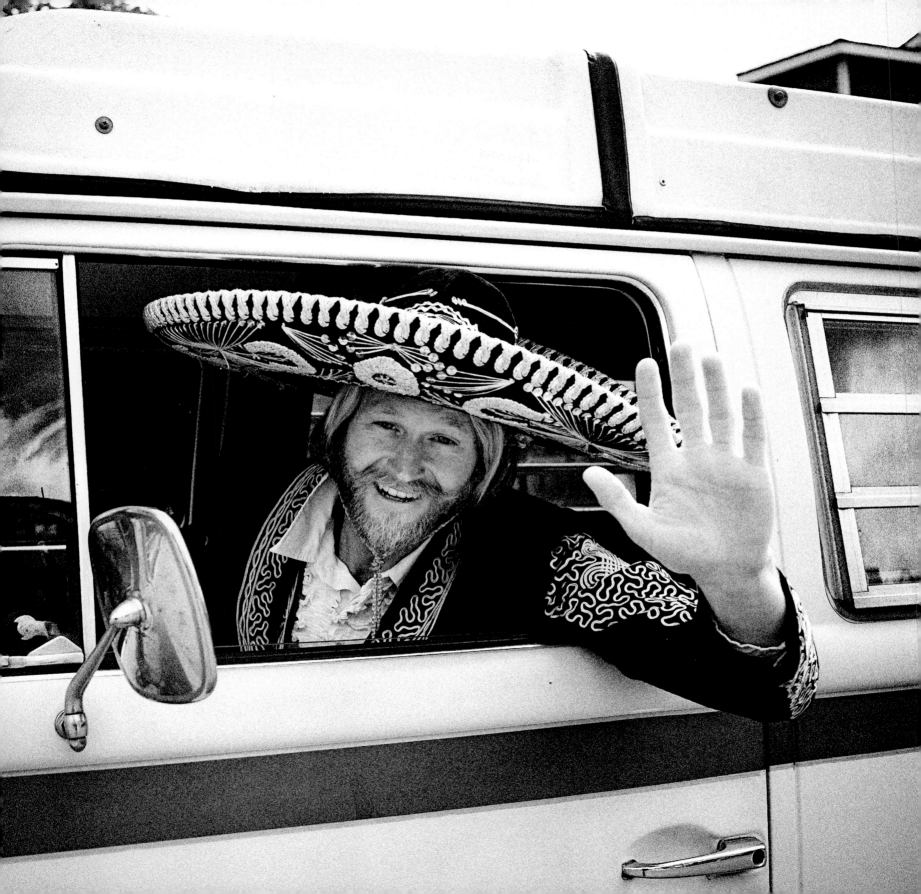

ADIOS

Just past the Tijuana Sloughs, the pavement turns to dirt. California comes full circle and you will find ranches and horse trails leading to nowhere. With Tijuana in the distance, we had come to the end of our fifty-day journey along the California coast. The Golden State was host to a trip of a lifetime and we are fortunate to live in such a beautiful place. May we enjoy it for many years to come and good luck on a journey of your own.

Fin del camino.

"Ha sido muchos dias manejandonos del norte, al sur, y ahora llegamos a la frontera del Mexico. El autobus manejo fuerte como una tortuga sabia y vieja."

It had been many days from the north and now Mexico sat before us.
The bus proved strong like an old wise turtle.

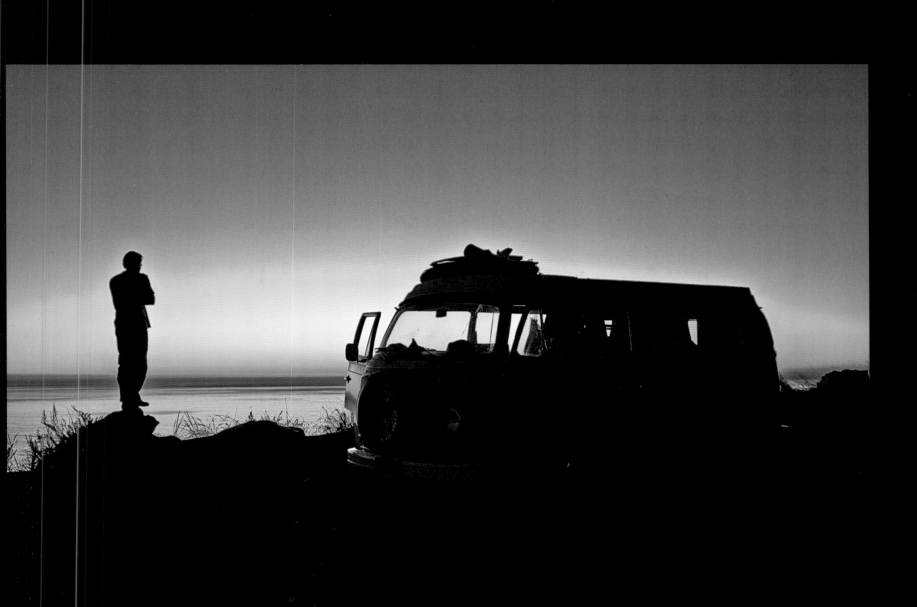

ACKNOWLEDGMENTS

Eric Soderquist:
To all my friends and family: My grandparents for my existence and being so truly grand. My simple living parents Scott and Debbie for always letting me explore, and my brothers Loch and Hugh for leading the explorations. Tony Emanuel for being the guinea pig on the bike-jumps near my house—"My God did he eat it." The lovely Monique Nelson, Dave Malcolm, Chris Burkard, and everyone that made this possible. Last and not least, California: "May your nature reign."

Chris Burkard:
I would like to thank God first and foremost. Also thanks to: My loving wife Breanne for sticking by my side even though I left home for two months to make this book. My Mom and Dad for being my best friends, and my 3 brothers—you guys are my heroes. Marcus Sanders and Dave Gilovich for believing in this project, and everyone else at Surfline.com for their support. Pete Taras for teaching me the ways of the Jedi master, and everyone at Transworld Surf for the tuttelage. Candace and Larry Moore and everyone at the Follow The Light Foundation and Surfing Heritage Foundation; if it were not for the Flame Grant this book would not have happened. Neil Young, Modest Mouse, Four Tet, and the Apple iPod for keeping our spirits up when the rain just wouldn't quit. And last but not least, thanks to Eric Soderquist for providing comedic relief on the road and putting up with me for 50 days—I couldn't have done this with out you, buddy.

AUTHOR BIOGRAPHIES

Eric Soderquist is a surfer and artist who has wandered this planet looking for waves for the past twenty years. He has surfed in Australia, Samoa, Canada, Indonesia, Peru, and Chile, among other countries, and has been featured in *Surfer, Surfing, Transworld Surf, Water, Surfer's Path, Surfing Life Japan,* and various foreign publications. He has participated in many art shows, art festivals, surf films, and community events, and lives in Shell Beach, California.

Chris Burkard is a senior staff photographer for *Water Magazine* and Surfline.com. At age twenty he won the first annual "Follow the Light Grant," which was founded in honor of Larry "Flame" Moore and recognizes the best young surf photographer. His work has been featured in more than forty publications around the world, and his advertising clients include American Airlines, Patagonia, Quiksilver, Fuel TV, Volcom, Channel Islands, and Burton Snowboards. Formerly a photo editor at *West Coast Surf Magazine* and a photo assistant for *Transworld Surf,* he lives in Arroyo Grande, California. For more information, visit www.bukardphoto.com.

The California Surf Project
Companion DVD Credits
Mastered by David Malcolm

Cadillacs out West
Cadillac Angels
Written by Tony Balbinot
Los Cadillaxe: 16 Tons of Twang
Rockin' Rebel Music
www.cadillacangels.com

Long Time
Resination
Written by Vance Fahie
Conscious Development
www.resinationmusic.com

Keep It on the Grass
Cuesta Ridge Mountain Boys
Mountain Boys Live

Sunsets in the West
Cuesta Ridge Mountain Boys
Mountain Boys Live

Swing 006
Cuesta Ridge Mountain Boys
Mountain Boys Live

I'm Justa Surfer
LaymAn Raw
Dreamin' the SurfLife
www.laymanraw.com

Dear Myth America
Rayman Law
Underdevelopedment
www.laymanraw.com

The Grass Grows Greener
Cuesta Voce
Written by Anders Edenroth,
The Real Group
Timepieces

Shaded Mountain
The Trio, Solana Beach Social Club

Turkish Banjo 1
Paul Roach, Solana Beach Social Club

Turkish Banjo 2
Paul Roach, Solana Beach Social Club

Daniel's Dog Gets a Laugh
Solana Beach Social Club
Written by James Barak
Vocals and slide guitar by Daniel Mead

Real Hotshots Don't Take Showers
Ku-dog
Hurdy Dirty Records

Butterfly
Chancho
Hurdy Dirty Records